S0-BSO-445

# EXPLORING THE
# BANCROFT LIBRARY

Mom,

A nice little tour
through another interesting
Library!

Mike

# EXPLORING THE
# BANCROFT LIBRARY

*Foreword and
Introduction by*
Charles B. Faulhaber,
*James D. Hart Director,
The Bancroft Library*

*With Contributions by*
Anthony S. Bliss
Gillian Boal
Walter Brem
William T. Brown, Jr.
Richard Cándida Smith
David Farrell
Todd M. Hickey
Robert H. Hirst
Theresa Salazar
Jack von Euw

*Edited by*
Charles B. Faulhaber
*and* Stephen Vincent

The Centennial
Guide to Its
Extraordinary
History,
Spectacular
Special
Collections,
Research
Pleasures, Its
Amazing Future,
and How It
All Works

THE BANCROFT LIBRARY,
UNIVERSITY OF CALIFORNIA,
BERKELEY,
IN ASSOCIATION WITH
SIGNATURE BOOKS,
SALT LAKE CITY, UTAH
2006

Copyright © 2006
Regents of the University of California for The Bancroft Library

All rights reserved under International and
Pan-American Copyright Conventions.

Published in the United States of America.

Library of Congress Cataloging-in-Publication Data

Printed in Korea

Exploring the Bancroft Library : the centennial guide to its
extraordinary history, spectacular special collections, research
pleasures, its amazing future & how it all works
  / edited by Charles B. Faulhaber and Stephen Vincent
     p. cm.
   ISBN 1-893663-19-1 (hc) -- ISBN 1-893663-18-3 (pbk.)
    1.  Bancroft Library. 2.  Academic libraries--California--Berkeley.
3.  Research  libraries--California--Berkeley. I. Faulhaber, Charles.
II. Vincent, Stephen, 1941-

   Z733.B198E97 2006
   027.7794'67--dc22

            2006042208

Permission acknowledgments:

*Kathleen Cleaver and Black Panther Party members meeting in the Alameda
County Prosecutor's office during the murder trial of Huey P. Newton,
Chairman of the Black Panther Party.* © 1968 Peter Breinig.
By permission of the estate.

*The Hughes Flying-boat ("Spruce Goose") being pulled across an
intersection.* © 1947 Chuck Brenkus. By permission of the estate.

*Gay is Good.* © 1971. Cathy Cade.  By permission of the photographer.

*Amber.* © 2003. Sasha Kulish. By permission of the photographer.

*Fire! Sunland, 1955.* © 2004. By permission of the Charles Phoenix
Collection.

*Dancers, Saturday night at Shalimar in Oakland.*  © 1981 Michelle Vignes.
By permission of the photographer.

*Beverly Stovall playing the blues at Eli Mile High Club in Oakland.* © 1981
Michelle Vignes. By permission of the photographer.

*Northern Vista, George Moscone Site, San Francisco, CA.* © 1980
Catherine Wagner. By permission of the photographer.

*Constructing the Rebar Cage: Al Zampa Memorial Bridge (Carquinez
Strait).* © 2004 Joseph A. Blum. By permission of the photographer.

Book and cover design by John Sullivan and Dennis Gallagher,
Visual Strategies (visdesign.com).

*Text editing development and support*: Gail Larrick.

*Additional Photography*: Beth McGonagle, Library Development Office.

The editors wish to thank the following Bancroft staff for generous
contributions of time and support to the development of this volume:
Peter E. Hanff, Deputy Director; James Eason, Principal Pictorial
Archivist, Erica Nordmeier, Photo and Digital Manager; Susan Snyder,
Head, Public Services; Tanya Hollis, Archivist, Rare Books and Literary
Manuscripts; and Lisa Rubens and  Ann Lage, Regional Oral History
Office.

# Contents

# Foreword

THE PUBLICATION OF EXPLORING THE BANCROFT LIBRARY takes place at a crucial moment in Bancroft's distinguished history as one of the premier research libraries of the world. Hubert Howe Bancroft (1832–1918) laid the library's foundations in 1860 when, as a bookseller and publisher in San Francisco, he began a reference collection on California. Almost fifty years later, on November 25, 1905, the University of California signed a contract to buy The Bancroft Library. On May 2, 1906, just two weeks after San Francisco's great earthquake and fire—from which the collection was fortunately spared—President Benjamin Ide Wheeler authorized the removal of the library from its San Francisco home on Valencia Street to its new quarters on the third floor of California Hall—at the time the newest building on the Berkeley campus. Now, as we embark on an extensive renovation project, Bancroft is celebrating the past one hundred years at Berkeley and simultaneously preparing for the next one hundred years—at least.

After 146 years of acquiring "stuff"—a technical term in librarianship—ranging from ancient Egypt to the modern American West, this book provides an opportunity to celebrate, and describe, the library that has grown from the one begun by H. H. Bancroft. The library's diverse collections offer a bewildering wilderness of possibilities. Here we attempt to tame that wilderness, with forays into the history of each collection, its contents, and future development. Our curators introduce some of their most significant holdings and write of the research opportunities provided by their collections and programs. In the "At Work" essays, scholars, students, and artists describe new discoveries based on Bancroft collections. We explain our research and publication programs and Bancroft's growing emergence as a campus center for learning as well as research. We also offer a behind-the-scenes view of how the library works to collect, organize, and provide public access to its wealth of resources.

Charles B. Faulhaber
THE JAMES D. HART DIRECTOR

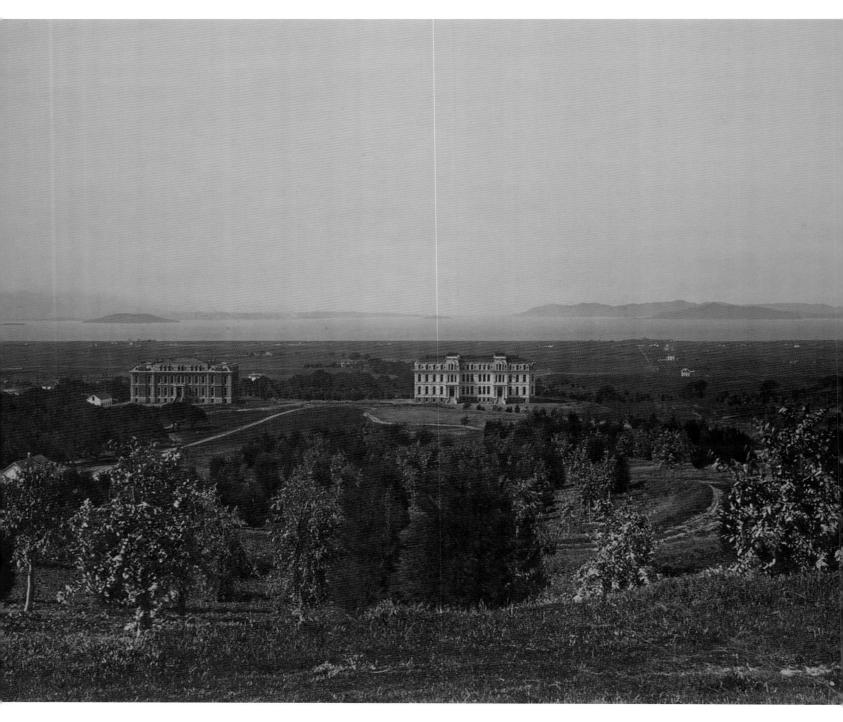

*View from the university ground[s] at Berkeley: the Golden Gate (in the distance).* Mammoth plate photograph by Carleton E. Watkins, 1874.

The University of California's first two buildings, imaginatively named North Hall (to the right) and the still existing South Hall, were constructed in 1873.

# Introduction

A GREAT LIBRARY DOES NOT SIMPLY HAPPEN. It is the result of the conscious efforts of generations of men and women, all imbued with the same goal: to capture the material record of a culture's collective and private aspirations, conflicts, accomplishments, and disappointments. Its collections of primary and secondary sources—books, maps, manuscripts, institutional and company records, newspapers, pictorial materials, and artifacts—illuminate the particulars, the character and soul of a culture's memory and presence. Ultimately, the library's ever-growing collections enable each generation to research, enrich, and reshape the telling of its story, undoubtedly the most precious gift a culture can give itself.

The University's acquisition of The Bancroft Library was one of the signal events that led to Berkeley's current eminence as the world's most distinguished public university. As President Benjamin Ide Wheeler stated presciently at the time:

> *The purchase of The Bancroft Library marks a great day in the history of the University.... It means the inevitable establishment at Berkeley of the center for future research in the history of Western America; it means the creation of a school of historical study at the University of California; it means the emergence of the real University of study and research out of the midst of the Colleges of elementary teaching and training.*

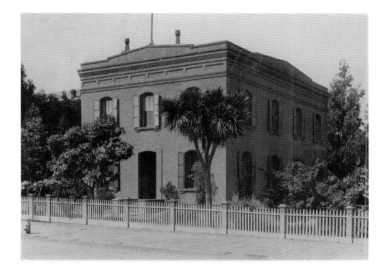

The Bancroft Library at 1538 Valencia Street, San Francisco, 1905.

H. H. Bancroft's collection originally focused on the "Pacific Slope"—California, Oregon, and Washington—but soon expanded to cover Central America, Mexico, the entire Western United States, British Columbia, and Alaska. Bancroft eventually sought to document the creation of "Pacific Civilization," the history of human activity in North America from the Rocky Mountains west to Hawaii and from Alaska south to the Isthmus of Panama. By the time of the sale to the University, the initial gathering of books in Bancroft's bookstore and publishing house had grown to more than 50,000 volumes. Unlike many of his nineteenth-century peers, who were primarily interested in, for example, first editions, fine printing, and quality bindings, Bancroft attempted to collect *everything*:

> *I did not stop to consider, I did not care, whether the book was of any value or not; it*

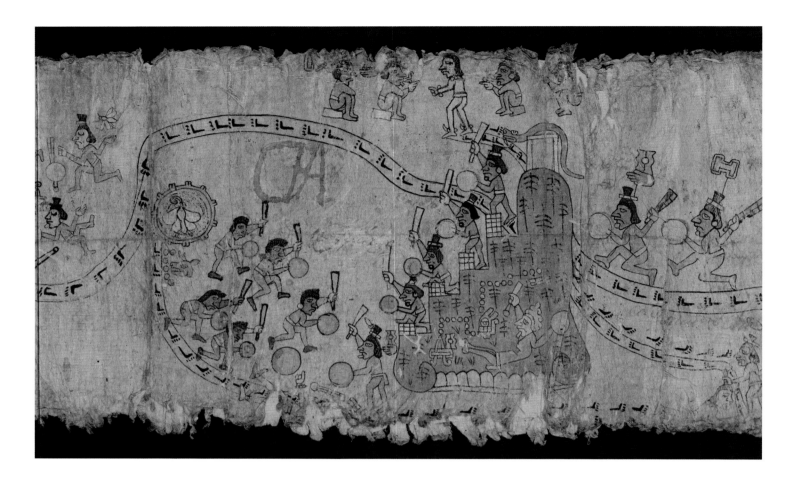

*Codex Fernández Leal*
(detail). Mid 16th century.

Based on pre-Colombian
models, it depicts warfare,
conquest, and sacrificial
ceremonies in the Cuicatec
region of modern Oaxaca.
The original scroll is
approximately 16 feet long.

*was easier and cheaper to buy it than to spend time in examining its value. The most worthless trash may prove some fact wherein the best book is deficient, and this makes the trash valuable.*

In 1906, shortly after the University acquired the library, Henry Morse Stephens, professor of history and the person probably most responsible for its purchase, recognized Bancroft's genius, noting that

*Mr. Bancroft's greatest characteristic as a collector was that he had imagination. He swept in with his dragnet all sorts of stuff—business directories, diaries, handbills, account books. He had the imagination even to see the importance of ships' logs and he took these in. He sent a man to Alaska for all the records of the early fur companies. As a result we have more of these than there are at St. Petersburg.... One knows not where to begin or end an enumeration. There are five thousand volumes of newspapers, many of them country newspapers at that, many of which exist alone in this collection. There is a magnificent pile of briefs in Spanish land cases; an extraordinary collection of records of the old Missions. We can trace the pious Father Serra, founder of missions, step by step on his journeys. We have also the entire records of the old Presidio in San Francisco; large masses of correspondence of old Spanish families; the actual minutes of the Vigilance*

*Committees, which are under lock and key and not to be opened until all the participants have passed away.*

The idea of the library was born in 1860 when Bancroft, returning from a trip, discovered that his assistant, William Knight, charged with editing a guide to the Pacific Slope, had assembled a small reference collection of about a hundred volumes. Within a decade Bancroft had gathered in 16,000 volumes and begun to seek ways to make use of them as well as to make money from them. Eventually this led to the publication between 1883 and 1890 of *Bancroft's Works*, thirty-nine volumes on the history of California and the West—but that's another story.

The collection continued to grow as the result of collecting trips to the East and to Europe, as well as through extensive purchases at major auctions, most notably of collections like those that became available on the European market after the collapse of Maximilian and Carlota's ill-fated Mexican empire in 1865. Another significant milestone in Bancroft's collecting was winning the friendship of General Mariano Guadalupe Vallejo, then retired and living

*The Works of Hubert Howe Bancroft*. San Francisco: History Company Publishers, 1883–1890.

Some of the original 39 volumes published by Bancroft's own publishing company. This set, bound in full calf, was sold complete with glass-fronted walnut bookcase to Henry Stiner of Eagleville, California. He bought the first 12 volumes in 1884 for $5.50 per volume.

on a large land-grant ranch in Sonoma, the town he had founded. As a leader of the *Californios* and the last commandant of Alta California, Vallejo had amassed a large quantity of records that complemented the official archives of the Mexican government. Thanks to Vallejo's influence, other important *Californio* families gave Bancroft their papers. If Bancroft could not secure original documents, he had transcriptions made of relevant portions, as in the case of the Archives of Spanish and Mexican California in the hands of the U.S. Surveyor General in San Francisco's City Hall, whose originals perished in the 1906 earthquake and fire. When no documents existed, he sought out and interviewed figures from all walks of life throughout the American West. These "dictations," hundreds of oral histories, became important sources for his *Works*, preserving recollections that might otherwise have been lost. Among the most heavily-used documents in the collection, the "Bancroft Dictations" preceded the library's current Regional Oral History Office.

Karl Bodmer (1809–1893).
"Bison-Dance of the
Mandan Indians in front
of their Medicine Lodge
in Mih-Tutta-Hankush."
Aquatint engraving, from
Maximilian, Prinz von
Wied, *Reise in das innere
Nord-America in den Jahren
1832 bis 1834*. Coblenz:
J. Hoelscher, 1839–1841.

When the University of California acquired Bancroft's library in 1905, it was—and it remains—the largest library in the United States devoted to a single region. Without Bancroft's vision and collecting efforts, much of the history and myriad details of one of the world's most spectacular migrations and its aftermath would have been lost.

From its arrival on the Berkeley campus in 1906 to the present day, a continuous and noteworthy relationship has existed between the library and faculty, scholars, and students. Under the leadership of Stephens and the first three directors (Herbert E. Bolton, 1919–1940; Herbert I. Priestley, 1940–1944; and George P. Hammond, 1946–1965), all professors of Latin American history, the library deepened and expanded Bancroft's original vision, particularly to the south. The astonishing breadth and depth of the library's holdings of Latin Americana established Bancroft as a singularly valuable resource for any student of the history of Mexico, California, and the Southwest.

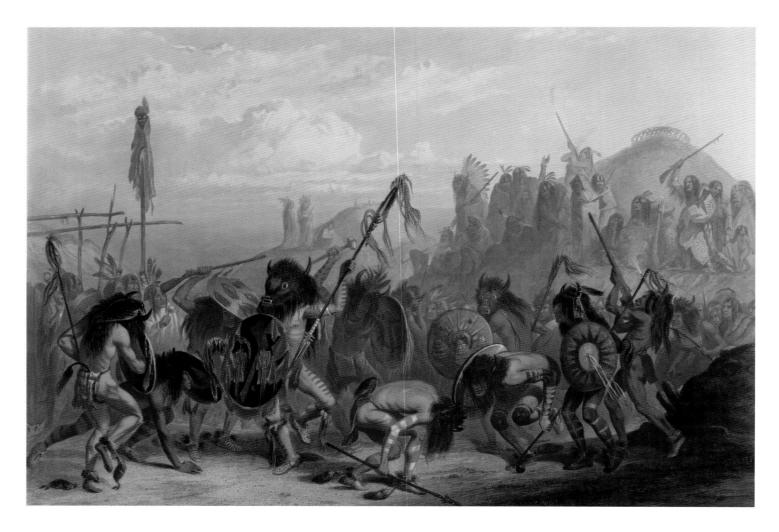

During the last years of his tenure, Hammond began to take a broader view of Bancroft's mission, tucking both the University Archives and the Regional Oral History Office, founded in 1954, under Bancroft's wing. Both colorably could be linked to the history of California. Under the directorship of James D. Hart, 1970–1990, however, the library substantially restructured and expanded its historic mission. Hart, a former Chairman of the English Department, Vice-Chancellor, and Provost, was the author of the classic *Oxford Companion to American Literature* (1941) and *A Companion to California* (1978).

With the transfer of the Rare Books Department from the Main Library in 1970, Bancroft at a stroke expanded its reach to include the entire sweep of Western civilization, ranging from the Tebtunis Papyri Collection from ancient Egypt to medieval manuscripts, incunabula, rare books and fine printing, and modern literary manuscripts. Two years later the creation of the History of Science and Technology Program balanced the focus on history and the humanities with a concentration on the sciences, especially big science, the large-scale projects in physics and chemistry that had marked the University's rise to prominence in the 1930s. Hart's eye, however, was never far from California. Rare Books continued to focus on the manuscripts and papers of contemporary Western authors and on the work of California's fine presses. The Mark Twain Papers and Project, which came to Bancroft with Rare Books, made the library the signature location for the study and edition—in collaboration with the University of California Press—of the author's letters and literary works.

Today Bancroft's holdings are national treasures. In announcing the award of a $750,000 Challenge Grant for the 2006 renovation of the library, Dr. Bruce Cole, Chairman of the National Endowment for the Humanities, called Bancroft's collections "unique, irreplaceable, and of stellar significance." They are all of that—icons and images of the human experience—and Bancroft preserves and protects them with the same loving care that the Church lavishes on its icons. No digital surrogate or reproduction, no matter how accurate, can duplicate the historical artifact itself—the first printing of a book, an author's

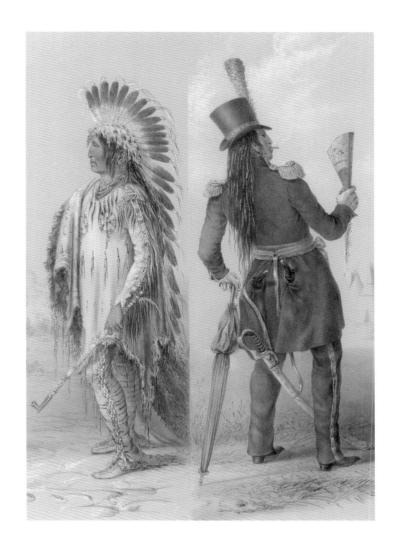

George Catlin (1796–1892). "Wi-Jun-Jon." Hand-colored lithograph, from his *North American Indian Portfolio: Hunting Scenes and Amusements of the Rocky Mountains and Prairies of America*. London: Geo. Catlin, C. and J. Adlard, 1844.

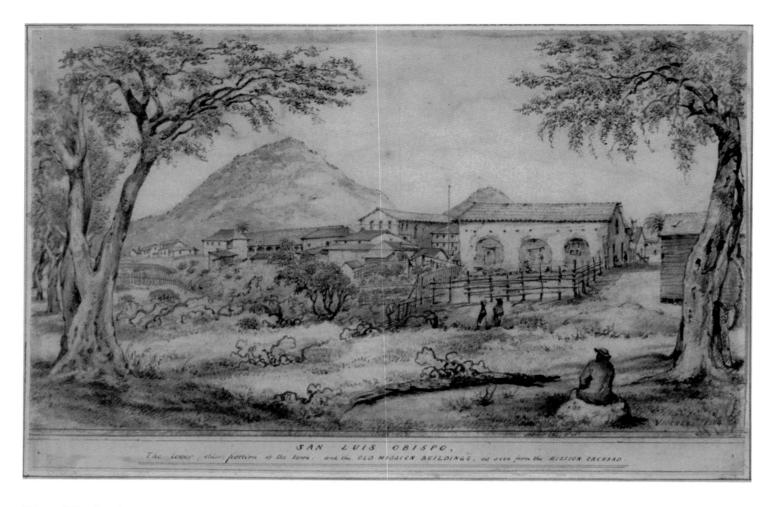

SAN LUIS OBISPO,
The lower (older) portion of the town and the OLD MISSION BUILDINGS, as seen from the MISSION ORCHARD.

Edward Vischer (1808–1878). "San Luis Obispo, the lower (older) portion of the town and the old mission buildings, as seen from the mission orchard." Watercolor drawing, 1864.

Vischer, from Regensburg, Bavaria, first came to Alta California in 1842, then returned after the Gold Rush. He published several volumes of his California sketches, and in 1878, the year of his death, completed a suite of 49 drawings that he called *The Mission Era: California under Spain and Mexico and reminiscences.*

manuscript, a personal letter, or an original document, painting, or vintage photograph.

These are the crown jewels of any library. Bancroft's include the only known lines from Sophocle's *Inachos*, in a papyrus fragment dated to the second century B.C.; medieval manuscripts of the entire cycle of the great Arthurian prose romances in Old French; the *Codex Fernández Leal*, one of the key sixteenth-century pictographic manuscripts recording Mexico's pre-Columbian history; all four seventeenth-century folio editions of Shakespeare; Joseph Breen's diary of the experiences of the Donner Party, marooned in the Sierra Nevada during the winter of 1846–1847; Carleton Watkins' nineteenth-century mammoth-plate photographs of Yosemite and California's Central Valley; the love letters between Mark Twain and his wife Olivia; the archive of cartoonist Rube Goldberg; the manuscripts of Frank, Charles, and Kathleen Norris, Richard Brautigan, Joan Didion, and Maxine Hong Kingston; and the records of Lawrence Ferlinghetti's San Francisco City Lights bookstore. The more than 2000 oral history interviews include those of photographer Dorothea Lange; Nobel Prize-winner Charles Townes, inventor of the laser; and Earl Warren, Chief Justice of the United States Supreme Court. And these treasures are the veriest tip of the iceberg.

*The Bancroft Library of the Twenty-first Century: Continuity and Change*

If the preceding historical précis has done anything, it has demonstrated that Bancroft has changed dramatically over the past one hundred years. The pace of change will only accelerate as we strive to keep up with the advent of new technologies, on the one hand, and, on the other, the economic, social, cultural, and political realities of a California that is larger and more diverse than all but a handful of countries.

What will not change, however, are the underlying principles that have guided Bancroft's growth for more than 140 years. We shall continue to document the development of California and the American West, but we shall not neglect our more recent interest, the history of Western civilization from Antiquity onward; we shall use state-of-the-art technology to provide access to our collections; and we shall open these resources not only to research scholars but also to students and the general public.

*Building the Collections*

One classic principle guides Bancroft's collection policy: Build on strength. Because in a very real sense Bancroft is the institution of record for the history of California from the earliest period, we shall continue to collect Californiana comprehensively, adding retrospective items as they become available through gift or purchase as well as keeping up to date with contemporary materials. It is much cheaper to acquire today's materials today rather than through the book trade even ten years from now.

Just as H. H. Bancroft documented the California of his day with the reminiscences of figures like General Vallejo, so too will Bancroft's curators document contemporary

Fray Junípero Serra (1713–1784). Circular letter sent from Mission Dolores in San Francisco to the heads of the seven other California missions reporting the death that same day, May 11, 1784, of Fray José Antonio de Murguía, the architect and head of Mission Santa Clara.

Patrick Breen (d. 1868).
Opening page of his Diary,
recounting the ordeal
of the Donner party
snowbound in the Sierra,
1846–1847.

"came to this place on the 31st
of last month we went on to
the pass the snow so deep we
were unable to find the road,
when within 3 miles of the
summit then turned back to
this shanty on the Lake…."

California with the archives of organizations like the Sierra Club or political figures like Governor Pat Brown, and the oral histories of winemen and women, educators, and mining engineers. And just as Bancroft collected the ephemera of his age, the sorts of things that were so common that everyone discarded them, so too will The Bancroft Library continue to collect the ephemera of our age—the advertising supplements, the tourist leaflets, the political protest flyers that add color and context to more substantive texts and images.

Bancroft will also continue to document California's economic development, its agriculture, mining, logging, building, and labor interests, high-tech and biotech, and even tourism; the history of environmentalism; the State's physical infrastructure—the great water projects and the building of highways, bridges, and prisons; its political history and the lives of its politicians and political activists; its literature, art, architecture, and performing arts; its ethnic diversity—new generations of immigrants from South and Southeast Asia as well as the continuing influx from China and Latin America; the growth of the University of California itself, with its expansion from one campus to ten and its manifold contributions to the development of the state and the world.

Many of Bancroft's most significant acquisitions are built on the fact that there are two sides to every story—at least—and with a fine impartiality, befitting H. H. Bancroft himself, we attempt to collect the appropriate primary sources so that posterity, with a longer perspective, can be the judge. The opposing views of the timber and mining industries and the environmental movement, for example, liberal and conservative activism for and against affirmative action, the debate about gay and lesbian rights, and the arguments about building highways or mass transit systems—all are

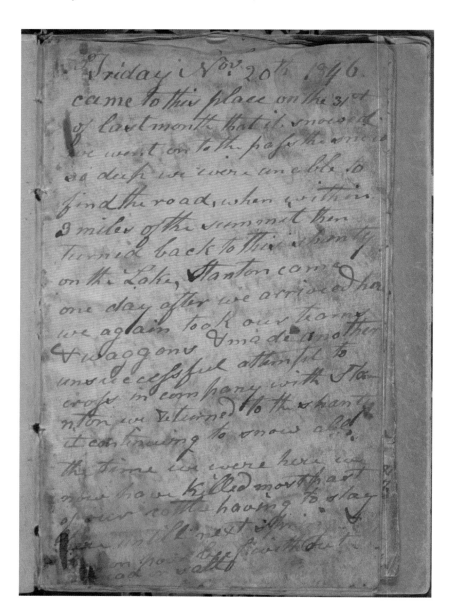

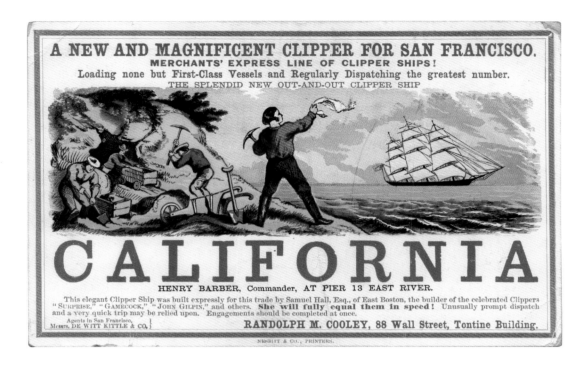

Clipper Ship
Advertisement Card for
the Clipper *California*.
New York: G. F. Nesbitt &
Co., circa 1850s.

Like most advertising
ephemera, these cards are
now extremely rare.

areas where conflict stimulates and demands a comprehensive range of materials. Indeed, just as during H. H. Bancroft's day, the state of California has remained at the creative cutting edge and turbulent center of globally significant political, economic, academic, and cultural conflicts and transformations.

Both collection policy and a deep knowledge of the collections sharpen the focus of the search and allow the curators to evaluate the materials that come into their ken, but book collecting is not a dispassionate science. There is the thrill of the chase. Indeed, the search has much in common with big game hunting; expert knowledge of the habitats and lairs of the prey is key: rare book catalogues, ongoing relationships with dealers and personal collectors, attendance at antiquarian book fairs and auctions, word of mouth about private collections and archives, and just plain serendipity—the items that come in "over the transom," as it were.

There is also more purposeful collecting when we set out to build or deepen a collection for a particular scholarly purpose. Thus, in order to support the research agenda of students of early modern Germany in the Departments of History and German, Bancroft has been systematically acquiring sixteenth-century historical texts, in both Latin and German.

Material culture—the built environment—is of as much interest as intellectual history. Bancroft contains extensive documentation of the physical development of the San Francisco Bay Area; for example, vast collections document the construction of the Golden Gate and Oakland-San Francisco Bay bridges. Occasionally the library initiates the documentation of significant projects or events. Bancroft commissioned photogra-

pher and former boilermaker Joe Blum to document the building of the new Carquinez Bridge, completed in 2003. Currently Blum is photographing the construction of the new East span of the Bay Bridge.

And always, the fundamental questions the curators ask themselves in the continual balancing act between the desire for comprehensive documentation and the realities of limited space, staff, and budget are the following: Will these materials prove of lasting historical value? What will scholars a hundred, or five hundred, years from now want to know about the reality of life in California in the twenty-first century? Who are the epoch-making authors, artists, scientists, political figures? Who are mere footnotes?

If bringing in trophy collections is the glamorous part of Bancroft, the back room staff of Bancroft Technical Services have the decidedly unglamorous but absolutely essential task of scholarly taxidermy, reducing to order the newly acquired collections of archival materials, the printed books, the ephemera, the photographs, restoring them to their pristine state, and putting them on display for the scholarly world to see, admire, and use. At the end of this process, the recent acquisitions will join the serried rows of Bancroft's other treasures on the more than 100,000 linear feet of shelving on and off campus. For further details, see "Behind the Scenes" (pp. 178–188).

*Technology and Access*

Bancroft will also continue to use the best available technology to provide access to its collections, just as H. H. Bancroft did. In his case it was the steam-powered printing press combined with impressive Yankee entrepreneurship that scattered thousands of copies of what is in essence the catalogue raisonée of his library the length and breadth of California and the West in the form of *Bancroft's Works*. In The Bancroft Library of the twenty-first century we shall continue to take advantage of the latest advances in information technology to make our and his collections better known and accessible from any point on the globe at any time of day or night. Already students and scholars enjoy Bancroft's online collections (*Honeyman Collection of Western Art, Japanese-American Relocation Archive, Chinese in California 1850–1925, 1906 San Francisco Earthquake and Fire*) and exhibitions (*Bear in Mind: the California Grizzly at The Bancroft Library*; *Images of Native Americans*; *Looking Backward, Looking Forward: Visions of the Golden State*). Such digital resources will multiply exponentially in the future.

*Bancroft's Readers*

In all of these efforts of collecting and disseminating, we continue to carry out the work that H. H. Bancroft started, giving back to the general public, as well as to professional scholars, the wealth of information originally gathered from that public and interpreted by those scholars. We also continue to serve, fundamentally, the students of the Berkeley campus. Indeed this was one of Henry Morse Stephens' primary justifications for the purchase of the library:

> *A good collection of secondary books can always be purchased; but all the money in the world cannot get together in a moment a collection of books and manuscripts and newspapers that shall afford to the student examples of every type of historical source-material. All teachers of history away from the great centres of historical collections realize the impossibility of adequately training their students. They can give them books to read; they can even give them source books; they can occasionally show them some original documents; but they can practically never give them the use of such an amount of diversified material as shall illustrate the various sorts of historical material which the student of history should be able to understand.*

Today, year in and year out, almost half of Bancroft's users are Cal students. Just as in Stephens' day, one of Bancroft's major functions is to teach the privilege, promises, and pitfalls of working with primary sources. The digitization and online sharing of Bancroft's holdings, valuable though they are, cannot substitute for the hands-on research that takes place in the Reading Room. The curators, in informal one-on-one sessions or in individual and even semester-long classes held in Bancroft, show student (and faculty) researchers how to use the collections to answer different kinds of questions.

These relationships are fostered especially by Bancroft's three research programs. Undergraduate research apprentices receive academic credit for their work in the Regional Oral History Office, the Mark Twain Papers and Project, and the Center for the Tebtunis Papyri—interviewing participants to study the racial integration of the Oakland Fire Department, deciphering Greek texts on ancient papyri, or transcribing Mark Twain's letters. At a more advanced level, Bancroft fellows work on their dissertations, studies like David Igler's "Industrial Cowboys: Nature, Private Property, and Region in the Far West, 1850–1920" (1996) or Isabel Breskin's "Visualizing the Nineteenth-century American City: Lithographic Views of San Francisco, 1849–1905" (2002).

Research opportunities for studies like these often arise from the synergistic relationships among the various archives and diverse formats. Documents in the Henry

## Dorothea Lange on the "incidents" that form the way one works:

Then also I was physically disabled, and no one who hasn't lived the life of a semi-crippled knows how much that means. I think it perhaps was the most important thing that happened to me, and formed me, guided me, instructed me, helped me, and humiliated me. All those things at once. I've never gotten over it and I am aware of the force and the power of it....

Years afterwards when I was working, as I work now, with people who are strangers to me, where I walk into situations where I am very much an outsider, to be a crippled person, or a disabled person, gives an immense advantage. People are kinder to you. It puts you on a different level than if you go into a situation whole and secure ... I can't say it well, but do you know what I mean? Well this kind of thing, you see, forms us. We all have those things that form us. They are of what we are built; they are our architecture. And there's much we don't know. I mean this is only a part of it. But the explanation of a person's work sometimes hinges on just such a succession of incidents....

From *Dorothea Lange (1895–1965), The Making of a Documentary Photographer*, an interview conducted by Suzanne B. Riess, 1960, 1961. Regional Oral History Office, 1968.

J. Kaiser Papers on the 1930s history and designs for Hoover Dam, for example, are greatly enhanced by construction photographs in Pictorial Collections. The oral histories of participants in the 1964 Free Speech Movement can be juxtaposed with University Archives' records of Academic Senate meetings during the same period. Critical analyses of historical events no longer need to be limited to the written document. Visual images and oral histories may contradict—or confirm—the written record.

### The Paradox of Success

In addition to basic principles, other similarities exist between The Bancroft Library of the early twentieth century and of today, sometimes painful realities that are in fact symptoms of success. In 1906 the Regents of the University of California were willing to fund only 10 percent of Bancroft's $11,000 budget, placing the bulk of the financial burden into the hands of private supporters. The Regents' share of Bancroft's budget, now more than $8 million annually, is larger today, just over 32 percent, but Bancroft still depends on private giving for almost half of its budget, with the rest coming from grants. In 1906 the original two staff members and three students could only begin to make Bancroft's riches available; today, even with 60 career and temporary staff and 80 student employees, Bancroft cannot keep up with the large and ever-growing backlog—more than 21,000 linear feet—of unarranged manuscript and archival collections. In 1906 the attic of California Hall was less than ideal storage space, and too small to boot, and the first-floor Doe Library quarters in 1911 were not much better. Almost from the beginning off-site storage was needed, initially under the bleachers at the Edwards Field track stadium on campus, later in the old Ford assembly plant in Richmond, and, since 1982, in the Northern Regional Library Facility in the same city.

## Renewal: The Bancroft Centennial Campaign

In 2001 the Berkeley campus scheduled Bancroft's fifty-year-old home, the Doe Library Annex, for seismic renewal. From the beginning it was clear that this was a not-to-be-missed opportunity to renovate and reconfigure the building, originally designed as generic library space, in order to serve Bancroft's programs and patrons more effectively. The problem was that the state would pay only for the seismic work, at a cost of some $32 million. A state-of-the-art renovation would cost at least as much more, but that funding would have to come from private sources.

In 2008 Bancroft will move back into a newly renovated, reconfigured, fully modernized—and safe—building, the beneficiary of a capital campaign that has raised over $32 million in little more than three years. Instead of occupying just two-thirds of the Doe Annex, Bancroft will have more than 90 percent of the building, thanks to the transfer of the library's Periodical, Newspaper, and Microfilm collections to the Doe Library. Bancroft collections will be stored on compact shelving under complete temperature and humidity control, allowing for approximately twenty years of collection growth. The entrance floor will have an expanded exhibition gallery and space for the Regional Oral History Office, as well as direct access to the Doe Library. In order to provide for better collections security, the Edward Hellman Heller Reading Room, the four seminar rooms (one

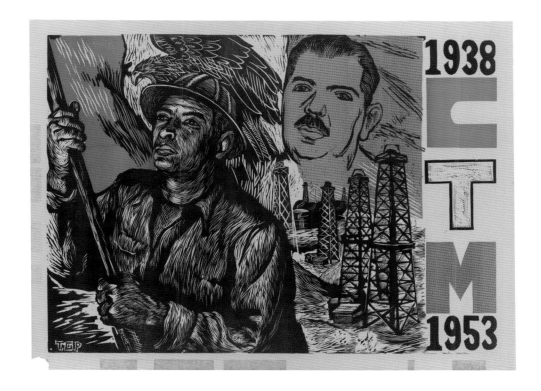

Adolfo Mexiac (b. 1927). *CTM 1938–1953*. Print on paper: linocut. Mexico City: Taller de Gráfica Popular, 1953.

This poster in honor of the Confederación de Trabajadores de México, the consortium of Mexican labor unions, celebrates the 15th anniversary of the nationalization of Mexico's oil industry by President Lázaro Cárdenas (1895–1970).

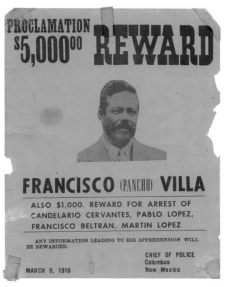

*Proclamation: $5,000.00 Reward, Francisco (Pancho) Villa*. Chief of Police, Columbus, New Mexico, 1916.

This rare "wanted" poster for Pancho Villa (1878–1923) was issued after the Mexican Revolutionary leader attacked the town of Columbus.

more than previously), an expanded Press Room, a new Reference Center, the curatorial offices, and the Public Service offices will move up one floor. The seminar rooms will have state-of-the-art multimedia equipment, while the Reading Room and Reference Center will provide both wired and wireless internet access. The fourth floor will house administrative offices, some of the technical services operations, the Mark Twain Papers and Project, and the Center for the Tebtunis Papyri, each of the latter with its own storage vault. The rest of technical services will occupy a new fifth floor in what had been uninhabitable attic space.

For the first time since Hubert Howe Bancroft constructed a building for his library at Valencia and Mission streets in 1881, Bancroft will have a home designed specifically for its needs, both immediate and long-term, an appropriate setting for this crown jewel of California culture.

*In Conclusion*

Bancroft's mission is to gather and host the material record of our cultures' diverse histories, to make that record accessible, and to preserve it for generations yet unborn. But time does not stop. History is in constant flux, and Bancroft's collections are ever expanding, or being rediscovered. Even those of us who work in Bancroft on a daily basis find it impossible to understand or even fully to comprehend the complexity of its collections and programs and the uncountable ways in which they find their use in scholarly, educational, and public realms. Ultimately we know the quality of our service by the scholarly work and public discourse that it informs; the content of public projects such as film documentaries; and, especially, the excitement on the faces of students as they triumphantly locate just the right document that provides the missing piece to a historical jigsaw puzzle.

# Bancroft Online Resources

- bancroft.berkeley.edu/ (home page)
- bancref@library.berkeley.edu (reference desk queries)
- http://www.lib.berkeley.edu/BANC/ Fellows/ (fellowships)
- http://bancroft.berkeley.edu/info/ fellowships.html#shumate (Hill-Shumate book-collecting prize)

## Online Catalogs

- http://sunsite2.berkeley.edu:8000/ (Pathfinder: UC Berkeley online library catalog)
- http://melvyl.cdlib.org (Melvyl: UC system-wide online library catalog)
- http://bancroft.berkeley.edu/collections/ findingaids.html (Finding Aids for Archival Collections)

## Research Programs

- http://bancroft.berkeley.edu/MTP/ (Mark Twain Papers and Project)
- http://bancroft.berkeley.edu/ROHO/ (Regional Oral History Office)
- http://tebtunis.berkeley.edu/ (Center for the Tebtunis Papyri)
- http://bancroft.berkeley.edu/ collections/uarc.html (University of California Archives)

## Digital Collections and Archives

- http://bancroft.berkeley.edu/collections/ earthquake.html (1906 San Francisco Earthquake and Fire digital archive and online exhibition)
- http://bancroft.berkeley.edu/reference/ africanamerican/ (African Americans in California reference collection)

- http ://sunsite.berkeley.edu/CalHeritage/ (California Heritage digital archive)
- http://bancroft.berkeley.edu/collections/ chineseinca/ (Chinese in California digital archive)
- http://bancroft.berkeley.edu/collections/ jarda.html (Japanese American Relocation digital archive)
- http://bancroft.berkeley.edu/collections/ honeyman.html (Honeyman Collection of Western Art digital archive)
- http://bancroft.berkeley.edu/collections/ landcases.html (Spanish and Mexican Land Grant Maps)
- http://sunsite.berkeley.edu/Scriptorium/ (medieval manuscripts)
- http://sunsite.berkeley.edu/incunabula/ (printed books before 1501)

## Online Exhibitions

- http://bancroft.berkeley.edu/Exhibits/ bearinmind/ (Bear in Mind: The California Grizzly at The Bancroft Library)
- http://bancroft.berkeley.edu/Exhibits/ Biotech/ (Bioscience and Biotechnology in History)
- http://bancroft.berkeley.edu/Exhibits/ physics/ (Breaking Through: A Century of Physics at Berkeley)
- http://www.lib.berkeley.edu/news_ events/exhibits/bridge/ (Bridging the Bay: Bridging the Campus)
- http://bancroft.berkeley.edu/Exhibits/ bancroft/ (Building Bancroft: The Evolution of a Library)
- http://bancroft.berkeley.edu/Exhib- its/nativeamericans/ (Images of Native Americans)

- http://bancroft.berkeley.edu/Exhibits/ Looking/ (Looking Backward, Looking Forward: Visions of the Golden State)
- http://bancroft.berkeley.edu/Exhibits/ MTP/ (Mark Twain at Large: His Travels Here and Abroad)
- http://sunsite.berkeley.edu/uchistory/ archives_exhibits/online_exhibits/ romapacifica/index.html (Roma Pacifica: The Phoebe Hearst International Architectural Competition & the Berkeley Campus, 1896–1930)
- http://sunsite.berkeley.edu/uchistory/ archives_exhibits/online_exhibits/1899/ index.html (The University of California at the Turn of the Century 1899–1900)

## Friends of The Bancroft Library

- http://bancroft.berkeley.edu/friends/ (Friends of The Bancroft Library)
- http://bancroft.berkeley.edu/events/ bancroftiana.html (Bancroftiana newsletter, nn. 112–128)
- http://bancroft.berkeley.edu/info/ lectures.html (Digitized lectures on California history)
- http://www.zazzle.com/collections/ home/default.asp?cid=23878058878690 4693 (Connection to zazzle.com [for reproductions of selected Bancroft images])

# Reading Room

WILLIAM T. BROWN, JR

Patrons in Bancroft's temporary reading room examine the Gregorian chant choir book written by Father Narciso Durán (1776–1846) for Native American neophytes at Mission San Jose in 1813.

Hard to imagine the reading room of an archival and special collections repository standing at the nexus of our modern Information Age? At The Bancroft Library's Edward Hellman Heller Reading Room, these worlds truly collide. Alongside researchers who are viewing the leaves of Tebtunis papyri from ancient Egypt, rare books from the fifteenth through twentieth centuries, manuscripts of Mark Twain, letters of Gold Rush pioneers, and photographs of the American West stand the latest computer workstations. The modern researcher enjoys powerful search engines of online catalogs and databases to discover and view centuries-old treasures. The workstations offer access to databases of electronic finding aids to archival and manuscript collections, tens of thousands of digital images selected from Bancroft's pictorial holdings, and other guides,

exhibits, and reference tools. Many researchers can now perform part or all of their research from the comfort of their homes, offices, or dorm rooms.

On a typical day the Reading Room hosts a combination of Berkeley undergraduates, graduate students, and faculty—more than 50 percent of annual researchers are from the University of California—and a steady throng of visiting students, scholars, and others from throughout the state, across the nation, and around the globe.

Bancroft is now a 24/7 online information resource. Bancroft's web site provides up-to-date information on everything from how to travel to campus and where to park; upcoming exhibits, lectures, and events; and news on the latest acquisitions, grant projects, and development efforts. The daily delivery of reference let-

ters and telephone calls is now supplemented by a growing stream of email inquiries.

Students in a fourth-grade class in Fresno, an undergraduate course at Georgia State University, and a graduate seminar at Yale may now enjoy a new-found access to the images and words of, for example, Japanese-American internment victims during World War II; student protesters of the Free Speech Movement in the 1960s; or pioneers in bioscience and biotechnology during the 1970s.

One can only wonder what changes in technology the next decade, the next year, or even the next week will bring.

The Reading Room, however, is a place where time may stand still but inquiry never does. The constant activity of staff and researchers begins when researchers first register. It includes the continual retrieval and reshelving of books, cartons of manuscripts, and other materials requested by visitors; reference assistance for researchers navigating online catalogs and printed resources; photocopying documents and reproducing photographs and images; and maintaining security and comfort for those who work and study in the Reading Room. This variety, and activity, surprises many who come in our doors expecting a more staid, even stuffy, atmosphere.

The Reference Desk and the related Reference Services remain a portal for inquiry, as scholars and students focus, refine, and reconfigure their research projects through conversations with Bancroft staff. For undergraduates, such as the hundreds who visit Bancroft in a given semester for their introductory History 7B course, the journey is as important as the result. Increasingly, faculty members wish to

have undergraduates experience the full spectrum of academic research, and Bancroft staff members work with colleagues in Doe and Moffitt libraries to coordinate this effort.

Each semester several Berkeley classes consider Bancroft a second home, as students explore its collections for class papers, honors theses, and dissertation projects. Bancroft also welcomes hundreds of thousands of virtual users who visit and explore our state-of-the-art web site. The reactions of undergraduate students to the rare and unique resources found in Bancroft are a constant source of inspiration. One undergraduate noted after her research on Mark Twain and the American West, it's "just unbelievable that I can use sources that scholars and historians use in their research, and I'm only a history undergrad." A graduate instructor commented, "I think all Berkeley students should use Bancroft at least once during their studies at Berkeley. When else will you get the chance to do so?"

*William T. Brown, Jr., is the former Associate Director of Development and Outreach.*

## Bancroft Statistics

Bancroft operates one of the busiest academic special-collections reading rooms in the nation:

- During the 2003–2004 academic year, Public Services staff accommodated more than 12,000 individual research visits, which generated requests for over 63,000 items.
- Staff answered almost 54,000 email, telephone, and mail reference inquiries.
- Bancroft received an additional 625,000 hits to the Bancroft web site and fulfilled requests for more than 60,000 pages of photocopies and 2,800 photographic reproductions (including digital images).

# Western Americana

Theresa Salazar, CURATOR

## Collection Profile

*Chronology*    Age of exploration to the present

*Subject Areas*

- Native American Studies and Anthropology (cultural anthropology, linguistics, archeology, social and cultural history of American Indians)

- European, Russian, and later American expeditions of discovery; the Spanish Colonial and Mexican encounter and settlement

- the United States-Mexican War; pioneer travel and settlement in the West

- the discovery of gold and world migration to California and other Western areas

- varied ethnic communities; religious and political freedom; the development of state and local politics, including governmental bodies

- the emergence in the West (especially California) of major commercial centers; maritime, agricultural, lumber, and mining enterprises

- land use, rights, and politics; the building of infrastructure; and transportation, travel, and tourism

- industrial, technological, and scientific innovation; the blossoming of the environmental movement

- the emergence of metropolitan areas as major business, cultural, and educational centers and, later, the rise of suburban communities

- twentieth-century cultural and artistic contributions

- the role and activities of labor and ethnic and minority groups

- the establishment of the State of California as a global economic entity

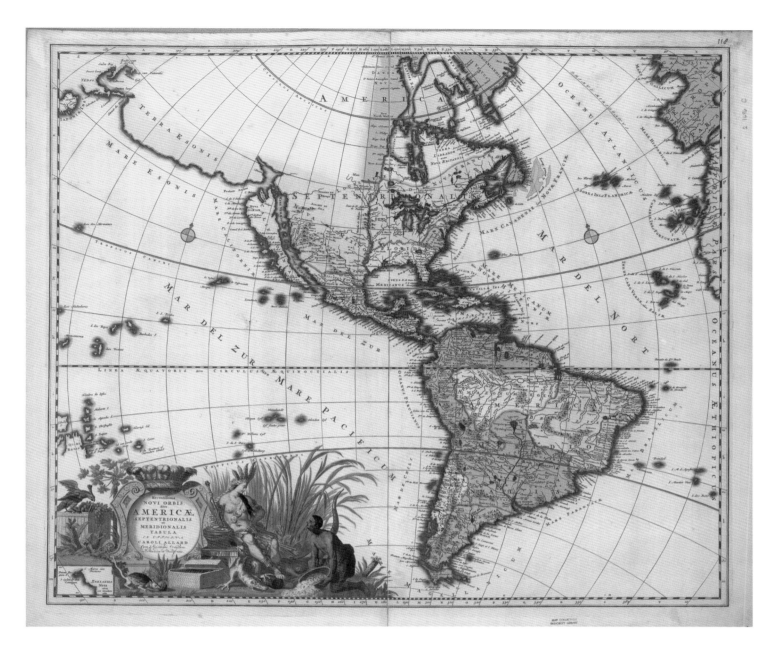

# Overview

Carel Allard. *Recentissima novi orbis, sive Americae septentrionalis et meridionalis tabula.* Amsterdam, 1696.

THE WESTERN AMERICANA COLLECTION constitutes the largest and most diverse group of research materials within The Bancroft Library. Like the original Bancroft collection, it covers not only the Western United States, including Alaska and Hawaii, but also Canada, Mexico, and Central America. The Latin Americana materials are described separately. These two collections provide an unparalleled opportunity to explore the social, political, economic, environmental, and cultural development of the western half of the United States, a unique opportunity made possible through the collection's wide range of primary and secondary resources. For each historical epoch up to the present day, the collection

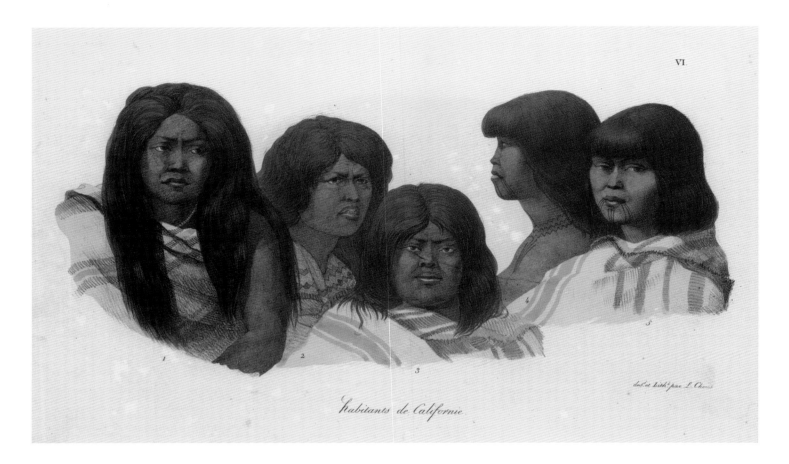

Habitants de Californie

Louis Choris (1795–1828). "Habitants de Californie," 1816. Hand-colored lithograph, from his *Voyage pittoresque autour du monde, avec des portraits de sauvages d'Amerique....* Paris: Firmin Didot, 1822.

Choris visited San Francisco as an artist for the Russian scientific expedition commanded by Otto von Kotzebue.

provides multiple points of view; portrays and critically re-interprets the region's history, constantly contesting and redefining the roles of its political organizations and leaders; examines the growth and subsequent encounters of its ethnic and migrant populations; explores the sources of its economic strength and direction and its cultural, artistic, and religious ambitions and struggles; and adds to the understanding of both exploitation and protection of the environment.

Hubert Howe Bancroft saw how historical analysis must depend on a broad range of contemporary materials. He aspired to nothing less than capturing the creation of a new civilization on California's virgin lands, a Pacific civilization that would crown and complete that of the United States as the culminating expression of Bishop George Berkeley's "Westward the course of empire takes its way," itself one of the last expressions of the classical and medieval trope of *translatio imperii.* The comprehensive, exhaustive nature of his collecting practices set the standard for continued expansion of the Western Americana collection.

The visual, textual, and oral documents collected under Pictorial Resources, the History of Science and Technology Program, University Archives, Rare Books and Literary Collections, and the Regional Oral History Office (ROHO) further enhance Western Americana's research opportunities. Bancroft's environmental collection offers an out-

standing example of this kind of synergy. Resources documenting the Sierra Club include correspondence with founder John Muir (1838–1914); the club's official records from its founding in 1892; the personal papers of its executive directors, including David Brower (1912–2000), Michael McCloskey, and Carl Pope, the current director; photographic collections, among them a large body of work by Ansel Adams (1902–1984); oral histories with leading members and staff of the club; and comprehensive collections of publications and ephemera.

Similarly, the history of the women's suffrage movement in California can be explored through oral histories conducted with women activists such as Alice Paul (1885–1977) and Sara Bard Field (1883–1974) as well as through manuscript collections, ephemera, pictorial collections, and a wide variety of printed resources, including government publications.

Karl Bodmer (1809–1893). "Hunting of the Grizzly Bear." Aquatint engraving, from Maximilian, Prinz von Wied, *Reise in das innere Nord-America in den Jahren 1832 bis 1834.* Coblenz: J. Hoelscher, 1839–1851.

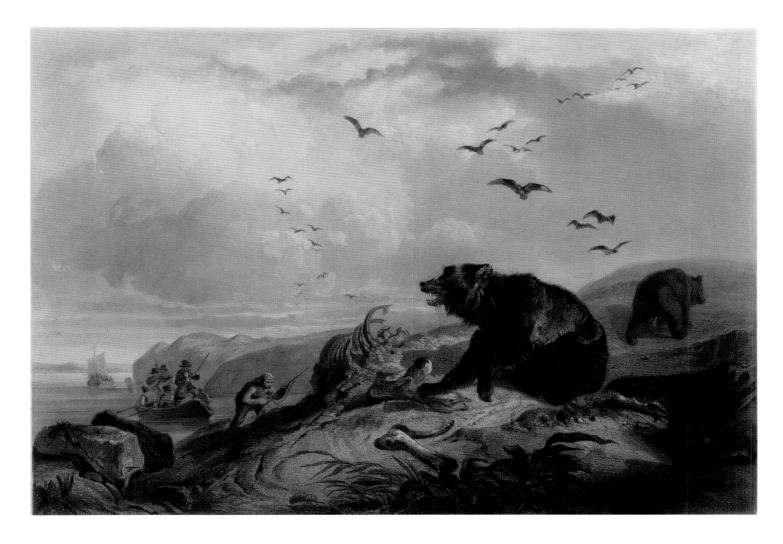

Collection development related to the American West remains focused on the acquisition of documentation that reflects the dynamics and diversity of the region. Up until 1920 Bancroft attempted to collect primary and secondary sources for the entire region; after that date we have increasingly focused on primary sources related to California while continuing to collect secondary sources for the entire American West.

One of our jobs as collectors of history is to build on our strengths, while at the same time anticipating new research trends. Like H. H. Bancroft, we too hope to anticipate the interests of future scholars. In the past few decades, for example, The Bancroft Library has given particular attention to social movements and protests, gathering documentation on the Free Speech Movement on the Berkeley campus, the Disability Rights movement, or activists associated with People's Park in Berkeley. Bancroft is also looking afresh at ways to collect materials related both to old and new immigrant communities in order to reflect the changing nature of California.

Many of the subject areas we collected early on remain essential to our mission. Curators acquire books and documents from earlier historical periods that continue to be of interest to researchers who are asking different questions and producing new narratives of those periods. Thus, Gold Rush diaries, family papers documenting agricultural activities in California, letters written to loved ones after the 1906 San Francisco earthquake, or journals kept on railroad or automobile trips are resources to be evaluated and analyzed anew.

## Collection Survey

*Origins*     Native American Studies (Anthropology/Archeology/Linguistics) from the Spanish Colonial period to the present

DOCUMENTATION OF THE NATIVE AMERICAN experience began with H. H. Bancroft's pursuit of sources to use in the first five volumes of his *Works*, dedicated to the native races: early descriptions of the various Native American tribes and their encounters—violent and peaceful—with missionaries, settlers, traders, and artists. Loss of indigenous populations and their lands in the nineteenth and twentieth centuries and the resurgence of Native Americans as a political and cultural power in the twentieth and twenty-first centuries are abundantly documented. Other references to the indigenous peoples of the West can be found in private papers and in the records of Spanish and Mexican officialdom, especially mission records.

Among Bancroft's outstanding treasures are the four North American nineteenth-century color plate books on Native Americans—all classic works. The earliest of these publications, by James O. Lewis, *The aboriginal port folio, or, A collection of portraits of the most celebrated chiefs of the North American Indians* (1836), was acquired as the nine-millionth volume of the University of California Berkeley Library in 2000. In general, the collection is rich in nineteenth- and twentieth-century publications related to the Native American West.

Perhaps the most important collection of primary sources for the life and culture of California's Native Americans are the field notes and other scholarly documentation of anthropologist Alfred Kroeber (1876–1960), his students Robert Lowie (1883–1957) and Robert Heiser (1915–1979), and the Anthropology Department at Berkeley. Kroeber, who studied anthropology with Columbia's Franz Boas, the founder of the field in the United States, devoted his life to research on California's hundreds of tribes, assembling a remarkable body of materials on the archeology, ethnography, and linguistics of California's first inhabitants, an essential complement to the collections of the Phoebe Apperson Hearst Museum of Anthropology on campus, which also owes its origins to Kroeber. In addition, Bancroft holds important collections on the peoples of the Plains, the Far West, Alaska, Mexico, Central America, and the Pacific Islands.

These materials are in constant use by scholars, laypersons, and members of the tribes themselves. We are especially proud of our association with "The Breath of Life—Silent No More," a language-restoration project of Native Americans throughout California. Participants work with Berkeley's Linguistics Department and Bancroft's rich anthropological archives of recordings, vocabularies, myths, stories, and photographs of cultural material and life to revive ancestral Indian languages, many of which were wiped out during Western settlement. Bancroft's materials are invaluable in recapturing the past and revitalizing the language for current use.

Alphonse L. Pinart (1852–1911). *Vocabulary of the Apache Yuma language*, collected at the San Carlos Indian Agency, Arizona. Notebook, 1876.

Pinart, a precocious French scholar who studied native cultures and languages from Alaska to Central America and the South Pacific, gave many of his ethnographic, historical, and linguistic materials to Hubert Howe Bancroft in 1885.

R. H. Bancroft Collection
Bancroft Library

Juan Bautista de Anza
(1735–1788). *Diario de la
Expedición a la Provincia de
Moqui del Nuevo Mexico.*
Manuscript diary, 1780.

## Spanish Encounter and Colonial Settlement

Settlement in the American West before the United States' annexation is well documented. Many points of view inform this experience, setting out the dynamic and often conflicting relationship of indigenous peoples and European explorers and settlers. Numerous sources document California under Spanish and Mexican rule, including diaries dating from 1725 to 1821. Important archival collections trace the history of the chain of twenty-one California missions from their founding in 1767 to the mid nineteenth century. The colonial materials also include Hubert Howe Bancroft's great collection of the *Archives of California, 1767–1846,* transcribed and extracted from the official Spanish and Mexican government records for Alta California that were destroyed in the 1906 San Francisco earthquake and fire. These transcriptions provide an indispensable account of the day-to-day activities of the Spanish and Mexican governments of California. Also documenting Mexican California are rare imprints from the press of Agustín Zamorano (1798–1842), the earliest printing press in California (1834).

Private papers collected from the Mexican Californians and gathered under the title *Documentos para la historia de California* include voluminous documentation of family,

social and cultural, official governmental, and political life. The papers of many of the prominent *Californio* individuals and families—Mariano Guadalupe Vallejo (1808–1890), last commandant of California, Manuel de Jesús Castro (1821–1891), Antonio María Pico (1808–1869), and Juan Bandini (1800–1859)—are represented. The later Bancroft Dictations with the *Californios* (also called *testimonios*), among them twelve interviews with women, provide reflections on and perceptions of Spanish and Mexican California as well as the later experiences of its citizens under United States rule. Land, an important issue for the Mexican Californians before and after the annexation of California, was key to development in the area. Bancroft has on deposit from the United States District Court the Land Case Records and associated maps *(diseños)*, which document the adjudication of all Spanish and Mexican land grant claims.

These materials are used to explore a wide variety of topics—for example, to uncover the history of private spaces that have now become public sites for exploration and edification. An ethnic studies professor and his students look at historical documentation related to Mexican California to help create a living history exhibit for the Peralta Hacienda in Oakland. This documentation provides an opportunity for students to work with original source materials and to connect directly to the lived experience of early settlers.

*Exploration of the Pacific Coast and the American West*
Narratives of Western discovery and exploration, including early Pacific voyages, are among the high points of the collection. A comprehensive collection of published works and many manuscripts record the explorations of the Spanish, British, French, Russians, Americans, and others, providing glimpses of the fur trade, relations with indigenous peoples, and settlement along the West Coast. Unique manuscript material, with some of the earliest descriptions of California, includes letters and reports by Gaspar de Portolá, Captain Pedro Fages, Fray Junípero Serra (1713–1781), Pedro Font, and Juan Bautista de Anza (1735–1788). Publications of the exploration of European as well as American explorers venturing into the West include the works of Sir Francis Drake (1628), Jean-François de Galaup La Perouse (1797), George Vancouver (1798), Meriwether Lewis and William Clark (1814), Louis Choris (1822), and Charles Wilkes (1831).

Bancroft's cartographic holdings complement the narrative sources, with more than three-quarters of them relating to the western half of North America, and the bulk of them documenting California and Mexico. Of interest among the early works are maps showing California as an island, including the title page of Antonio de Herrera y Tordesillas'

*Description des Indes Occidentales* (1622), the earliest depiction of this phenomenon. José de Cañizares' 1776 manuscript map of San Francisco Bay is the second oldest known, while the 1781 printed map based on his charts is the first separately published map of the Bay Area. One of the largest collections in The Bancroft Library consists of the maps (or *diseños*) and surveys of Spanish and Mexican land grants dating from 1781 through the 1860s, all now digitized and available on the web. Of the significant collections that have been acquired over the years, three of the most important are those of Charles M. Weber (1814–1881), the founder of Stockton, George Davidson (1825–1911), and Carl I. Wheat (1892–1966).

John Bidwell (1819–1900). *A Journey to California.* Weston or Liberty, Missouri? 1842? (Detail).

This is one of only two known copies of Bidwell's narrative of the first wagon train across the Great Plains to California in 1841. Here he discusses local rumors of American intentions to seize California—either peacefully or by force—from the control of Mexico.

*The United States-Mexican War (1846–1848)*

Bancroft possesses a great deal of material on the United States-Mexican War. Thomas Ap Catesby Jones's anticipatory (and illegal) taking of Monterey, California, in 1842 is documented in William Meyers' narrative and watercolor shipboard diary, one of Bancroft's outstanding journals. The American point of view is covered in materials such as Henry S. Burton's (1818–1869) diary and letter book relating to activities of the New York volunteers. John S. Griffin (1816–1898) comments on his participation in the Battle of San Pasqual. John Gallegher's "Personal Reminiscences" provide an account of Col. Jonathan D. Stevenson's regiment, while the diary of Robert W. Whitworth (1830–) does the same for the Mormon Battalion. The *Californios'* response to the war can be found in their dictations as well as in the wealth of political and personal papers they had accumulated, much of which was given to H. H. Bancroft. The Mexican side of the war is similarly documented in the Latin Americana Collection.

who started down to the Pueblo, were detained at the Mission, and that the others were sent for, in consequence of not bringing Passports from the States. He likewise brought a letter, from the Spanish Commander in Chief of Upper California to Marsh, requesting him to come, in all possible haste, and answer or rather explain the intention of the company in coming to California. News had just arrived by the papers of the United States, via, Mexico, it was the remark of some foolish Editor, that the United States would have California, and if they could not get it on peacable terms, they would take it by force. This created considerable excitement among the suspicious Spaniards. All however obtained passports from the General, till they should be able to procure them from the Governor at Monterry. On the 15th, I started for the Mission of St. Joseph, and arrived there on the 16th, returned to Marsh's on the 18th.

*Westward Migration*

Between 1840 and 1860, migration to the West grew exponentially, especially after the annexation of large sections following the United States-British Treaty of 1846, establishing the northern boundary of the Oregon Territory, and the end of the United States-Mexican War in 1848. Drawn to the Pacific Slope by the prospect of wealth, cheap or free land, health, and the mild climate, settlers were willing to make the arduous trip through deserts, mountain passes, and unfordable rivers. This migration and settlement are documented in an

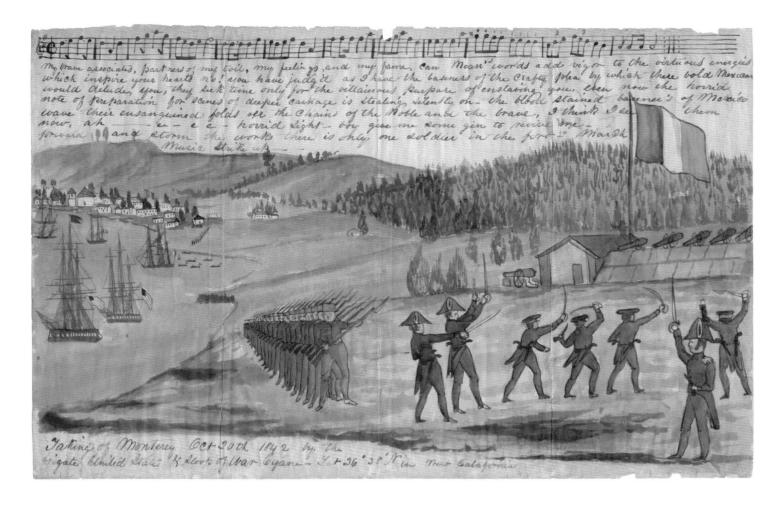

incomparable series of dairies, letters, graphic representations, and associated printed books and ephemera: accounts of sea voyages to the Pacific and of overland journeys through the American West in search of new opportunities. Unique narratives from the pre-United States period include those by John Bidwell, who led the first overland group of pioneers to California (1841), and Patrick Breen, a member of the ill-fated Donner Party (1846). Diaries and letters collected by and dictations taken down for H. H. Bancroft provide a similar history for the rest of the American West, especially for Washington, Oregon, Utah, and Alaska.

## The Gold Rush, Mining in the West, and Settlement

After the Treaty of Guadalupe Hidalgo was signed in February 1848, ending the United States-Mexican War, the United States annexed a huge portion of northern Mexico. A month earlier on January 24, at John Sutter's mill on the South Fork of the American River, gold was discovered by James Marshall. No event more transformed California. Bancroft holds almost embarrassingly rich documentation on the Gold Rush in diaries, letters, pictorial material, and illustrations. Encounters of adventurers along their journeys

William H. Meyers (b. 1815). "Taking of Monterey" (1842). Watercolor from his *Journal*, 1841–1844.

The misguided taking of Monterey (war had not in fact been declared) by the 18-gun U.S. sloop-of-war *Cyane* was rendered by Meyers, a crew member and amateur artist. The journal also includes the narrator's impressions of the landscape, social life and customs, and political events in South America, Mexico, and California.

and at their destinations in the gold fields illustrate the economic, political, social, and cultural give-and-take. The collection focuses on both accommodations and tensions as individuals and families from nations throughout the world and of various backgrounds came into contact with one another. Materials include both printed guides and informal advice found in hundreds of letters to family members and other settlers attempting the trek, and graphic illustrations of its vicissitudes as well as the desire and reality of striking it rich in the gold fields—or striking out. While many settlers returned home after their venture, others chose to remain to raise a family, start a business, and plant deep roots.

The Bancroft Dictations, precursors of oral history, also provide valuable historical material. Among the prominent pioneers and settlers that H. H. Bancroft interviewed are George Nidever (1802–1882), John Bidwell (1819–1900), and Captain John Sutter (1803–1880). In many instances he was also able to gather from prominent settlers in the area their professional, personal, and family papers.

Accounts of Gold Rush immigrants from all over the world give details of their lives and encounters with others, including inter-ethnic tensions. For example, documentation of Chinese immigrants illustrates their specific contributions to commerce and business, architecture and art, agriculture and other industries, and the cultural and social life of California. Significant resources focus on San Francisco's Chinatown, the oldest and largest community of Chinese in the United States, and on smaller Chinese communities throughout California. An abundance of materials also reflects California's anti-Chinese sentiment and the push for Chinese exclusion on a national level.

Along with the trials and tribulations of individual argonauts, Bancroft documents the development of mining, including its industrial, technological, social, and political manifestations. Operations for retrieving the rich mineral resources of the land become more sophisticated—from panning for gold to using simple mining machines such as the wooden "rocker" to tunneling into mountains and hydraulic mining, devastating to land and water until it was outlawed in 1884. These technological developments also mark the move from individual to corporate operations, as Bancroft's resources show.

The rush for mineral wealth in the West continued—in Alaska in 1849, in Colorado and Nevada in 1859, in Montana in 1864, and in the Yukon in 1896. The Western Americana collection provides a wide variety or resources documenting its exploitation, with information about the establishment of mining towns like the infamous Bodie, near Mono Lake, the disruption of native peoples, and the beginnings of the conflict between conservation and exploitation of fisheries and other natural resources.

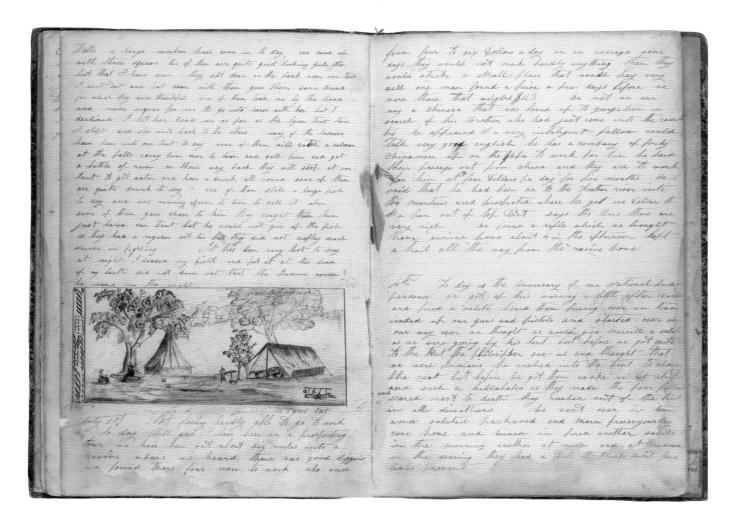

*Land Surveys and Scientific Expeditions*

Interest in the environment and the conservation of the West's natural resources began in the nineteenth century, as the United States government and its citizens attempted to encompass their vast new territories. Bancroft holds comprehensive documentation on government-sponsored surveys and scientific expeditions. John Bartlett (1805–1856), who was appointed U.S. Border Commissioner in 1850, records his experiences regarding the boundary survey after the U. S.-Mexican War. Moreover, the great published surveys of the American West—conducted by Ferdinand V. Hayden (1829–1867), John Wesley Powell (1834–1902), George Wheeler (1842–1905), and Clarence King (1842–1901)—in addition to recording baseline information about the West's flora and fauna, geography and geology, mineral resources, and water and land use potential and limitations, also provide information on Native American cultures and reflect federal, state, and local government efforts to establish parks and forests and to monitor and carry out environmental laws. Similar information is found in railroad right-of-way surveys and the writings of missionaries, traders, government employees, and other pioneers and settlers.

J. L. Akerman. Journal from Boston to California, September 23, 1849–February 1, 1854.

These two pages (July 1, July 4 [1850?]) record encounters with Native American men and women and a Chinese labor contractor and the celebration of Independence Day.

*Diseño del Rancho San Miguelito* (W 121° 17' N 35° 58'), M onterey County, 1841. Presented by José Rafael Gonzales in his successful case to have his Mexican land grant accepted by U.S. authorities.

*Economic Development: Railroads, Maritime, Lumbering, Agriculture, Commerce*
California grew dramatically after the discovery of gold. With the burgeoning population came growing business enterprises, extensive industrial development, and a need for more robust infrastructure. Maritime operations expanded as steamships brought hordes of immigrants to the region. The collection documents in some detail the shipping enterprise as well as the passengers making the arduous journey.

The construction of a transcontinental railroad, with the Central Pacific Railroad building east from Sacramento and the Union Pacific building west from Omaha, completed the grand linking of East to West on May 10, 1869, at Promontory Point, Utah. Railroads

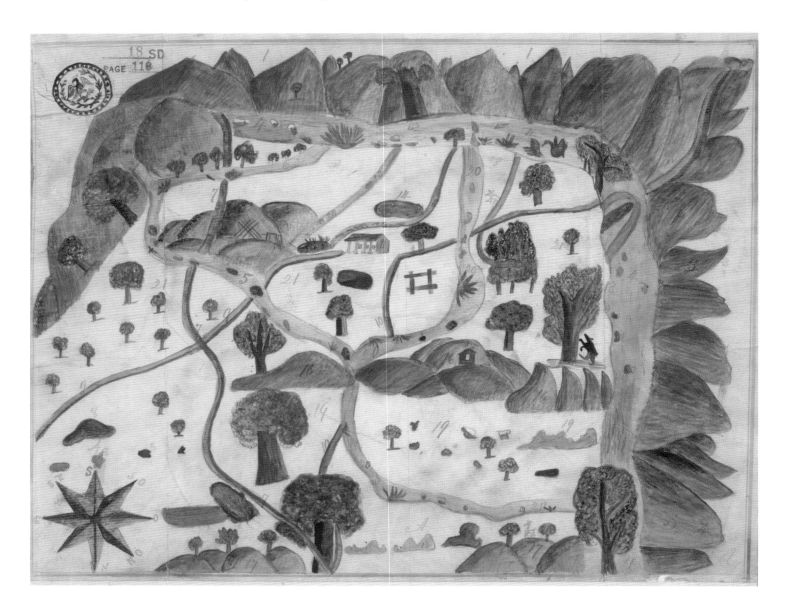

facilitated the transport of freight as well as people, ushering in a period of dramatic growth and development. With the ability to move products in and out of the region, key businesses evolved. As more was known about the West—its land and its inhabitants—more people were encouraged to visit and perhaps to settle. As travel became easier and people had more leisure time, tourism developed as an industry, lending boosterism to the cause of Western growth. Promotional materials documenting these efforts abound at Bancroft.

Evidence of further commercial enterprise exists in documentation of the lumber industry and agriculture. Both developed in response to the need to supply the area's metropolis, San Francisco, with building materials and food. Documentation runs the gamut from that of small, family-run enterprises to large private companies, such as the records of the Pacific, Sonoma, and Union Lumber companies.

Farming in California moved quickly from family-run operations to commercial farming. Due to patterns of land ownership and the need for irrigation and reclamation, large-scale farming became the norm. The collection covers agricultural development in California from specialized crops, such as wine grapes—for example, the records of Buena Vista Vineyards in Sonoma County in the 1860s—to large-scale agricultural and ranching operations, such as those of Miller & Lux, one of the one hundred largest corporations in America in 1900.

With urban and rural development also came a need to manipulate and control water, still the limiting factor in California's growth. City politicians, business people, and urban residents on the one hand, and rural residents and powerful commercial enterprises

*Constitution of the State of Deseret*. Kanesville: Orson Hyde, 1849.

Hoping for recognition by the United States Government, Brigham Young and the Church of Latter Day Saints conceived the provisional State of Deseret. The State's boundaries would extend throughout the Great Basin region, including what are now the States of Nevada, Utah, parts of Idaho, Wyoming, Colorado, New Mexico, Arizona and down to the Mexican border of Southern California.

such as railroads, mining operations, and corporate agriculture on the other, all vied for power over the West's limited water resources. Significant collections in this area include the records of the Spring Valley Water Company of San Francisco and the papers of its chairman, William B. Bourne, and his family. For the later twentieth century Bancroft holds voluminous documentation on the California State Water Project.

*Labor*

Labor in California has had a complex history, often quite volatile. Political, frequently exclusionary, the early labor movement was characterized by strong opinions from strong leaders such as Dennis Kearney (1847–1907), Frank Roney (1841–1925), and Andrew Furuseth (1854–1938). Resources on California labor include extensive documentation of various twentieth-century unions, especially the predominantly African-American Porters' Union and its president C. L. Dellums (uncle of U.S. Representative Ron Dellums) and the International Longshoremen's and Warehousemen's Union under firebrand Harry Bridges (1901–1990), leader of the 1934 longshoremen's strike.

Charles R. Parsons (1821–1910). *The City of San Francisco. Birds Eye View from the Bay Looking South-West.* Lithograph. New York: Currier & Ives, 1878.

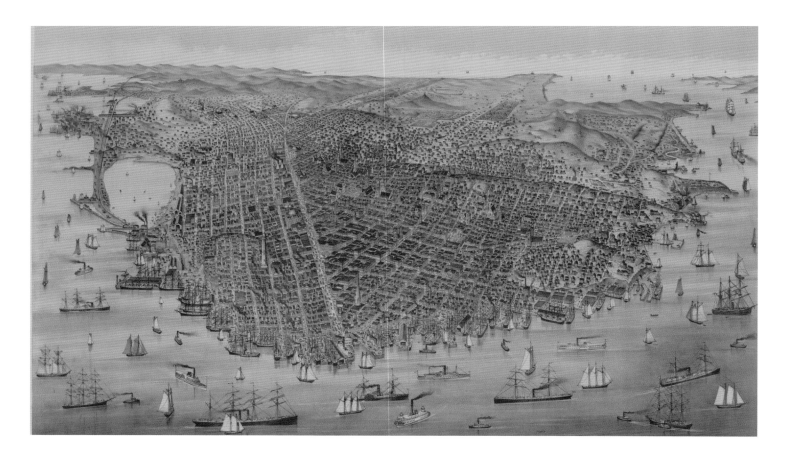

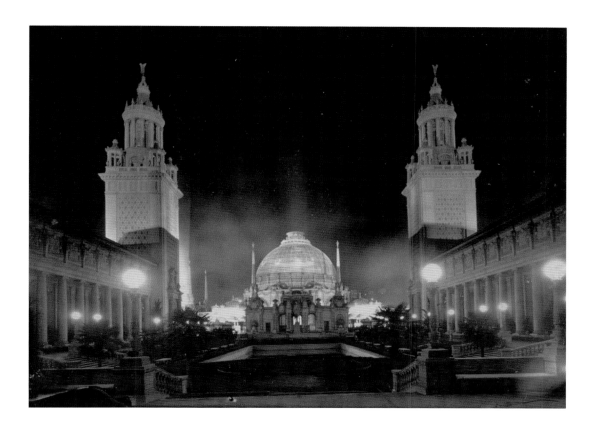

William Hood. "An evening view looking towards the Palace of Horticulture and Italian Towers from the Court of Palms." *Panama-Pacific International Exposition.* Hand-colored silver gelatin photograph. San Francisco: Cardinell-Vincent, 1915.

Arnold Genthe (1869–1942). "Jackson Street near Mason Street [sic] looking toward the Bay." *San Francisco Earthquake and Fire.* Photograph, 1906.

*Religious Life*

In the West, groups such as the Mormons sought refuge from religious persecution and a place to create a better society. Bancroft's documentation of the Mormon experience starts with the dictations that H. H. Bancroft, along with his wife Matilda and daughter Kate, conducted with principal men and women of various Mormon communities. Many diaries reflect the Mormon experience, including the movement of the community from Nauvoo, Illinois, to Salt Lake City; descriptions of smaller Mormon communities; the activities of the Mormon Battalion, led by Sam Brannan (1819–1889), in the West; and accounts from outsiders who observed Mormon activity.

Western Americana has many collections illustrating the contributions of Jews to the settlement of the West, especially in urban areas such as San Francisco, Portland, and Seattle. The papers of Samuel H. (1847–1920) and Eveline Brooks (1859–1924) Auerbach provide fascinating information on the economic and social conditions in Salt Lake City

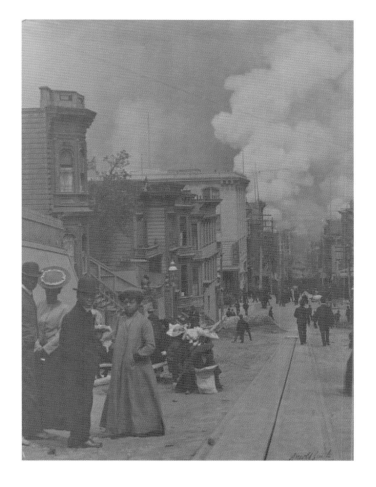

as well as descriptions of the landscape in the inner West. The family papers of the Gatzert-Schwabachers, prominent in Seattle and San Francisco, reflect the experiences of a pioneer merchant operation. Bancroft houses the papers of San Francisco's first Jewish mayor, Adolph Sutro (1830–1898), and, from a later period, those of the Stern-Haas family.

"Pickets on the highway calling workers from the fields," October 9, 1933. *San Joaquin Valley Cotton Strike.* Photograph by Ralph H. Powell. From the Paul Schuster Taylor Papers.

In the depths of the Depression, this month-long strike of 18,000 cotton pickers raised wages from 60 cents per hundred pounds of cotton to 75 cents. Powell, then an 18-year-old high school student in Hanford, documented the strike in a photo essay.

After the American annexation, mainstream protestant religions rapidly established churches and missions throughout the region, the former primarily for the new immigrants from the East, the latter to evangelize Native Americans, Alaskan Natives, and Hawaiians as well as Chinese, Japanese, and other foreign immigrant populations. At the same time the Catholic Church experienced a rebirth with Gold Rush immigration from Latin America and Western Europe, especially Ireland and Italy, establishing urban parishes to replace the missions secularized by Mexico in 1834.

*Urban Communities: Emergence and Growth*

Urban centers such as San Francisco were fundamental to western development. Begun as presidio and mission, San Francisco was transformed from a small town before the Gold Rush to a busy port city and eventually to the center of the Western economy. By the late nineteenth and early twentieth centuries, it had also developed a forceful, sometimes corrupt, political system and a powerful labor movement dominated by German and Irish Americans. Immigrants such as the Chinese, Japanese, and Italians were hindered and sometimes excluded outright from involvement in political and economic activity.

Architecture and urban planning in San Francisco and the San Francisco Bay Area are abundantly documented. The "City Beautiful" movement at the turn of the twentieth century advocated attractive, livable cities, functionally integrated so that people, traffic,

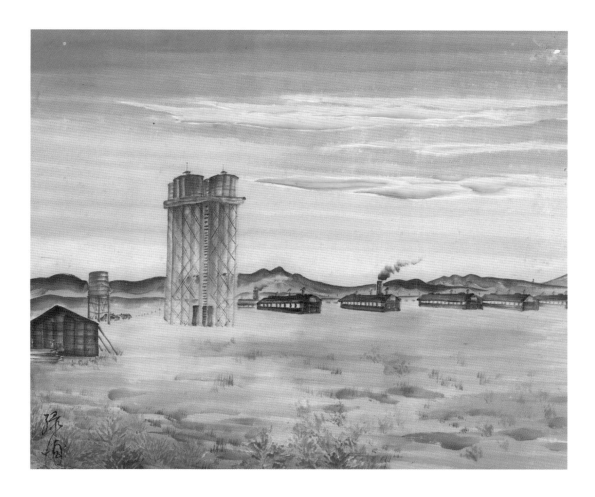

Yoshiko Uchida (1921–1992). *Internment Camp, Topaz, Utah.* Watercolor, circa 1942-1943. From the Yoshiko Uchida papers.

Rube Goldberg (1883–1970). "Dancing in the Dark." Editorial cartoon, August 13, 1946.

Although best known for his wonderfully weird machines (see p. 119), Goldberg (Cal '04) received the Pulitzer Prize in 1948 for an editorial cartoon in the *New York Sun*.

and goods all moved smoothly and easily. City planner Daniel Burnham's plan to redesign San Francisco included comprehensive park systems, infrastructure to move traffic, and the creation of sensible neighborhoods or districts. His was an exercise in thoughtful city planning, but it lost out to expedience after the San Francisco earthquake and fire of 1906. Politics and business dominated to drive a quick rebuilding of the city.

As the centennial of the 1906 earthquake approached, Bancroft staff were active in assisting the many researchers who are reexamining the quake's social, political, scientific, and economic consequences. For example, researchers from the United States Geological Survey have used photographs of the 1906 earthquake to track its path. A doctoral student looked at the relief effort after the earthquake and at women's roles in providing services to the many displaced citizens affected by the

calamity. Another researcher has published a book critiquing the political, economic, and social realities that citizens faced following what was—until Hurricane Katrina in 2005—the largest urban disaster in the country.

San Francisco quickly rose, phoenix-like, from its ashes after the earthquake, and the Panama Pacific International Exposition (PPIE) of 1915 provided an opportunity for its citizens to demonstrate to the world that it had completely recovered as a modern American city. Bancroft houses the PPIE records, as well as many other pictorial and manuscript collections related to this exposition, which was one of the most extravagant and colorful of World's Fairs. Similar materials document the 1939 Golden Gate International Exposition, which celebrated the completion of the Golden Gate and Oakland-San Francisco Bay bridges.

Kathleen Cleaver and Black Panther Party members meeting in the Alameda County Prosecutor's office during the murder trial of Huey P. Newton, Chairman of the Black Panther Party. Photograph by Peter Breinig (1924–2004), 1968.

Other sources record the physical transformation of San Francisco and the Bay Area into a major metropolitan region. The papers of Michael Maurice O'Shaughnessy, San Francisco city engineer, document the construction of the Twin Peaks Reservoir, the Municipal Railway system, the Stockton Street tunnel, and numerous streets throughout the city. O'Shaughnessy's most famous and controversial undertaking was the Hetch Hetchy Project, which dammed a valley in the Sierra as beautiful as Yosemite to provide water and power for San Francisco.

The collections also include the designs and drawings of many of the most important architects in California, such as the University of California's John Galen Howard (1864–1931); Bernard Maybeck (1862–1957); Julia Morgan (1872–1957), designer of William Randolph Hearst's castle at San Simeon; and Arthur Brown (1874–1957), who designed San Francisco's new city hall after the 1906 earthquake as well as, forty years later, the building that houses The Bancroft Library.

Bancroft also documents industrial and urban development broadly, but especially in the papers of businessmen Henry (1882–1967) and Edgar (1908–1981) Kaiser. The Henry J. Kaiser Papers provide almost exhaustive evidence for the demographic and

industrial transformation of the San Francisco Bay Area and the Pacific Northwest during and immediately following World War II. A tidal wave of immigrants came from the Midwest, Mexico, and the Deep South to work in the shipyards, which employed 280,000 workers in 1943.

*Race and Ethnic Relations*

The diversity and complexity of relationships among people living in California and the West continue to be important themes in twentieth-century history. Bancroft has rich resources for the study of ethnic communities in both rural and urban environments from the nineteenth century to the present, including the contributions of the Chinese to building early California and the role of Japanese, Filipino, and, especially, Mexican agricultural workers. Papers documenting the immigrant experience of Mexicans in the United States include the interviews of Mexican immigrants conducted by anthropologist Manuel Gamio (1883–1969) and the Paul Taylor Papers. Taylor (1895–1984), professor of economics at Berkeley (and the husband of photographer Dorothea Lange), was the first social scientist to study Mexican labor in the United States and to plot migrations

Cathy Cade (b. 1942). "Gay is Good." Photograph, 1971.

Since 1996 Bancroft has been documenting the gay, lesbian, bisexual, and transgender movement as well as its political and religious opponents in the Sexual Orientation and Social Conflict Collection.

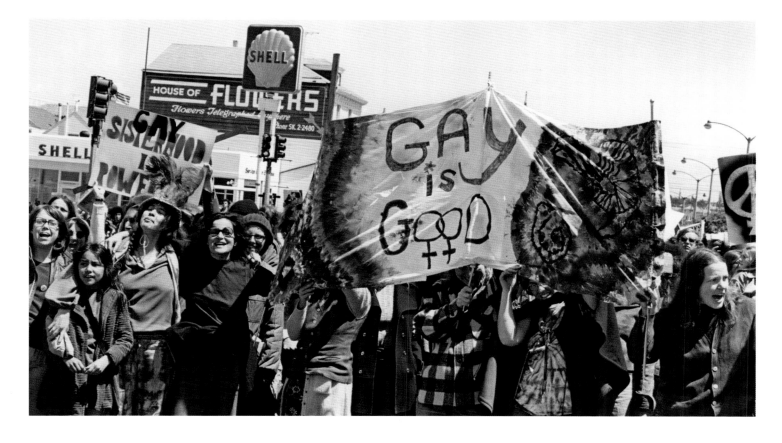

from Mexico and the return patterns of those immigrants to Mexico, a research method commonly used today.

Bancroft is one of three official repositories of the United States government's Japanese-American Evacuation and Resettlement records from World War II; these records are supplemented by poignant personal papers from Japanese-Americans in the camps.

The African-American experience, especially after World War II, is documented through the records of major social and political organizations such as the Western Region of the NAACP, church-affiliated groups, and the papers of private individuals, such as those of the Craft Trotter Family (1884–1994) and Jeremiah Burke Sanderson (1821–1875).

*Political Collections, Including Civil Rights and Social Activism and Protest*
Bancroft's extensive political collections document prominent California politicians from the Mexican period onward. They include the papers of mayors, governors, and U.S. and state senators and representatives from both major parties and many minor ones. Francis J. Heney's (1859–1937) and Hiram Johnson's (1866–1945) papers document progressive-era politics and the San Francisco graft trials, while those of John W. Stetson (1871–1919) highlight his tenure as president of the Roosevelt Progressive Republican Party. From the mid twentieth century, Bancroft holds the papers of Republican governor Goodwin Knight (1896–1970) and Democratic governor Edmund "Pat" Brown (1905–1996), and the papers of U.S. senators William Knowland (1908–1974), Thomas Kuchel (1910–1994), and Alan Cranston (1914–2000). The social tensions and social activism of the sixties and onward are reflected in a number of collections, especially the Free Speech Movement Archives and the Social Protest collection.

*The Environmental Movement in the Twentieth Century*
Documentation of the efforts of non-governmental groups to tackle a wide range of environmental issues in the twentieth century is comprehensive. Archival collections and personal papers from trailblazing environmental organizations and their leaders represent an incomparable resource for study at local, regional, and national levels of everything from wilderness preservation to the use of water resources to species survival to energy development to urban sprawl and its effects on the environment. In fact, the environmental collections, especially the records of the Sierra Club, are Bancroft's most heavily used collections.

Recent developments have focused on environmental justice at the grass roots level.

Thus, many of our collections, such as the records of the Earth Island Institute's Urban Habitat Program, document environmentalist actions with respect to environmental laws, regulations, and policies affecting individual neighborhoods, regardless of ethnicity or socio-economic status.

Researchers using these collections take diverse approaches to them. Contemporary environmental groups use historical records to inform a particular point of view—be it a campaign to restore Hetch Hetchy Valley or to create a walking trail around the San Francisco Bay. For an example of the use of Bancroft resources to illustrate the changing landscape of the San Francisco Bay Area, see Elise Brewster's essay (pp. 84–85).

*Personal and Family Papers*

H. H. Bancroft's pioneering efforts in collecting personal and family papers such as those of Vallejo, Bidwell, and Charles M. Weber have continued to this day. Later collections, such as those of the Hearst and De Young families, environmentalists Francis (1887–1974) and Marjorie Bridge (1903–1999) Farquahar and David Brower (1912–2000), CIA director John McCone (1912–1991), lawyers and UC Regents Farnham Griffiths (1884–1958) and John Francis Neylan (1885–1960), artists Jay DeFeo (1929–1989), Bruce Conner (1933–), and Joan Brown (1938–1990), and shipping magnate Robert Dollar (1880–1962), include a wide range of social, cultural, artistic, educational, and business materials, reflecting the lives of individuals involved in virtually every aspect of human activity in the West.

Of particular interest are the papers of women, which reflect not only their familial and private lives but also their public and professional experiences. Bancroft's holdings document Chez Panisse founder Alice Waters' interests in the culinary arts, organic farming, and nonprofit concerns; the work of peace activists Alice Hamburg and Lucille Greene; Florence Richardson Wyckoff's work on reforms in farm labor, rural poverty, health insurance, and the education of migrant children; and Elsa Knight Thompson's career as a journalist at radio station KPFA.

As Bancroft heads into its second century on the Berkeley campus our concerns and goals for the Western Americana collection remain very much those of Hubert Howe Bancroft himself: to document, in as much depth and detail as possible, the daily lives of today's Californians, from all walks of life and from all racial and ethnic backgrounds, as well as the great public issues and private concerns that challenge us—and all of this in order to help posterity to understand what it means to be a Californian at the beginning of the twenty-first century.

# At Work | *Serendipity*

GRAY BRECHIN

Turning yet another page in an 1899 issue of *The Wasp,* San Francisco's journal of political and social satire, I apparently couldn't staunch a revelatory squeal, for a researcher at the next table in the Heller Reading Room of The Bancroft Library flashed me an understanding grin, the equivalent of a high-five between scholars excavating old papers.

The double-page photo spread that opened before me neatly encapsulated more than 2500 years of imperial rationale that was as fresh at the time of the Philippine-American War as now. Apparently staged in a San Francisco studio, an imperious Juno representing Civilization beckoned from a throne for the riches owed and brought her by the children of her Pacific realm. Golden spikes radiated from her torso like bayonets, while a blood-red band bound her to her dusky subjects. A caption explained "San Francisco sits by the Golden Gate and receives the tribute of the Orient."

My synapses fired to connect that image with many others I'd discovered in period newspapers as well as with oratory such as Daniel Coit Gilman's inaugural address. The first president of the University of California declaimed at the new Berkeley campus in 1873 that "California, queen of the Pacific, is to speak from her golden throne and decree the future of her university," whose "influence in the organization and regeneration of lands beyond the sea is unquestionably just begun." (The nation's "Manifest Destiny" to expand westward during the Mexican-American War made a rhetorical encore during the Spanish and Philippine Wars to justify larger imperial ambitions in which San Francisco Bay would play a literally commanding role.) President Benjamin Ide Wheeler and

many others at Berkeley repeatedly echoed the mission and opportunity of the queenly city across the Bay and of the university established to serve her growing interests and appetite. That image in *The Wasp* visually summarized the underlying thesis of my dissertation, *Imperial San Francisco: Urban Power, Earthly Ruin* (Berkeley: University of California Press, 1999).

No one will ever be able to afford the time and money to compile an index to the popular images that proliferated in newspapers and magazines a century ago, images that carry the subliminal and meretricious messages of those press barons whom I call the "Thought-Shapers." Finding such images requires the sort of serendipitous research for which The Bancroft Library—with its complete runs of important and arcane journals—is ideally suited, especially if one has access to its stacks as did I when awarded a Fellowship in 1995. I needed that access after the little-used bound volumes I'd used in the late eighties in the old Doe Library stacks were removed to the Richmond storage facility to make room for newer material. Bancroft's ready access to the printed versions of these volumes proved invaluable to me. Unfortunately, many young researchers today have little idea what they are missing in the new Doe stacks. There is, so far, no substitute for browsing offline.

Few, too, now have the time for the kind of research that comes of turning thousands of pages and reeling miles of microfilm. If one is taking the pulse of an age, one simply must read the texts and images with which its people were familiar.

The Bancroft Fellowship enabled me—and continues to enable others—to enjoy what has

From Photos by Aliisky taken for the Wasp,
Miss Nance O'Neil, the famous actress, posing for San Francisco.

San Francisco sits by the Golden Gate receives the Tribute of the Orient.

Engraved by the
California Photo-Engraving Co.

become the luxury of serendipitous scholarship. For most academics in the humanities today, the attainment of a Ph.D. often marks the end of what in retrospect can seem a sinful self-indulgence. The ever-growing avalanche of contemporary information now combines with heavy teaching loads, administrative and fund-raising obligations, grant-writing, and email to eliminate much of the time required for primary research if one pursues an academic career. My work at The Bancroft Library taught me that serendipitous sauntering sometimes requires one to strike out on the solitary path of the independent scholar if one is to find oneself in what it has to offer.

*Dr. Gray Brechin, a former Bancroft Fellow, is an author and historical geographer with broad teaching experience emphasizing architecture and environmental issues.*

"San Francisco sits by the Golden Gate and receives the tribute of the Orient."
*The Wasp,* December 16, 1899.

# Collection Highlights

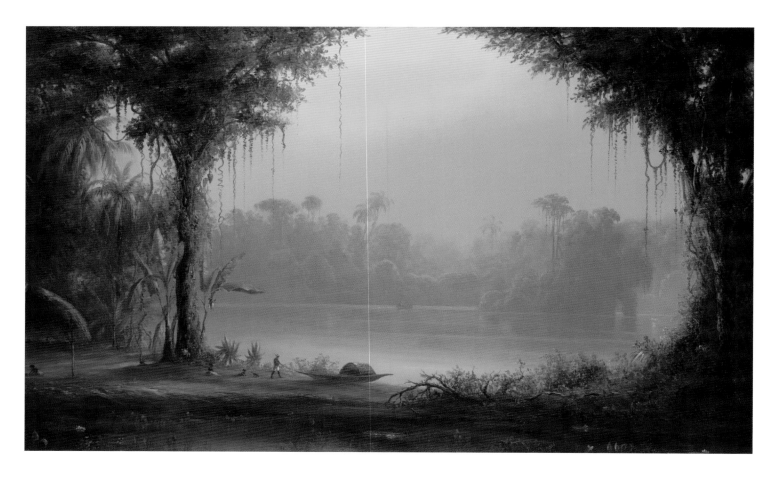

Norton Bush (1834–1894).

*The Chagres River, Panama.*

Oil painting, 1884.

In the classic passage to California through Panama, travelers who landed at Colón would first journey in launches rowed and poled up the Chagres River by native boatmen.

## *Native American Studies and Anthropology*

*Archivos de las Misiones,* 1769–1856

Documents relating to Missions of the Californias

Oliver M. Wozenraft papers related to Indian Affairs, 1849–1850

Journal of Pierson Barton Reading, transcript, 1843

James William Denver Collection

General E. O. C. Ord Papers

Pinart materials on indigenous groups

California League for American Indians Records

Social Protest Collection

## *Anthropology/ Archaeology/Linguistics*

Alfred Louis Kroeber Papers and Photographs

Robert Harry Lowie Papers and Photographs, 1872–1968

Robert Fleming Heizer Papers, 1851–1980

C. (Clinton) Hart Merriam Papers and Photographs, 1871–1942

Samuel Alfred Barrett Papers, 1893–1977

A. H. (Anne Hadwick) Gayton Papers, (bulk 1925–1965)

Elizabeth Colson Papers, ca. 1940–2002

Ethnological documents of the Department and Museum of Anthropology, University of California, Berkeley, 1875–1956

Florence Merriam Bailey Papers, 1887–1940

Theodora Kroeber Papers

Felipe Arroyo de la Cuesta Notebook, 1810–1819

Records of the Department of Anthropology, 1901–

Dorothea J. Theodoratus Papers, 1900–

Margaret Langdon Papers

## Western North American Exploration

Miscellaneous documents related to:

Pedro Fages

Gaspar de Portolá

Father Junípero Serra

Pedro Font

Juan Crespí

Juan Bautista de Anza

Pinart Materials on Russian America

Explorations of New Mexico, California, and the Northwest Coast, related papers

Jacobo Sedelmayr reports, concerning explorations in the Southwest, 1750

David Thompson reports on his explorations in the Pacific Northwest, 1807, 1813

## Spanish Colonial and Mexican Encounter and Settlement

Archives of California, 1846–1850 [i.e. 1783–1850]

*Testimonios* (Bancroft's Dictations) with *Californios*

Mariano Guadalupe Vallejo. *Documentos para la historia de California*, 1769–1850

Land Cases and associated maps (*diseños* and surveys)

*Californio* Family Papers

New Mexico Originals

## U.S./Mexican War and Aftermath

William Meyers. Journal

Henry S. Burton. Diary and letter

John S. Griffin Materials

John Gallegher. *Personal Reminiscences*

Robert W. Whitworth. Diary

Westward Migration, Gold Rush, and Mining in the West

Wimmer Nugget and associated documentation

California Gold Rush letters and diaries

Bancroft Dictations with California and Western Pioneers

Dictations with Jewish community leaders

Dictations with Mormon community members

M. P. Berry Papers

Warren Matthews Papers, 1865–

John Welch. Notes of a trip to the Stekeen [sic] River mines

Patrick Breen Diary (Donner Party)

Christopher (Kit) Carson Papers

Bidwell Family Papers

Weber Family Papers

Samuel Whitney Richards. Journal

W. R. Hayes. Diary 1855

James Knox Polk Miller. Diaries

Henry W. Bigler. Diary of a Mormon in California 1872; with recollections of the Mormon Battalion and of a journey of the Mormon wagon train from California to Salt Lake.

Samuel H. Auerbach and Eveline Brooks Auerbach Papers

The Gatzert-Schwabacher Family Papers

Bancroft Scraps

Hayes Scraps (bulk 1847–1875)

## Urban Communities: Emergence and Growth

San Francisco Committees of Vigilance, 1851 and 1856

George and Phoebe Hearst Papers

William Randolph Hearst Papers

William Randolph Hearst, Jr., Papers

Michael Maurice O'Shaughnessy Papers

Spring Valley Water Company Records

George Derleth Papers

Panama-Pacific International Exposition Records

John Galen Howard Papers

Bernard Maybeck Papers

Julia Morgan Papers

Arthur Brown, Jr., Papers

De Young Family Business Papers, 1877–1991

## Economic Development: Mining, Lumbering, Maritime Business, Agriculture, and Commerce and Infrastructure

Pacific Lumber Co. (1865–1938)

Sonoma Lumber Company (1877–1884)

Union Lumber Company

Elk River Mill and Lumber Company

Miller and Lux Records

Crowley Maritime Corporation Records

Robert Dollar Records

Railroad Surveys, 19th c.

Edgar Kaiser Papers

Henry J. Kaiser Papers

Western Sugar Refinery Records

## Labor

Workingman's Party documentation

San Francisco Labor Council Records

Thomas J. Mooney Papers

California State Council of Lumber and Sawmill Workers Records

Cottrell Laurence Dellums Papers

International Fishermen and Allied Workers of America Records

International Longshoremen's and Warehousemen's Union Collection

The Federal Writers' Project on Migratory Labor Records

## Racial and Ethnic Documentation

Paul Schuster Taylor Papers

Carey McWilliams Papers

California. Dept. of Industrial Relations. Division of Immigration and Housing Records

Simon J. Lubin Papers

West Coast Regional Office of the National Association for the Advancement of Colored People (NAACP) Records

The Craft Trotter Papers

Japanese-American Evacuation and Resettlement Records

Yoshiko Uchida Papers

Samuel J. and Portia Bell Hume Papers

California Federation of Civic Unity Records

Jeremiah Burke Sanderson Papers

Channing and Popai Liem Papers

## Land and Environment: Movements

Sierra Club Records and Pictorial Collection

Save-the-Redwoods League Records

Save San Francisco Bay Association Records

Tuolumne River Preservation Trust Records and Photograph Collection

Conservation Associates Records

Point Reyes National Seashore Foundation Records

Urban Habitat Program Records

Friends of the River Foundation Records, 1970–1983

Friends of the Earth Records, 1980–1987

Earth Island Institute, Urban Habitat Program Records, 1987–2001

## Individual Conservationists

LeConte Family Papers

Sierra Club Members Papers, 1892–

Michael McCloskey Sierra Club Papers, 1950–1999

Michael L. Fischer Sierra Club Papers, 1986–1990

David R. Brower Papers and Pictorial Collection

Carl Pope Papers

Sylvia McLaughlin Papers

Kent Dedrick Papers

Robert Underwood Johnson Papers

John Muir Papers

Robert Marshall Papers and Photograph Collection

Francis P. Farquhar Papers and Pictorial Collection

William Colby Papers

Stephen Tyng Mather Papers

Horace M. Albright Papers

Robert Bradford Marshall Papers

William Penn Mott, Jr., Papers and Pictorial Collection

Margaret Wentworth Owings Papers and Photograph Collection

Edgar Wayburn Papers

Peggy Wayburn Papers and Photograph Collection

Sally Reid Papers

Florence Merriam Bailey Papers, 1887–1940

## Political papers

Adolph Sutro Papers

James Phelan Papers

George Cooper Pardee Papers

Edmund G. "Pat" Brown Papers

Culbert Olson Papers

Hiram Johnson Papers

William Knowland Papers

Thomas Kuchel Papers

Alan Cranston Papers

Gwinn Harris Heap (1817–1887) *Central Route to the Pacific*. Philadelphia: Lippincott, Grambo, and Co., 1854.

The 1853 Edward F. Beale expedition described here explored a potential railroad route to California.

John F. Heney Papers

John W. Stetson Papers

## Civil Rights, Social Activism, and Protest Movements

The League of Women Voters (of Berkeley and the East Bay) Records

San Francisco Women for Peace Records

Anne Weymouth Deirup Collection on desegregation of Berkeley schools [ca. 1960–1990]

Social Protest Collection

Disability Rights Education and Defense Fund (DREDF) Records

Center for Independent Living, Berkeley, California Records

Watts Riots Papers

Meiklejohn Civil Liberties Institute Records

National Lawyers' Guild Records

Sara Diamond Collection on the U.S. Right

Vietnam Veterans Against the War/ Winter Soldier Organization, California Nevada Regional Records, 1966–1978 (bulk 1972–1974)

## Individual activists

Charles Garry Papers

Eldridge Cleaver Papers

Judy Heumann Papers

Edward V. Roberts Papers

Louise Green Papers

Florence Richardson Wyckoff Papers

Helen Nelson Papers

Elsa Knight Thompson Papers

# Latin Americana

Walter Brem, CURATOR EMERITUS
Charles B. Faulhaber, DIRECTOR

## Collection Profile

Mexico and Central America: Pre-Columbian indigenous civilizations and cultures to the present, including Spanish Empire before 1821; Spanish Borderlands to 1821; Spanish and Mexican California to 1846; U.S.-Mexican Border Region.

*Format*  All forms of primary and secondary sources, including strong collections of bibliographical and reference sources, all forms of printed materials; more than 2200 manuscript collections and many surrogates of foreign archival materials, beginning with the manuscript and typescript transcriptions produced for H. H. Bancroft and later for Herbert Bolton, and from roughly 1920 supplemented by more reliable microfilms and photostats.

*Subject Areas*  ▪ Agriculture, Anthropology, Archaeology, Folklore, Art and Architecture, Journalism, Demography, Business and Economics, Education, Geography and Travel, History, Languages and Linguistics, Law, Performing Arts, Philosophy and Religion, Political Science and Government, Science and Technology.

*Interdisciplinary Subjects*  ▪ Marginalized Peoples and Groups, Ethnicity, Gender, Race, Migration, Social Conflict, Human Rights, Urban and Regional Studies, Ecology and Environment.

OPPOSITE PAGE

"Gateway, Casa del Gobernador, Uxmal."
Lithograph by Frederick Catherwood, from
his *Views of Ancient Monuments in Central
America, Chiapas and Yucatan.*
London: F. Catherwood, 1844.

BANCROFT'S LATIN AMERICANA COLLECTION is one of the world's great repositories of primary and secondary materials for historical and contemporary research on Mexico and Central America, especially for the history of Mexico.

The Mexican and Central American sections of the Bancroft Collection, originally seen as ancillary to the California history collection, were built by Hubert Howe Bancroft during a fifteen-year period between 1869 and 1883; most of the Mexican collection became available at auction in just over a decade, 1869–1880. Three important Mexican collections figured in this diaspora, the result of one of the great political convulsions of the period. José María Andrade (1807–1883) and José Fernando Ramírez (1804–1871), conservative bibliophiles and collectors, became enmeshed with Padre Agustín Fischer, adventurer, collector, and Secretary to the Emperor, in the politics of Maximilian of Habsburg (1832–1867) and his ill-fated Mexican Empire. Upon the fall and execution of Maximilian, the three collectors spirited their treasures away to Leipzig and London where they were auctioned.

Although Bancroft's Central American collections were much smaller, because the universe of Central American imprints and documents is much smaller than that of Mexico, they were no less important for the region covered. They came largely from the Ephraim Squier (1821–1888) and Alphonse Pinart (1852–1911) auctions. Pinart's collection included books and manuscripts from Abbé Charles Etienne Brasseur de Bourbourg (1814–1874), one of the leading students of Mayan culture of the nineteenth century.

From 1906 through World War II, The Bancroft Library grew with minimal state funding supplemented by gift funds. Considerable amounts of printed materials also were collected by traveling faculty and as gifts solicited by Herbert I. Priestley, librarian under director Herbert E. Bolton and his successor. From Bolton's directorship onward, Bancroft funded large projects to photograph or microfilm extensive selections from archival collections in Spain and Mexico.

## Collection Strengths

*Native Mexico and Ethnohistory*

Perhaps the single most famous item in the Bancroft collection is the Codex Fernández Leal, produced in the mid sixteenth century, although possibly based on a pre-Columbian predecessor. A pictographic scroll almost sixteen feet long written on native amatl fiber paper, the codex describes warfare, conquest, and sacrificial ceremonies in the local region

of the Cuicatec, a small indigenous culture in what is now the state of Oaxaca.

Bancroft also holds a large and significant collection of historic Nahuatl manuscripts dating from the sixteenth to the nineteenth centuries. These manuscripts are typically religious works such as sermons, confessional guides, and catechisms; legal records; grammars and glossaries; ethnographic works; and cultural pieces such as poetic and dramatic texts. Complementing the Nahuatl manuscripts are dozens of manuscript and printed works in Spanish that document Aztec and other indigenous cultures. Perhaps the most important are early manuscript copies of Fernando de Alva Ixtlilxochitl's (1578–1650) various historical writings, based on materials from Nahuatl pictorial sources now lost or unintelligible without his commentaries.

## Spanish Colonial Period

The holdings for colonial Spanish America (1519–1821) are the richest portion of the Latin Americana collection. Focusing primarily on Mexico and Central America, the collection reflects the social, economic, demographic, and cultural evolution of Nueva España—greater Mexico—and its Central American dependencies. An impressive collection of high-profile individual manuscripts, originals and copies, is complemented by thousands of rare colonial imprints and the most extensive collections of Mexican and

"Plaza de Armas [Mexico City]." Lithograph by Casimiro Castro, from *México y sus alrededores. Colección de vistas monumentales, paisajes, y trajes del país. Dibujados y litografiados por los artistas mexicanos C. Castro, G. Rodríguez, y J. Campillo, bajo la dirección de V. Debray.* Mexico City: V. Debray, 1869.

Spanish archival microfilms, photostats, and transcriptions in the United States.

Among the earliest manuscripts is a series of letters from the 1540s regarding the Guatemalan hacienda of Alonso Díaz de la Reguera, a companion of Pedro de Alvarado, one of Cortés's chief lieutenants, as well as a series of letters by Alvarado himself. Most colonial manuscripts have a strong church (religious treatises, sermons, mission activities) or governmental (royal and viceregal decrees, official correspondence and reports, minutes of town council meetings, legal proceedings) focus. Among literary works one may cite manuscripts of the Mexican scholar Carlos Sigüenza y Góngora (1645–1700) and of the late colonial author José Joaquín Fernández de Lizardi (1776–1827).

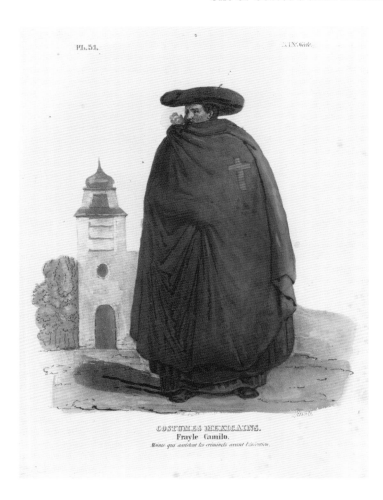

"Costumes Mexicains: Frayle Camilo." Hand-colored lithograph by Claudio Linati (1790–1832), from his *Costumes civils, militaires et religieux du Mexique; dessinés d'après nature*. Brussels: C. Sattanino, 1828.

Although dwarfed by the monumental Inquisition collection of Mexico's Archivo General de la Nación, Bancroft holds the largest collection of original Mexican Inquisition manuscripts in the United States—135 dossiers of trials, investigations, and administrative issues, including some of the Inquisition's most significant cases. The most important are the records of the trials of Isabel and Leonor, the sisters of Luis de Carvajal, in 1595. Luis, a crypto-Jewish mystic and intellectual, implicated 116 family members and close associates, nine of whom, including his sisters, were tortured, garroted, and burned at the stake in the great auto-da-fé of 1596. Other cases focus on breaches of orthodoxy and on sexual misconduct, especially among the clergy. The case of a priest who was jailed for four months because he officiated at the burlesque marriage of two dogs in 1771 illustrates the lengths to which the Inquisition was prepared to go in its defense of religious orthodoxy.

Bancroft also holds some 5000 Mexican publications from 1539 to 1821—including fifteen Mexican incunabula, books printed before 1601. For modern scholars perhaps the most interesting are Mexican newspapers of the eighteenth century and the numerous grammars of the indigenous languages, but official and religious subjects comprise the two largest genres. Besides the many official publications of legislation and decrees (*cédulas*), Bancroft holds thousands of religious imprints: sermons, pastoral letters, funeral elegies,

rules and biographical compilations of the various religious orders, priests' manuals and breviaries, occasionally annotated by the owner, Inquisition decrees, and others. The collection becomes progressively richer for the seventeenth and eighteenth centuries. These Mexican imprints are complemented by many Spanish and other European books that came to the Indies and ended up in private hands or in the libraries of the religious orders, the primary sources of H. H. Bancroft's original purchases.

Bancroft has one of the best university collections of atlases and maps of Spain's American colonies, including hundreds of manuscript maps. The collection also documents the major scientific expeditions of the eighteenth and nineteenth centuries. Thus materials from the Alessandro Malaspina expedition (1789–1794) include some of the earliest depictions of the San Francisco Bay area and its native inhabitants by shipboard artist José Cordero.

### The Spanish Borderlands and the Northern Mexican Frontier

Herbert Eugene Bolton's *The Spanish Borderlands: A Chronicle of Old Florida and the Southwest* (1921) led to an entire school of historical research under his leadership. For Bolton the Spanish Borderlands are those areas in the United States and northern Mexico once controlled and claimed by Spain, defined by an imaginary and flexible line running from greater Florida to the Pacific. Their history includes seaborne exploration in the Atlantic, Gulf of Mexico, and the Pacific Coast, and overland exploration and expeditions that opened up the region over a period of three hundred years. The history of the region's sparse frontier settlements of civilians, presidios, and missions is inextricably bound up with relations between Spaniards and the diverse sedentary and nomadic Indians of the vast region.

H. H. Bancroft set the stage for Borderlands collecting with his writings about the regions from Texas to the Pacific. The Bancroft Library's Hispanic collections under Bolton and his successors Herbert Priestley and George Hammond grew finally to encompass the entire Spanish Empire in North America. Using Bolton's and Charles E. Chapman's great published finding aids as guides, Bancroft acquired vast quantities of microfilm and photostats, thus becoming the indispensable repository of documentation on Spain's action in North America. Especially significant are the materials for the Jesuit missions of

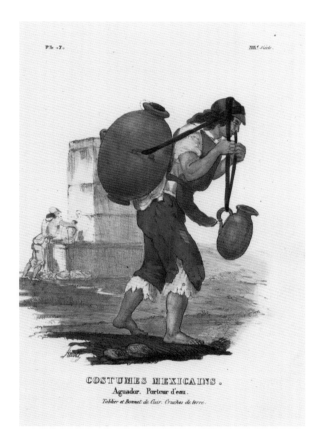

"Costumes Mexicains: Aguador. Porteur d'eau." Hand-colored lithograph by Claudio Linati (1790–1832), from his *Costumes civils, militaires et religieux du Mexique; dessinés d'après nature.* Brussels: C. Sattanino, 1828.

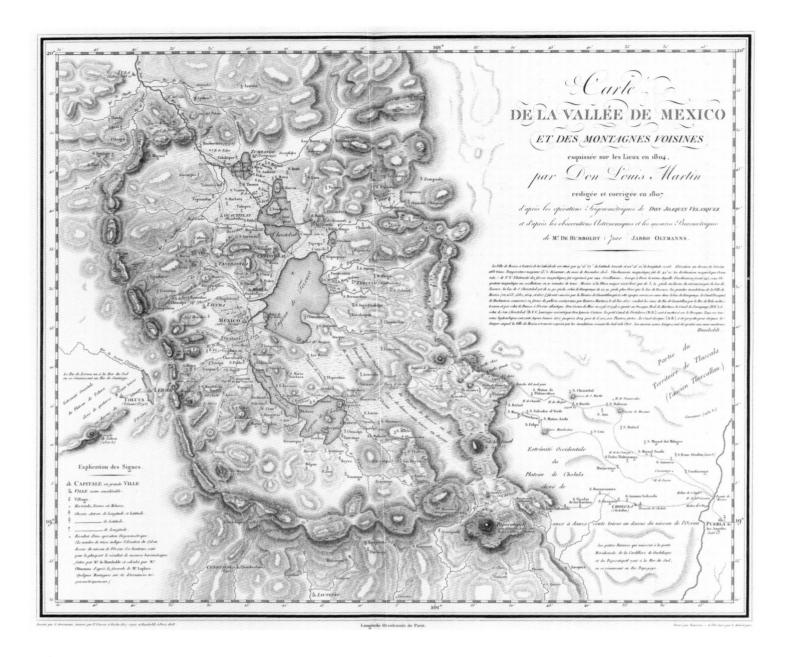

"Carte de la Vallée de Mexico et des montagnes voisines." Map by Louis Martin, from Alexander von Humboldt, *Atlas physique et géographique du Royaume de la Nouvelle-Espagne.* Paris: F. Schoell, 1811.

northern Mexico (Sinaloa), southern Arizona (Pimería Alta), and Baja California, under the direction of Father Eusebio Kino (1644–1711) and his Austrian compatriots until the expulsion of the Jesuits in 1767.

### National Period, 1821–1910

The Bancroft Library's collections trace the socio-political, economic, and cultural development of Mexico and the Central American nations after independence, recording the ideological struggles between centralists and federalists, clerical and anti-clerical parties, conservatives and liberals, and the intervention of foreign powers, most significantly the United States and France. With the presidencies of Benito Juárez (1806–1872) and Porfirio

# Mexican Inquisition Documents: Conservation Challenges

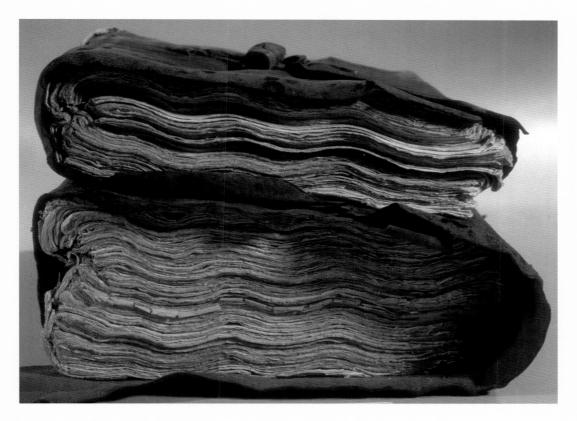

Profile of the bottom edges of two leather-bound Inquisition trial records.

GILLIAN BOAL

The history of the Inquisition remains a central element to understanding the relation of Christian culture to other cultures of both the Old and New worlds. The Inquisition traces its origin to thirteenth-century France, where it was established to protect religious orthodoxy. Introduced into Castile in the late fifteenth century, it was especially aimed at "New Christians," or *conversos,* primarily Jews converted to Christianity. In the Americas the Inquisition was established principally to protect against the Protestant menace. Although it periodically focused on the secret practice of Jewish observance, crypto-Judaism, the Inquisitors focused more on other breaches of orthodoxy and sexual misconduct, especially among the clergy: the solicitation of sex in the confessional, moral turpitude, bigamy, blasphemy, superstition, and witchcraft.

The richness of these handwritten paper documents can only be suggested. Most of them are *procesos* or trials that typically include the indictment supported by genealogical lists, records of property, and the most minute details of evidence. Because these documents span the years 1593–1817, they lend themselves not only to research by scholars for the information that they have written in them but for the research opportunity they offer on the physical materials themselves—the handwriting, the inks, and the paper with its watermarks. A research paper titled "Identification of Granular Materials Found in the Mexican Inquisition Documents" by Alison Murray and Michele Philips analyzes the ink

Trial record of Blas de Magallares, accused of not believing in the Holy Virgin, and the cord with which he hanged himself while in prison. 1597.

Trial record of José Manjarres, accused of superstition, with hand-drawn booklet as evidence. 1793.

debris brushed from each document and sent to the Art Conservation Program at Queen's University in Canada. The authors confirmed that it was probably sand that had been used to blot the ink—which supports the practices gathered from literature, documented, for example, in Samuel Pepys' diary. The paper has a series of watermarks that richly deserve further study but indicate that most of the paper was supplied by Italian papermakers.

Although scholars had known about their existence, these documents had remained in private hands since the nineteenth century. They had been stored in a relatively sound environment; all but one were in very good condition. This one document was badly mold-damaged and needed comprehensive conservation

treatment. Some of the documents had iron gall ink that had deteriorated the paper substrate in places, forming a lacy pattern. The papers were in great demand from the moment they were acquired, so conservation took several years. It was interrupted by various exhibits, demands by visiting scholars, and the need for them to be treated together as a collection rather than as single items. One of the conservation challenges of these materials was to preserve intact the information that future scholars would find useful but also to preserve and protect the artifacts themselves from use and wear over time. Consequently, several of the documents were digitized.

This collection is unique as, unlike other collections, it contains two of the original covers, made of limp leather, which were left intact. Two other covers were wrapped around cases but not attached. The evidence is uncertain that these two covers do indeed belong to these cases but they were left where found, so that future scholars can decide on their authenticity. On looking at their physical condition it became evident that the "unevenness" of the edges or "waviness" of the pages was due not to dampness but to previous folding by the scribes to create the margin for their notes and later organization. This folding was standard practice and is being echoed in the twenty-first century by regular comp books for lawyers where the pages are divided into three columns, with a wide margin on the left of the page to facilitate taking notes during the modern trial process.

These documents were sent for treatment to the Library Preservation Department, Conservation Treatment Division. Most of the documents needed only protection from future

handling. The majority of the *procesos* posed little conservation challenge and were conserved by mending the iron gall ink damage, sewing them into individual protective archival folders, and boxing them in groups. Three of the trial records with evidence attached needed more extensive treatment. The challenge was to document this evidence, such as a package containing powder or a small leather pouch that contained a bone. There was some uncertainty as to whether this was a finger bone or a bone from a small animal skeleton. There was also a need to restrict access to these packages to prevent repeated handling, as the evidence would be lost or damaged. The Library Photographic Services Laboratory took accurate photo documentation of the contents and the Conservator encased the items in a sealed container, within the box, with their relevant documents. The black-and-white prints provided a visual image of the contents and until a legitimate scholar arrives to do the research these items are restricted.

Another document with the evidence attached had sewn into its middle a rope that the accused had used to hang himself. This rope was acidic and had burned its image into the adjacent paper. To keep this artifact as it was assembled, the conservation approach was to sew an insert Mylar folio between the adjacent pages and the rope itself. The insert protects the document from handling by acting as a barrier sheet. When the Mylar pages are turned, the rope is no longer touched by the user.

The conservation of these Mexican Inquisition documents is all the more vital as the history of wars of religion is for obvious reasons attracting the attention not only of scholars but of the general public.

*Gillian Boal, the Hans Rausing Conservator, Preservation Department.*

Trial record of José Manjarres, accused of superstition, with hand-drawn booklets containing images of "devil" worship. 1793.

Díaz (1830–1915), the triumph of classical nineteenth-century liberalism was assured; but during the same period the economies of Mexico and Central America became increasingly dependent on exports of raw materials and agricultural products under the control of local oligarchies and foreign corporations and businesses.

Despite the turmoil of the Wars of Independence and the political upheavals that followed, Mexican intellectuals and scientists established in 1833 the first scientific society in Latin America, the Sociedad Mexicana de Geografía y Estadística. Bancroft holds a complete run of its *Boletín* (1839–). During Maximilian's short imperial reign, and despite the wars of the French Intervention, French scientists carried out extensive research in Mexico, resulting in the Archives de la Commission Scientifique du Mexique (1865–1867). Finally, in 1877 the Mexican government mounted the research and publishing project of the Comisión Geográfico-Exploradora to map the country, a project that continued for more than thirty years.

With the diplomatic and commercial opening of the newly independent Latin American countries, increasing numbers of travelers, especially English and North Americans, began to traverse and describe the regions in print. Probably the most enduring works are those of the American John Lloyd Stephens (1805–1852) and his British illustrator/collaborator, Frederick Catherwood (1799–1854). Bancroft's holdings of Stephens's personal papers provide the background and context to his diplomatic and commercial activities. Especially interesting for the Gold Rush period are hundreds of published and unpublished journals, diaries, and letter collections that describe the trip to California by the two major routes, through the Isthmus of Panama and around Cape Horn.

Bancroft has a small but excellent collection of drawings and watercolors of Mexican scenes by Gold Rush artists and later figures, and, from the 1850s onward, over two hundred photographic collections covering Mexico and Central America. These are the works of commercial photographers but especially the records of the travels of Americans as tourists, engineers, businessmen, or soldiers. (See *Pictorial Collection*, pp. 75–77)

With the proliferation of printing presses after Independence and the ending of institutional censorship, a wider array of imprints emerges to supplant handwritten documents and their copies, the chief mode of communications with the public during the colonial period. On the whole, published works throughout the nineteenth century were relatively short, especially until the 1850s, when the hand printing press gave way to the steam press. Except for periodicals, most publications were pamphlets or broadsides, especially in Central America. Thousands of these nineteenth-century volumes, no lon-

ger extant in the countries that produced them, are found only in Bancroft.

With the opening of political, administrative, and policy issues to broader sectors of society, government publications frequently represent the best sources for the study of the policies, rationales, and official versions of a country's aspirations and accomplishments. The Mexican collections especially are among the finest and most complete in the U.S. Bancroft also has one of the outstanding collections of national and regional statistics for Mexico, spanning the period from the late eighteenth century until the present.

Equally important as a primary source is the periodical press. Colonial newspapers start with the *Gazeta de México* in 1722, a licensed publication that included official information and some news, often from Spain and the various regions of Mexico. Bancroft's collection includes the first two years of the second series of the *Gaceta* (1728–1730) and a complete run of the third series and its successors from then on (1784–1809). With Independence, gazettes split between those that purveyed official information and those that became newspapers. Bancroft has one of the most comprehensive collections of the former for both Mexico and Central America. As for newspapers, Bancroft also has an excellent collection for Mexico, beginning with the *Diario de México* in 1805, the first daily

José Guadalupe Posada. *Calaveras del Montón* [Piles of Skeletons]. Zinc etching. Mexico City: Antonio Venegas, circa 1906–1913.

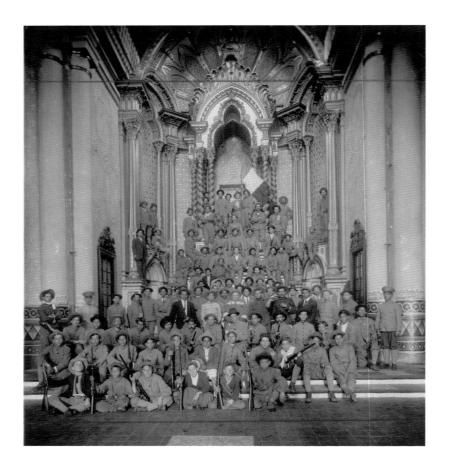

*"Military School -
in Santa María Church.
Students in front row
very young. Many of
the officers avowed
socialists."*
Photograph with note
by John Murray,
circa 1910–1915.

newspaper in Latin America. To these one may add the nineteenth- and early-twentieth-century regional newspapers from the Terrazas collection (see below). Bancroft has now ceded the collecting and microfilming of post-1900 newspapers to the Main Library.

From the gazette also came more specialized periodicals or magazines after Independence. One may mention, for example, José Joaquín Fernández de Lizardi's *El conductor eléctrico* (1820), *El mosaico mexicano* (1836–1842), or the politico-satiric *La orquesta* (1861–1877). Periodicals like these were accompanied by more practical almanacs, calendars, and guides, such as the *Calendario manual y guía de forasteros* (1789–1854). By the twentieth century personal primary sources (diaries, journals, memoirs) increasingly complement printed information. For Mexico Bancroft holds hundreds of such works.

Bancroft's collection of Mexican graphic arts is dominated by the figure of José Guadalupe Posada (1852–1913), Mexico's signature popular artist, and the later work of the Taller de Gráfica Popular. Bancroft holds roughly 450 of Posada's woodcuts, lithographs, and, especially, engravings, but even this is but a small fraction of his estimated output of 20,000 prints. He was especially known for his *calaveras*, the skeletons so closely associated with the Day of the Dead (All Saints), which he used for satirical purposes. Posada illustrated newspapers, chapbooks, posters, handbills, and broadsheets containing everything from prayers and lives of saints to current events and *corridos*, the popular narrative ballads that served, and continue to serve, as commentary on personalities and events that have shaped Mexican history.

Bancroft documentation of the dictatorship of Porfirio Díaz (1876–1911) is among the broadest and richest anywhere. Books, pamphlets, and broadsides number in the thousands. The Terrazas Papers are a tremendously important source for this period as well as for the Mexican Revolution of 1910, with more than 450 letters alone of Ricardo Flores Magón and other *revoltosos* that reveal the organization and plans of the Partido Liberal Mexicano in its struggle against the Porfiriato during the years 1899–1910.

## Revolution to Democratic Developments, 1910–2000

During the last century Bancroft has tended to focus more on Mexico than on the Central American countries. The Mexican Revolution of 1910 is documented in a highly diverse collection of personal and institutional manuscript collections, of which the single most important is that of the Mexican newspaperman and politician Silvestre Terrazas (1873–1944), editor and publisher of *El Correo* of Chihuahua. This, the largest single collection of original manuscripts on Latin America in Bancroft, is also the largest Mexican collection on the Revolution held in the United States. Spanning the period from 1899 to 1935, it documents the origins and violence of the Mexican Revolution and the reconstruction of the Mexican state, society, economy, and culture in its aftermath. For the revolutionary and postrevolutionary period it holds voluminous correspondence with all of Mexico's presidents from Porfirio Díaz to Lázaro Cárdenas and hundreds of other figures, including

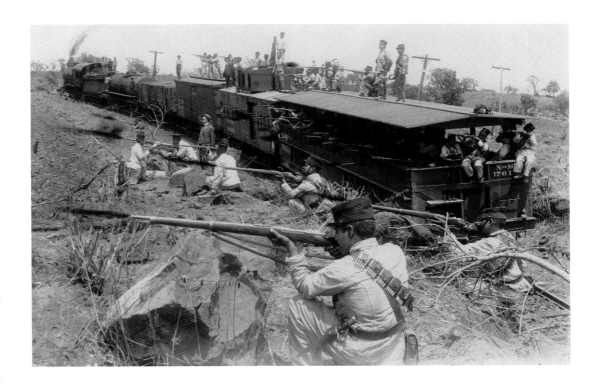

*Federales* troops and an *"Armored train near Cuernavaca."* Photograph with note by John Murray, circa 1910–1915.

more than 100 letters from Pancho Villa (1878–1923). Villa in fact looms large in Bancroft. Especially interesting is a clutch of letters from the Wells Fargo Papers, 1909–1922, which recount in great detail a Chihuahua train robbery, negotiations, and the eventual ransom of 121 bars of silver bullion by Wells Fargo in the spring of 1913, a ransom which provided Villa with seed money to raise troops and buy arms for the Revolution.

The violence and dislocation of the Mexican Revolution spurred Mexican immigration into the U.S. Southwest after 1910. Two collections of papers document this exodus to and life in the United States, those of anthropologist Manuel Gamio (1883–1960) and economist Paul Taylor (see *Western Americana*, p. 39).

The same period saw the foundation of the Taller de Gráfica Popular (Workshop of Popular Graphic Art) or TGP, of whose production Bancroft holds a large and diverse collection, over 700 items. From its founding by Leopoldo Méndez in 1937 through the 1960s, the TGP became widely known for its progressive social and political themes and enjoyed the support of some of Mexico's most lionized and activist visual artists, including Diego Rivera and David Alfaro Siqueiros. Bancroft's holdings of TGP materials include posters and handbills, cards, programs, brochures, the small periodicals it sponsored, and the innumerable books to which the affiliated artists contributed. Bancroft also holds significant samples of the original art work: sketches, paste-ups, and artist proofs.

The past thirty-five years have seen the Zapatista revolt in Chiapas, the end of single-party domination of Mexican politics and government, an increasingly difficult war against drug cartels importing Colombian cocaine into the U.S., and the uneven effects of the 1994 North American Free Trade Agreement. Bancroft has documented all of these events and historical trends systematically with contemporary imprints, serving, as for California and the West, as the library of record for Mexico.

For this period Bancroft's archival collections are primarily the result of organizational and personal collecting within the framework of left-wing political activism in northern California. Thus the DataCenter was a major Bay Area information resource for those who disputed U.S. policy and actions both locally and abroad, but especially in Latin America. The records of the Nicaragua Information Center (1980–1991) document efforts to support the Sandinista government and to combat U.S. government support of the "Contras." Smaller personal collections from individuals who

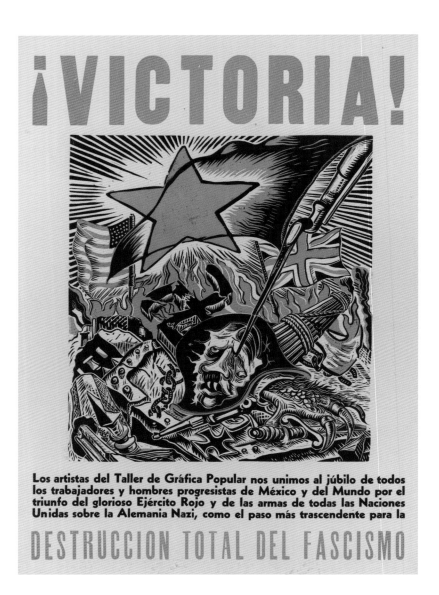

Ángel Bracho (b. 1911). *¡Victoria! Destrucción total del Fascismo*. Print on paper: linocut. Mexico City: Taller de Gráfica Popular, 1945.

MINISTERSTVO KULTURY A ÚSTŘEDNÍ SVAZ ČS. VÝTVARNÝCH UMĚLCŮ

VE VÝSTAVNÍCH
SÍNÍCH
**MÁNESA**
ČERVEN - ČERVENEC
1954
DENNĚ OD 9-18 HOD.

# MEXICKÁ GRAFIKA
## TALLER DE GRÁFICA POPULAR

went to Central America in the 1980s contain ephemera—flyers and pamphlets—primarily from Nicaragua, Guatemala, and El Salvador.

Bancroft will continue to collaborate with institutions inside and outside of Mexico to make our holdings better known through state-of-the-art digital technology. For example, a 2002 collaborative project to catalog all known Mexican pamphlets from independence in 1821 to the Revolution of 1910 recorded 24,000 items, of which Bancroft holds 13,000, 4000 uniquely. The vast majority of these were acquired by H. H. Bancroft, confirming his bibliographical acumen.

Today as much as at any time in the past, the fortunes of California and Mexico are inextricably linked. Bancroft is uniquely positioned to provide materials for comparative historical and policy studies.

Alberto Beltrán (1923–2002). *Mexická Grafika* (based on his *Manuela Sánchez*, 1952), created for a Taller de Gráfica Popular exhibition in Czechoslovakia. Print on paper: linocut. Mexico City: Taller de Gráfica Popular, 1954.

# At Work | *Colonial Mexico: Priests and Their Parishes*

WILLIAM B. TAYLOR

The Bancroft Library was important to my research on colonial Latin America long before I became a faculty member at the University of California at Berkeley in 1998. In 1979 I launched a big project on priests in their parishes in late colonial Mexico and stumbled on a book, *El itinerario para parochos de indios*, that truly opened the subject for me. This thick moral-theology text designed to instruct American priests entering pastoral service in Indian parishes is not particularly scarce. For its time it was a best seller, with seven editions printed between 1668 and 1771; copies often show up today on the rare book market. What made the Bancroft copy so important to me were the annotations by a Mexican parish priest at just the time in the mid-eighteenth century when the role of the pastor was reconceived by the Bourbon monarchy. The various editions of the itinerario and the annotations in Bancroft's copy became my touchstone for how parish priests imagined their responsibilities in a time of great change, and how they felt thwarted, confused, and sometimes energized by the Bourbon reforms.

The Bancroft Library is still important to my research and writing on colonial Latin America. It is even more important to me now as a deep reservoir from which to explore this subject in ways that I can share directly with my students. I could write, for example, about a famous Bancroft holding such as the Codex Fernández Leal, a mysterious pictorial record from Oaxaca that illustrates how native Americans reckoned with the Spanish colonial system of law and justice in the sixteenth century. Instead, I want to touch on two of the many more prosaic and less obviously attractive colonial manuscripts in Bancroft's collection. I find these resources even more compelling for helping students imagine themselves as historians and discover something of their own in the written record of the time.

The first is a long, detailed inspection of the *ejidos* (or municipal lands) of Mexico City ordered by the city council in 1691 in an attempt to recover common lands for grazing cattle and sheep for the city's meat markets. To establish what had happened to the municipal lands outside the central city, the inspectors included in the report a copy of a similar inspection of the *ejidos* from 1608. Setting these two inspections side by side, two of my undergraduate research apprentices and I have begun to chart the changing face of the Valley of Mexico during the seventeenth century, virtually place by place. The competition for these semi-rural lands documented in this manuscript between 1608 and 1691 belies the old idea of a seventeenth-century depression while also showing the displacement and urbanization of the Indian population of the valley, as small dispersed settlements gave way to fewer but larger Indian pueblos. The manuscript offers one of those rare opportunities to address before-and-after questions within a single resource.

The second document is an Inquisition investigation into the bigamy of a married Basque Spaniard who made his way to a little mining settlement of north-central Mexico in the 1570s, where he took an American wife. Such multiple marriage cases usually turn out to be less juicy than those in the *National Enquirer*. But this one, I discovered, contains something intriguing and unexpected. In a little collection of letters that the erstwhile bigamist sent back to his first wife and other relatives in Spain shortly after he reached Mexico, he describes his life and fortunes on the edge of the Spanish empire as colonial towns were just then forming.

His first letter to his wife, Catalina de Elordi, was dated March 22, 1571:

*My Lady,*

*I write you this letter to say that I sent another one with the last fleet, and have had no reply. I really have a great desire to receive news of your health, for which reason I wrote to tell you about my trip to these Indies.*

*I don't know whether you received any letter about this from me. I won't say more than that I am well, thanks be to God. I want you to know that I am living well, earning 300 pesos de tepusque [copper/gold pesos], and planning to leave here within two years, if God may grant me good health, since I am making a very good fortune, able to earn 300 ducats [gold coins] in these two years. I won't write more about this. Rather, I want you to let me know about your health and answer the letters I sent over there because I'll be very glad to have news of the homeland and of your health.*

*Do give my best regards to Señor Martín de Urbieta and his wife; to Domenja, to Señor don Gaspar, Señora Aneza, and to those holy women, I kiss their hands; also to my godmother, to your mother, and to all who may ask about me. I beg you to do me the favor of sending me an answer because it would please me greatly.*

*I'll say no more except may Our Lord give you health and the rest that you desire. From the mines of Sombrerete, March 22, 1571.*

*He who would rather see you than write to you.*
*Your husband. Juanes de Galarraga.*

When he received no answer, he wrote again, saying:

*Perhaps there is a shortage of paper and ink.*

By 1575 Catalina de Elordi knew that her husband had married again. She and several other women of his hometown of Urbieta gave depositions to the effect that she was his legitimate first wife. The depositions, along with the 1571 letters, were sent to the Inquisition in Mexico City. An arrest

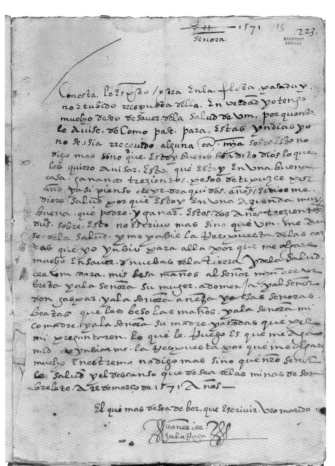

Juan Vizcaíno (known as Juanes de Galarraga), letter to his wife, Catalina de Elordi. From the Mines of Sombrerete [Zacatecas], March 22, 1571.

warrant was issued in March 1576, but Vizcayno was not actually arrested until 1582. He tearfully confessed to having married twice and was swiftly sentenced to the public humiliation of an auto-da-fé, 200 lashes, and perpetual exile from America.

Four veteran undergraduates in my Regional Approaches to Colonial Mexico class two years ago worked with me to transcribe, translate, and reckon with these letters for other members of the class. Those four students—Henry Bermúdez, Monalisa Gacutan, Yasmin Gilani, and Pedro Villa—tell me that learning to read and interpret those letters was a high point of their undergraduate studies at Berkeley. And their work lives on. Their translations of these letters have become a staple reading assignment for my introductory course on colonial Latin America.

*William B. Taylor is Professor of Latin American History at the University of California, Berkeley.*

# Collection Highlights

## Native Mexico and Central America

Codex Fernández Leal

Nahuatl MSS on land distribution from Xochimilco (Mexico City) (Techialoyan group), 16th century

Fernando de Alva Ixtlilxochitl (1568?–1648). Historical works and letters

Nahuatl MSS: Christian didactic works, legal records, ethnographic and literary works

Andrés de Olmos. *Arte para aprender la lengua mexicana* (ca. 1563)

Alonso de Molina. *Ordenanzas para los hospitales* (1552)

Nahuatl translation of Pedro Calderón de la Barca, *Gran teatro del mundo*, 17th century

St. Juan Bautista de la Concepción (1561–1613). Huehuetlatolli, or *Discursos mexicanos*

Mateo Lucas. *Catecismo Hispano-mexicano* (1714)

Documents relating to Dominican, Franciscan, and Jesuit missionary work

Bancroft Reference Notes on the Conquest of Mexico, 1521–1603

Francisco Ximénez (1666–1722?). Manuscripts on Mayan history and languages

Woodrow Wilson Borah, Spanish American research materials, 1700–1800

John Lloyd Stephens Papers, 1795–1882

Alphonse Louis Pinart Collection: Linguistic and Historical Materials relating to Central America

Abbé Charles Etienne Brasseur de Bourbourg Papers, 1814–1874

Frans Ferdinand Blom Papers, 1893–1963

Carl Ortwin Sauer Papers, 1909–1975

Francisco Mújica Díez de Bonilla Papers, 1956–1979

## Colonial Period

Carlos Sigüenza y Góngora Manuscripts, 1692–1699

Documents relating to the *Juzgado de Indios*, 1580–1820

Alfredo Chavero, *Maltratamiento de Indios*, 1609

Franciscan, Dominican, and Jesuit Church records

Philippine Commerce and the Manila Galleon Collection, 1769–1830

Mexican Inquisition Documents, 1595–1817

*Decretos de parte*: Cases brought before Viceroy of New Spain, 1801–1811

Documents from the José Fernando Ramírez Collection, 1480–1847

Bancroft Reference Notes for Mexico

Bancroft Documents concerning government affairs in Mexico, 1535–1597

First edition imprints: *Doctrina cristiana* (1546); Alonso de Molina, *Vocabulario en lengua castellana y mexicana* (1571); *Sermonario en lengua mexicana* (1577); *Tratado breve de anothomía y chirugía* (1579); Antonio del Rincón, *Arte mexicana* (grammar of Nahuatl) (1595); Bartolomé de las Casas, *Breve historia de la destrucción de las Indias* (1552); Gaspar Pérez de Villagra, *Historia de la Nueva México* (1610); Bernal Díaz del Castillo, *Historia verdadera de la conquista de la Nueva España* (1632); Bernardo de

Balbuena, *Grandeza mexicana* (1604); Sor Juana Inés de la Cruz, *Carta athenagórica* (1690), and others

Alexander von Humboldt Expedition documents, 1803–1804

Alessandro Malaspina Expedition documents, 1789–1792

Early Newspapers: *Gazeta de México, Diario de México, Diario mercantil de Veracruz*, and others

## Spanish Borderlands and Northern Mexican Frontier

Documents relating to Northern Mexico, 1531–1805

Papers relating to the Jesuits in Baja California and Other Northern Regions in New Spain, 1686–1793

*Documentos relativos a las misiones del Nuevo Mexico*, 1605–1720

*Documentos para la historia eclesiástica y civil de la Provincia de Texas*, 1689–1789

Documents relating to Texas, 1797–1810

Documents relating to Coahuila, Coahuila y Tejas, and Nuevo León y Coahuila, 1806–1860

Louisiana Papers, 1767–1816

Alphonse Louis Pinart Collection of Borderlands Materials

Herbert Eugene Bolton Papers

George Peter Hammond Papers

Abraham Phineas Nasatir Document Collection, 1775–1887

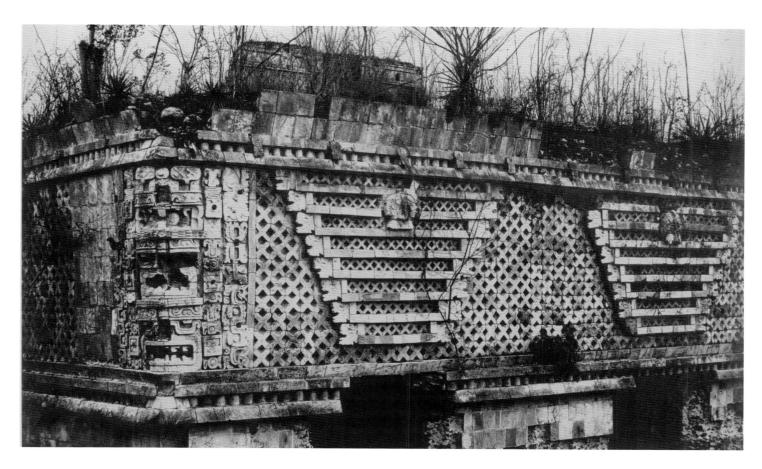

"Palais des Nonnes, à Uxmal; detail de la façade dite Egyptienne." [Mayan ruins at Uxmal, Nunnery Quadrangle, East Building, north end and west front], circa 1860. Photograph by Désiré Charnay, from his *Cités et ruines américaines: Mitla, Palenque, Izamal, Chichen-Itza, Uxmal.* Paris: Gide, 1863.

## Mexican Independence to the Mexican Revolution (1821–1910)

Bancroft Reference Notes for Mexico

José Joaquín Fernández de Lizardi Manuscripts

Jesus González Ortega Papers, 1844–1866, 1884

José Marcos Mugarrieta Papers, ca. 1837–1886

Plácido Vega Papers relating to Confidential Mission, 1858–1869

Norberto Ballesteros Letters, 1860–1865

Vicente Ortigosa Papers, 1864–1873

Mexía Family Papers, 1694–1951

*Boletín de la Sociedad Mexicana de Geografía y Estadística*, 1839–

Archives de la Commission Scientifique du Mexique, 1865–1867

Newspapers: *El Sol, El Republicano, El Monitor Republicano, Diario del Imperio, Voz de la Patria, El Hijo del Ahuizote,* and others

## Mexican Revolution and the Twentieth Century (1910–present)

Silvestre Terrazas Papers, 1883–1944

Wells Fargo Papers relating to Pancho Villa, 1909–1922

José Guadalupe Posada Collection

Taller de Gráfica Popular Collection, 1937–

## Central America

Bancroft Reference Notes

Papers from the Guatemalan National Archive

Alonso Díaz de la Reguera, Guatemala letters, 1540–1549

Ephraim George Squier Papers, 1841–1848

Tomás Martínez letterbooks, 1861–1863

Documents relating to William Walker's filibustering expeditions, 1851–1858

Nicaraguan posters

Nicaragua Information Center records, 1980–1991

# Pictorial Collection

Jack Von Euw, CURATOR

## Collection Profile

*Scope*   The Bancroft Library possesses some of the first pictures ever made of San Francisco, Monterey, and Yosemite, as well as images of countless other locations along the Pacific Coast, Alaska, and Hawaii. Comprising 8 million items, the Bancroft Pictorial Collection encompasses the history of America west of the Mississippi, concentrating primarily on California and Mexico, and dates from the European and Russian voyages of exploration to the West Coast in the late eighteenth and early nineteenth centuries to the present.

*Subject Areas*   
- The breadth of the Pictorial Collection is reflected in the variety of formats, everything from personal sketches, drawings, and illustrated journals to large-scale oil paintings of the Western landscape

- printed material from illustrated lettersheets and colorful clipper-ship cards to broadsides and bird's-eye-view lithographs

- photography, which makes up the greater part of the collection, includes intimate daguerreotype portraits from the Gold Rush, *cartes de visite,* family photo albums, mammoth-plate albumen prints, industrial photographs of dam building in the Kaiser Company collection, and the millions of negatives that belong to the *San Francisco Examiner* and *San Francisco Call-Bulletin* newspaper archives. This assortment of media is commensurate with the sweep of subjects covered by the collection, which encompasses almost every aspect of life in the West, from exploration of the terrain and first encounters with the indigenous populations to discovery, exploitation, and commodification of its vast natural resources.

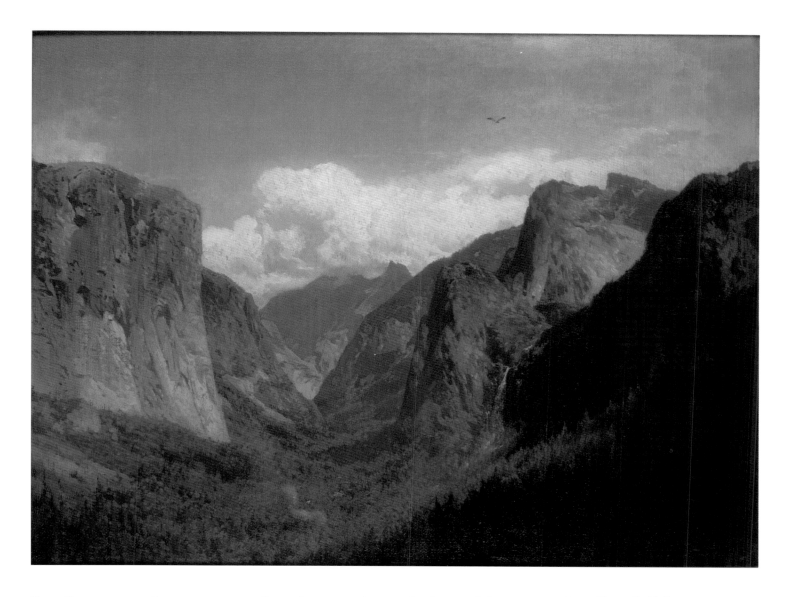

THE PICTORIAL COLLECTION reflects the perceptions and cultures of the creators of the visual record as well as their multifaceted attempts to document their subjects' physical, social, and political environment. The historical significance of the collection's huge array of images derives both from their recording of the changing physical landscape as well as the changing perceptual landscape of the West. To go from Louis Choris's (1795–1828) watercolor sketches of the Mission Indians in San Francisco at the beginning of the nineteenth century to C. Hart Merriam's (1855–1942) photographs of Northern California Native Americans in the teens and twenties of the twentieth century is to traverse not only more than a century of changes in the physical landscape and technology of documentary tools but also to travel the distance in their perceptual approaches. And yet both Choris's sketches and Merriam's photographs attempt to document the physical, social, political, and cultural circumstances of the peoples of Northern California.

For many years the Pictorial Collection grew primarily through the accumulation of

*Yosemite Valley.*
Oil painting by
Herman Herzog, 1873.

sketchbooks, drawings, photographs, and a variety of illustrated printed matter; materials transferred from the personal papers and institutional records that form the core of The Bancroft Library Western Americana and Latin Americana collections. The papers of prominent individuals, such as Adolph Sutro, George Davidson, Francis P. Farquhar, Governors James Phelan, Pat Brown, and Earl Warren, and of families such as Vallejo, Cooper-Molera, Hearst, and Haas contained substantial quantities of photographs. Collections of institutional and business records like those of the War Relocation Authority and the Crown Zellerbach Company also yielded thousands of photographs.

*The Robert B. Honeyman, Jr., Collection of Western Americana and Art*
From its beginnings as an amorphous but growing entity, the Pictorial Collection served primarily to illustrate text. The purchase of the Robert B. Honeyman Collection in 1963, however, came at a time when the research value of images began to go beyond the illustrative. With that purchase, the Pictorial Collection came into its own as a significant, inherently valuable resource central to the critical study of the history of the West.

The Friends of The Bancroft Library and the Regents of the University of California's purchase of the Honeyman Collections remains the single most important acquisition of visual material for Bancroft. It anchors The Bancroft Library's Pictorial Collection, augmenting and enhancing Bancroft's core holdings of manuscripts and primary and printed sources of Western and Latin Americana. Thus, the José Cardero (1768–) drawings relate directly to the 1792 Malaspina expedition's primary documents in Bancroft. Likewise, the John Sykes' (1773–1858) watercolors illuminate George Vancouver's 1798 three-volume report on his voyage of discovery to the North Pacific Ocean.

The value and importance of the Honeyman Collection as a visual history of California and the Western states is impressively clear in the presence of works by such shipboard explorer-artists as Richard Brydges Beechey (1808–1895), Georg Heinrich von Langsdorff (1774–1852), and William Smyth (1800–1877).

The collection's impressive array of 2371 items is a treasury of the tradition of the foreign artist as surveyor, scientist, sailor, soldier, and seeker of fortune and fame. It includes many fine examples by major artists of California such as Thomas Ayers (1816–1858), Albert Bierstadt (1830–1902), Albertus Del Orient Browere (1814–1887), George Henry Burgess (1831–1905), Alexander Eduoart (1818–1892), Augusto Ferran (1813–1879), Herman Herzog (1831–1932), Thomas Hill (1829–1908), William Keith (1838–1911), Charles Christian Nahl (1818–1878), and Ernest Narjot (1826–1898). Many of these painters empha-

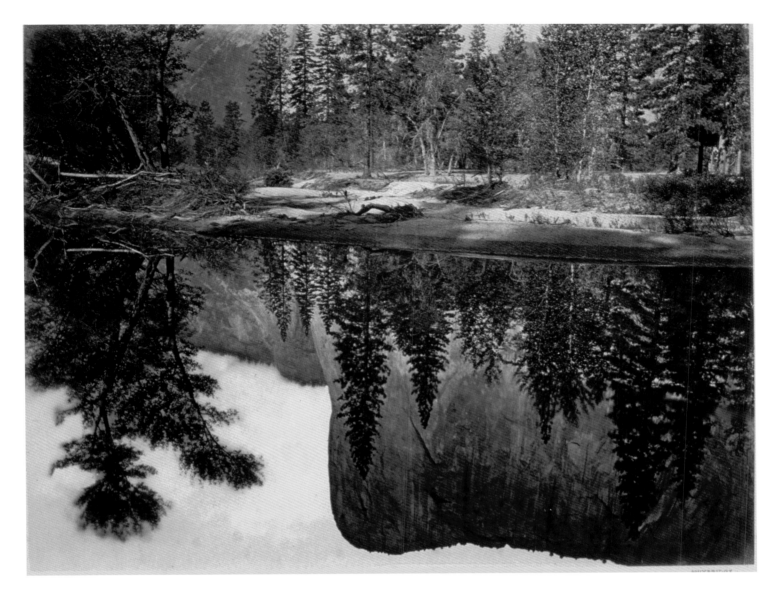

size the grandeur of the landscape and the adventures and dangers of "going West." The surrounding forests were filled with enough giant trees to supply lumber for the lone prospectors, industrial mining, and the rapid growth of towns and cities.

Although the collection visualizes the Old West as filled with the promise and possibility of exploration and discovery, people and land, enterprise and growth, it also depicts some of the less salubrious effects of the nineteenth-century vision of progress.

### Photography: California and the West

Not only is the technological development of photography chronologically parallel to the development of the American West, photography also played a significant role in settling the West: Photographic surveys commissioned by federal and state governments helped bring the railroads; investors were lured by photographs of mining operations; the Yosem-

*Tutokanula. Valley of the Yosemite. (The Great Chief) "El Capitan." Reflected in the Merced. No. 11.* Mammoth plate photograph by Eadweard Muybridge, 1872. From the collection, *Valley of the Yosemite, Sierra Nevada Mountains, and Mariposa Grove of Mammoth Trees.*

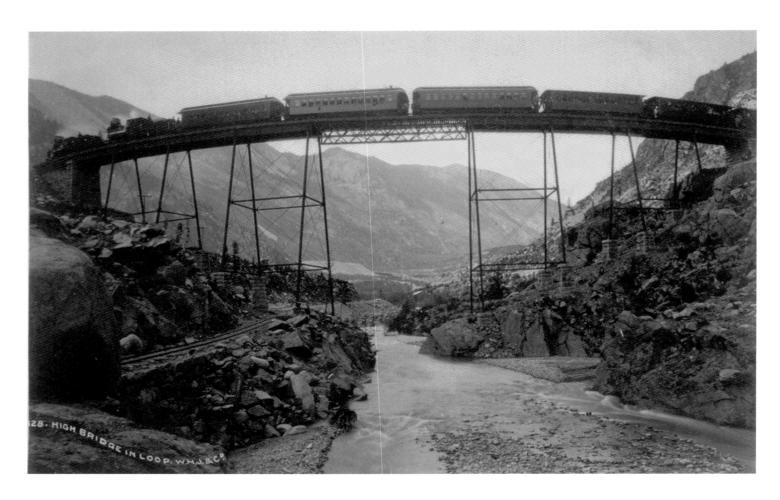

*High Bridge in Loop*
*[near Georgetown, Colorado].*
Photograph by
W. H. Jackson & Co.,
circa 1885.

ite photographs of Carleton Watkins (1829–1916), Eadweard Muybridge (1830–1904), and many others contributed to the valley becoming first a state and then a national park.

The photograph, with its inherent objectivity—the word for camera lens in German is *das Objektiv*—ultimately became the medium by which the West became transparent to the world and a witness to itself. The Pictorial Collection provides a photographic panorama of settlement and expansion from the late 1840s through the beginning of the twentieth century. Early examples of photography include daguerreotypes of the California Gold Rush, salt prints of Yosemite and San Francisco, albumen mammoth prints of industrial mining, as well as thousands of stereoviews of railroad scenes, cityscapes, and landscapes.

The Bancroft Library houses the work of many of the most famous and accomplished nineteenth-century photographers of the West, from the pioneer daguerreotypists who came west with the Gold Rush, such as William Shew (1820–1903) and Robert Vance (1825–1876), to the great landscape photographers Timothy O'Sullivan (1840–1882), William Henry Jackson (1846–1933), and Carleton Watkins, who were employed by the U.S. territorial surveys and the railroad and mining companies. The Pictorial Collection includes some of the finest collections of Eadweard Muybridge's photographs of the West

as well as the best collection of Watkins's photographs in a public institution. Historical firsts include Charles Leander Weed's photographs of Yosemite, the first ever made to record the valley, and George Fardon's 1856 *San Francisco Album: Photographs of the Most Beautiful Views and Public Buildings of San Francisco,* the first photographically illustrated book ever made of an American city.

In addition, the collection contains thousands of photographs of Yosemite and other wilderness areas; mining in California, Nevada, and Alaska; portrait files of individuals prominent in the history of the West; Native Americans in California; the California missions; thousands of photographs of the 1906 San Francisco earthquake and fire; vacation, business, and leisure activities; Chinese Americans in California; immigrant labor; and major infrastructure projects, such as railroad, bridge, and dam construction. More than 7000 photographs from the War Relocation Authority, depicting the Japanese-American internment and relocation, and the pictorial archive of Kaiser Industries document World War II in California.

Photographs by some of California's most renowned early and mid twentieth-century photographers—Arnold Genthe (1869–1942), Edward Weston (1886–1958), Imogen Cunningham (1883–1976), Dorothea Lange (1895–1965), Ansel Adams (1902–1984), and Johann Hagemeyer (1884–1962)—can be found in the collection, as well as the work of commercial photographers such as San Francisco's Isaiah West Taber (1830–1912) and Gabriel Moulin (1872–1945) and of hundreds of lesser-known California photographers who are just now beginning to be documented. Also of great historical and human interest are the thousands of photographs taken by amateur photographers over the past 140 years, which provide researchers with an extraordinary insight into daily lives, personalities, and events.

In addition to individual photographs by "blue chip" photographers, the Pictorial Collection contains significant photograph archives of individual photographers, like the portrait photographer Johan Hagemeyer, who was a friend of Edward Weston's and part of the artists' community of the 1920s and 30s in Carmel, California, and C. Hart Mer-

*Jerry James and wife; Humboldt Bay. Soolahteluk Stock (Wiyot).* Circa 1910. From the C. Hart Merriam Collection of Native American Photographs.

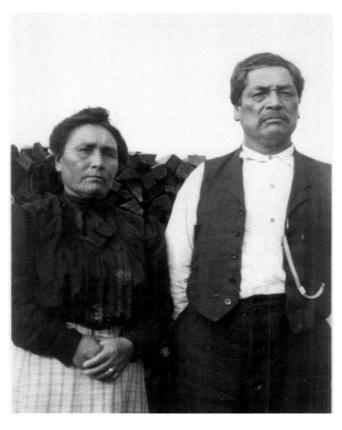

The Wiyot people around Humboldt Bay were one of numerous California tribes decimated by white settlement. Before 1850 they numbered between 1500 and 2000; by 1910 the Wiyots— ravaged by massacres, slavery, disease, intermarriage, and relocation—were reduced to fewer than 100 full-blooded members.

riam, who created a unique record of more than 4000 photographs as part of his project to document the languages of California Indian tribes from 1910 until 1936.

Collectors of photography have contributed to the Pictorial Collection in significant ways: Paul Padgette's collection of Carl Van Vechten's (1880–1964) photographs of Gertrude Stein and Alice B. Toklas not only complements and enhances the holdings of Alice B. Toklas in Bancroft but is also a unique and intrinsically valuable cultural record. Roy D. Graves started collecting photographs in 1902 and continued to add to his collection until shortly before his death in 1971. The general subjects of the Graves collection are the history of transportation—especially of railroad transportation in California—and the history of San Francisco and its environs. His collection consists of more than 23,000 prints, which he arranged in 98 volumes, and approximately 10,000 negatives.

Also of historical significance are the hundreds of thousands of photographs and negatives that document the institutional histories of the environmental, journalistic, political, and corporate arenas in California and beyond. These are represented by, among others, the Sierra Club and the *San Francisco Examiner* and *San Francisco News Call Bulletin* photo archives.

At the end of the nineteenth century, the advent of roll film and the subsequent availability of portable cameras made the personal photo album possible. Consequently, scrapbooks and family photograph albums, often donated with personal papers, figure prominently in the Pictorial Collection. They provide unique and personal historical perspective on the lives of the prominent as well as the no-less-important "ordinary" family. In the context of the manuscript and archival records in the Western Americana collection, the accumulation of the personal pictorial record adds depth to the portrait of life in the West.

Among the many personal albums, the thirty-five Jesse Brown Cook Scrapbooks are remarkable in their documentation of the history of law enforcement in San Francisco from the 1880s through the 1920s. The twenty-nine albums from the Elise Stern Haas Family Photograph Collection make for a rich portrayal of several generations of a distinguished Bay Area family's social activities and leisurely pursuits. The album entitled *The Records of an Unbroken Friendship but the Mortal Severance* was apparently

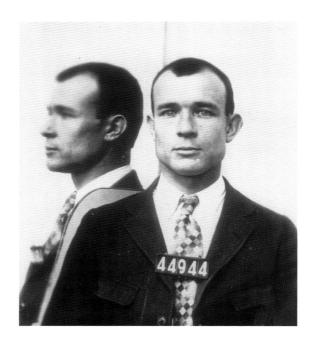

*Edgar La Pierre.*
*San Quentin. 44944.*
*Executed Feb. 12.1929. Age - 31.*

Police report reads, "Killed William Davis, an Oakland Policeman—subject with his wife, Mrs. Garrielle La Pierre. His wife [sic] brother Leo Archambault with deceased were in apartment of La Pierre, drinking, during an argument, killing followed,—Archambault is serving Life and Mrs. La Pierre is serving 0–10 years for their participation if [sic] the crime."
From the Jesse Brown Cook Scrapbooks Documenting San Francisco History and Law Enforcement, Volume 30.

created as a memorial to Taizo Kato, a Japanese-American who died in 1924 at the age of 36. Kato was the proprietor of a Los Angeles photo, art, and stationary goods business named "The Korin." This album offers an understanding of Kato's life, social standing, and aspirations. The photographs of the store, the outings on his motorcycle, his cars—his obvious display of pride of ownership—seem to be part of the "All American Dream." What a sharp contrast these images are to those of the Japanese Americans from the archive of the War Relocation Authority taken less than twenty years later!

What will be the fate of the photo album in the digital age? One of the challenges for the Pictorial Collection will be to determine how and if those personal visual histories, once safeguarded in the family album, can be preserved when electronic exchange of images and the ubiquity of digital cameras are making the printed image and light-lens photography obsolete.

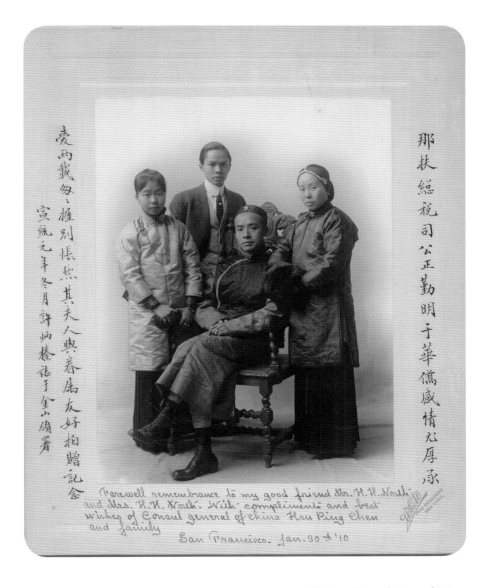

*Chinese Consul General, Hsu Ping Chen and family*. 1910.

The image bears the inscription, "Farewell remembrance to my good friend Mr. H.H. North and Mrs. H.H. North. With compliments and best wishes of the Consul General of China Hsu Ping Chen and family. San Francisco, Jan. 30th '10." North was Commander of the Angel Island immigration station.

## Mexico: Visual Resources

Represented by more than one million images, beginning with the 450-year-old Codex Fernández Leal and continuing through the early part of twentieth century, Mexico is the second largest subject and geographic area in the Pictorial Collection.

As is true for most of the Pictorial Collection, photography is the predominant medium. Nevertheless, non-photographic media including political posters, broadsides, and illustrated publications, such as those of José Guadalupe Posada and in particular of the Taller de Gráfica Popular, are among Bancroft's most valuable visual resources for Mexico.

Founded in 1937 as a left-wing printmaking collective, the Taller de Gráfica Popular

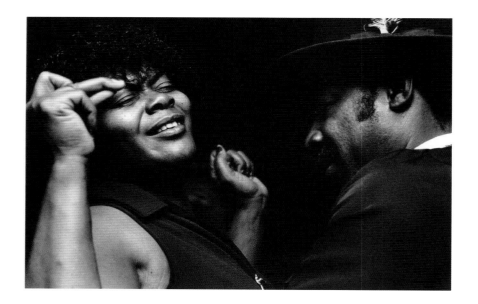

*Dancers, Saturday night at Shalimar in Oakland.*
Photograph by Michelle Vignes, from her Oakland Blues series, 1981.

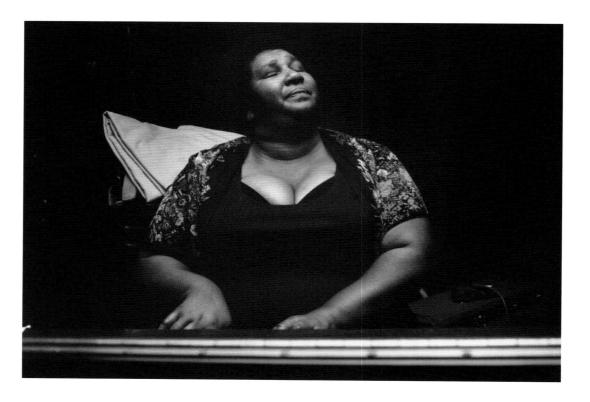

*Beverly Stovall playing the blues at Eli Mile High Club in Oakland.* Photograph by Michelle Vignes, from her Oakland Blues series, 1981.

had the support of some of Mexico's most lionized and activist visual artists, including Diego Rivera and David Alfaro Siqueiros. The Pictorial Collection houses more than 700 prints and continues to collect more, making it one of the most comprehensive collections outside of Mexico.

The 150 watercolor drawings of Andrew Jackson Grayson's *Birds of the Pacific Slope* comprise one of Bancroft's rarest and most historically significant visual resources. Commissioned by the Academy of Science and Literature in Mexico, Grayson, Mexico's Audubon, settled in Mazatlán, where he worked on his drawings for the last ten years of his life. Although discouraged by lack of funds and the repudiation of his contract with the Academy following the execution of Emperor Maximilian, Grayson pressed on with his project. Financial aid finally came from the Smithsonian, but Grayson was already ill with coast fever, from which he died on August 17, 1869. In 1879, after many unsuccessful attempts to publish Grayson's watercolors, his widow gave them to the University of California. In 1984, the Arion Press in San Francisco published Grayson's *Birds of the Pacific Slope* in a limited facsimile edition.

*Mexico: Photography*

Mexico attracted numerous foreign photographers, such as Claude-Joseph-Desiré Charnay (1828–1915) and Abel Briquet (active in Mexico from 1876–1911). Charnay first traveled to Mexico in 1857 with a commission from the French government to photograph Mayan ruins, where over a period of almost three years he photographed the pre-Hispanic site of Mitla and others on the Yucatán Peninsula. His 1863 *Cités et ruines americaines, Mitla, Palenque, Izamal, Chichen-Itza, Uxmal* is significant on a number of levels: it provides the earliest photographic evidence of many of the sites depicted, and it is one of the first publications to use photography to document New World archaeology.

Briquet left his successful photography studio in Paris for Mexico in 1876. A variety of business enterprises commissioned his photographs; later under the patronage of President Porfirio Díaz, Briquet became Mexico's first major commercial photographer. His publications included a series of commemorative albums entitled *Vistas Mexicanas*, of which Bancroft has four. An indication of Briquet's commercial success is the ubiquity with which his photographs appear in personal collections and albums in the Pictorial Collection.

In addition to commercial or government-sponsored publications, personal collections of photographs such as albums and scrapbooks augment the documentation and study of events taking place from the mid nineteenth and early twentieth century in Mexico. A unique album entitled *Souvenirs de la campagne du Mexique de 1861 à 1867* is Bancroft's earliest photographic album from Mexico and also the most substantial visual record of the French military intervention in support of Emperor Maximilian. Moreover, many of the buildings, structures, and monuments depicted in this album no longer exist—they do not appear in later photographs of Mexico—or have undergone major modification. The initials E.L. appear within many images, perhaps indicating they were taken by Ernest Louet (1831–1888), the chief paymaster of the French forces in Mexico.

Major Charles Rosedale compiled his album of "snap shots" while serving as an engineer with the "Angel's Brigade" in 1914. Although his album is informal, it is significant and unique—the only album in Bancroft that depicts an American, quasi-military force participating in the building of infrastructure in Mexico during the revolution. Many of Rosedale's photographs document the "Angel's Brigade" assisting in the construction of railroads, bridges, and a hospital in the Madera Region.

*Out of Scope: Beyond Western and Latin Americana*

While the Pictorial Collection's major strengths parallel those of the Western and Latin

Americana collections, Bancroft also holds important collections that reflect the eclectic nature of Bancroft's many functions as the special collections library of the Berkeley campus. One of these is the Thérèse Bonney Photograph Collection, which consists of more than 10,000 photographs and negatives: photographic portraits of artists and literary figures, photographs of World War II in France, the Russian invasion of Finland in 1940, her "Pictorial Manuscript of Europe's Children," and other works for publication.

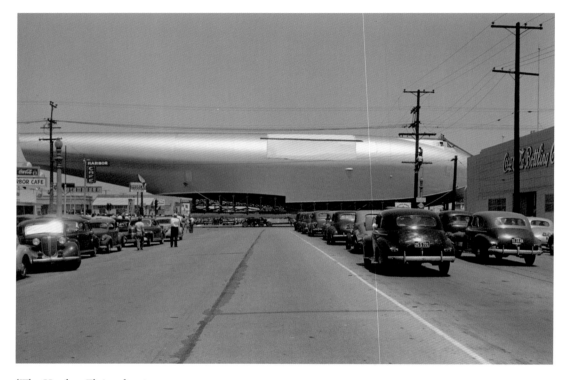

[The Hughes Flying-boat ("Spruce Goose") being pulled across an intersection.] Photograph by Chuck Brenkus, 1947.

Bonney (1897–1977), educated at Berkeley, Harvard, Columbia, and the Sorbonne, settled in Paris in 1919 to pursue photography and promote cultural exchange between France and the United States. Her collection reflects her multi-pronged career, in the course of which she founded a stock photo agency, wrote guidebooks, and brought French fashion and interior design to the U.S. During World War II Bonney became a photojournalist—her photographs were widely published in the U.S.—and activist on behalf of the displaced civilian populations and refugee children of France.

*Recent Collecting: Individual Photographers' Archives*

While still building to the strength of the pictorial holdings from mid nineteenth- to mid twentieth-century California, the past decade has seen a shift in collection development to document more specifically the period from the second half of the last century to the present. Current pictorial collecting emphasizes archival collections that record the cultural, social, and economic changes of the more recent past. Establishing relationships with local documentary photographers has been key to this shift in emphasis. As a result

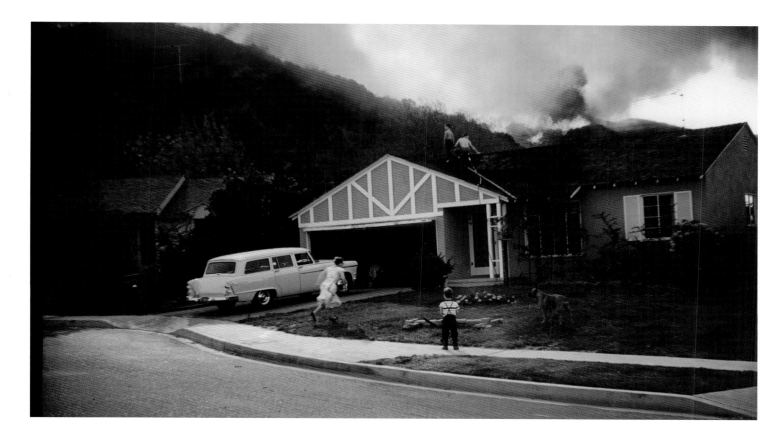

several archives and thematic series have been acquired by Bancroft. Among them are the complete photograph archives of Chauncey Hare (1934–), the only photographer ever awarded three consecutive Guggenheim Fellowships. In 1978, *Aperture* published *Interior America,* a collection of his portraits of "working class" people, many of them Californians, in their home environments. In addition, the archives of Michelle Vignes, Jon Brenneis, Morrie Camhi, and Ted Streshinsky have been added to the Pictorial Collection in the past five years.

Vignes (1926–), recipient of the Dorothea Lange Award for Women in Photography, is known for her in-depth documentary projects, which include the American Indian Movement, Bay Area blues musicians, local gospel performers and congregations in storefront churches, and Occumicho, a village in Mexico. Her California subjects run the gamut from the 49er Truck Stop outside Sacramento, to Frontera, a prison for female felons in Corona, to bullfighting in Escalon.

Jon Brenneis donated his archive, which spans his entire career as a professional photographer from the 1940s to 1985. Over his almost 50-year career, Brenneis turned away from the early journalistic assignments he did for *Life* and other magazines and instead focused his lens on assignments for *Scientific American* and, in particular, on California corporations. His annual reports for many of the Bay Area's largest corporations include the oil, high tech, wine, and lumber industries.

*Fire! Sunland. 1955.*
Printed circa 2000–2003.
From the Charles Phoenix
Collection.

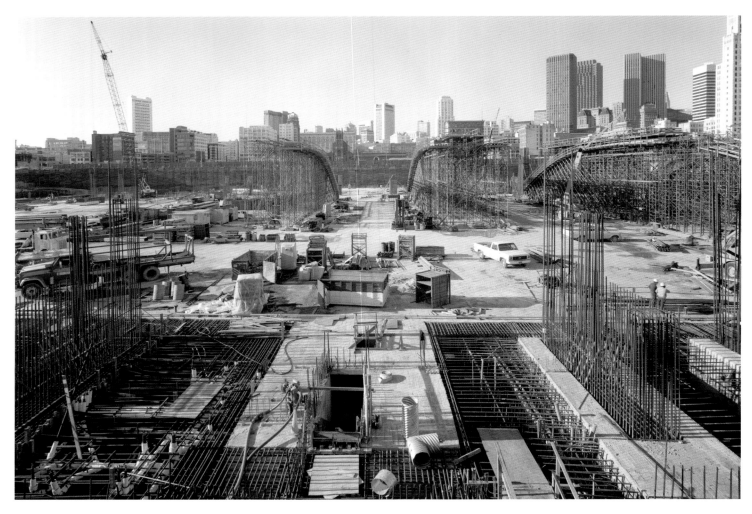

*Northern Vista, George Moscone Site, San Francisco.* Gelatin silver print. Photograph by Catherine Wagner, 1980.

Morrie Camhi (1928–1999) began his career as a commercial studio photographer, focusing on consumer and industrial products. He is, however, best known for his two books, *The Prison Experience* and *Faces and Facets: The Jews of Greece*, and as the director and one of the six photographers in the project ESPEJO: Reflections of the Mexican American. The Morrie Camhi Photograph Archive, in addition to all his published photographs and those pertaining to ESPEJO, includes his documentary series on California farm workers and his hometown of Petaluma, as well as a series of portraits of people who placed "ads" in the personal columns of Bay Area newspapers.

Ted Streshinsky, born in Harbin, China, in 1923 to Russian expatriate parents, emigrated after World War II to the U.S., where he graduated from the University of California, Berkeley, with degrees in journalism and political science. Beginning in the late 1950s Streshinsky turned to photojournalism. Working for most of the major magazines of the time, he created a body of work that documents the major events of the last half of the twentieth century. The most significant part of his archive consists of images that Streshinsky made in the San Francisco Bay Area as well as other locations in California

through the 1980s. His coverage of the politics and subculture of the 1960s includes a photo story on Ken Kesey and the Merry Pranksters with the writer Tom Wolfe for the *New York Herald Tribune* magazine, a topic Wolfe later wrote about in *The Electric Kool-Aid Acid Test*. Streshinsky also collaborated with Joan Didion, whose papers are in Bancroft's manuscript collection, on a piece that ran in the *Saturday Evening Post*, an article that later became the title essay of *Slouching Toward Bethlehem*, Didion's 1968 book.

Ted and his wife, the writer Shirley Streshinsky, spent their honeymoon in Delano, where Streshinsky stayed for weeks photographing César Chávez and the Farm Labor movement for the *Saturday Evening Post*. Other highlights from Streshinsky's archive include the Free Speech Movement in Berkeley, portraits of Bay Area artists and sports figures, and the documentation of dance companies in the Bay Area.

### Individual Themes and Series

For a variety of reasons, including subject, scope, the expense of storage, and the like, it is not always appropriate or possible to collect a photographer's archive in its entirety. Sometimes the better alternative is to collect comprehensive series of photographs that add depth to subject areas already present and for which there is a strong collecting precedent or to develop new collecting areas that represent important social and cultural changes that are still undocumented or under-represented in Bancroft. Thus, Betty Medsger's series of photographs documenting the evolution of the disabled community in Berkeley and San Francisco during the late 1970s and early 1980s augments the ongoing Disability Rights and Independent Living Movement Project, which consists of personal papers, organizational records, oral histories, books, sound recordings, and films.

The South of Market Redevelopment Project documents the San Francisco Redevelopment Agency's far-reaching urban renewal program, first drafted in 1959 and implemented throughout the 1970s; it is comparable to the 1915 San Francisco Panama

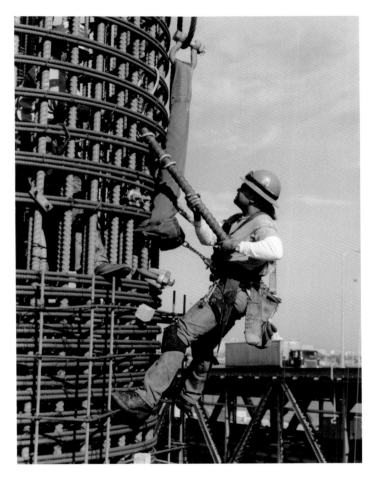

*Iron Workers Adjusting Column Cage, First Pier, New East Bay Span, San Francisco-Oakland Bay Bridge: KFM-HSBAR (Contractors). August 14, 2003. Photograph by Joseph A. Blum.*

Pacific International Exposition in the scope of its impact on San Francisco's urban, political, social, and economic landscape. To date, the visual record consists of three in-depth collections from three photographers. Ira Nowinski's No Vacancy Archive, more than 500 photographs, includes prints made from the Redevelopment Agency's historic negatives, the photographer's field notes, flyers, and ephemera from the TOAR organization (Tenants and Owners Against Redevelopment).

Janet Delaney's South of Market Survey focuses on the residents, especially the artists and businesses that were once part of a vibrant San Francisco neighborhood. Her survey consists of several hundred color enlargements made from large-format negatives, slide presentations, texts by Delaney and her collaborator Connie Hatch, and an audio archive of residents in the South of Market (SoMa) area.

Catherine Wagner's series consists of 19 large-format views of the construction of the Moscone Convention Center, which was the cornerstone building for the subsequent redevelopment of SoMa. Although Wagner's photographs of the Moscone Center have been shown extensively and are in the collections of a number of museums, several of her Moscone photographs, including 109 contact prints, are unique to the Pictorial Collection.

Unlike many of the photographs of the Black Panther movement that appeared in the media, the Steven Shames Black Panther Series is an intimate portrait of the Black Panther leadership, the rank-and-file membership, and the communities to which its members belonged. Shames not only documents the Panthers' highly publicized political protests but also the community and social programs that the movement initiated and supported in Oakland, California. The food and clothing giveaways, the educational programs, and the less sensational community actions that included merchant and product boycotts are all captured in the tradition of social documentary photography. PBS's "American Photography" web site named Stephen Shames along with Lewis Hine and Marion Post Wolcott as photographers whose work promotes social change. The acquisition of photographs from Shames's Black Panther archive is a significant addition to Bancroft's social protest collections, which contain the Eldridge Cleaver papers, the Rosalie Ritz courtroom drawings, the Social Protest Collection, and the Free Speech Movement archives.

Contemporary with Shames's work are Gene Anthony's photographs from his Summer of Love Archive, reproduced in *Time*, *Life*, *Playboy*, and numerous other publications. Filling a gap in Bancroft's historical record of San Francisco, they document many of the major "counter-culture" events in and around the San Francisco Bay Area in 1966 and 1967. Anthony captured the era with his photographs of the "Be In," the "Trips

Festival," and "Now Day." Included are musical groups such as The Grateful Dead, The Charlatans, and The Jefferson Airplane. The sexual revolution of the 60s is represented by The Cockettes and events such as "Nude Beach Days"; the psychedelic world, by hippies, the Haight-Ashbury, the Diggers, and the Merry Pranksters. Anthony also took compelling portraits of many of the dominant personalities of the era such as Ken Kesey, Timothy Leary, Sonny Barger and the Hells Angels, Jerry Rubin, and Bill Graham.

Photographers Cathy Cade and Clifford Baker document with different approaches the politics of gender and sexual identity, and the establishment of the Bay Area's gay and lesbian community. Cade's work focuses primarily on lesbian political and social protest with an emphasis on work equality, while Baker captures the celebratory aspects with his almost twenty-year series of photographs of the San Francisco Gay Pride Day Parade.

It is rare for Bancroft or for any repository of archival documents and records to be engaged in pro-active collecting. By definition, archival collecting is primarily a retrospective activity; documents and records come to the library usually well after an event has occurred. Often this means that the historical record has to be pieced together without the assistance of the participants and that the intellectual description and arrangement of the archival records is difficult and may be concluded only after labor-intensive research.

*Argonaut Brand California Selected Plums.* Chromolithograph. From the Schmidt Lithograph Company Records, between 1912 and 1929.

Joe Blum's proposal to create an archival visual record of two major infrastructure projects in Northern California—the Al Zampa Memorial Bridge over the Carquinez Straits and the new East Bay Crossing of the San Francisco-Oakland Bay Bridge—is an important strategic collecting initiative. A former secretary of the San Francisco chapter of the Boilermakers Union with advanced graduate work in UC Berkeley's Sociology Department and twenty years' experience as a practicing photographer specializing in labor processes, Blum brings a unique perspective to his work. This project, which began in 2004, will augment Bancroft's historical collections on the original Oakland Bay, Golden Gate, and Carquinez Straits bridges. It will also ensure that a high-quality documentary record of a major rebuilding of California's physical infrastructure will be available to the local and national research community and to the campus through the academic program of the University.

# At Work | *Land Grant Research and the Pictorial Collection*

ELISE BREWSTER

Over the past decade I have conducted research on the historical characteristics of the San Francisco Bay Area landscape as part of the Historical Ecology Program of the San Francisco Estuary Institute [SFEI]. Analyses of the pre-Euro-American landscape and its changes through time have formed the basis for the restoration of wetlands and streams throughout the region. As an artist for the Program, I have used The Bancroft Library's archives of maps, scientific records, and photographs as a major resource in this recovery process. For example:

- The collection's Mexican-California land-grant maps of the Bay Area provide an in-depth, multiple topography, with detailed views of lands held by families around the Bay. Such grant information was used to resolve property and boundary suits between Mexican landowners and new settlers.
- The land-grant maps are supported by Bancroft's substantial collection of photographs by Carleton Watkins, probably the most esteemed photographer of the nineteenth-century American West. In the years following statehood, to protect the ownership of legally contested land, Watkins was hired to photograph various land grants. Watkins also testified in court; for the first time, photography was used as courtroom evidence.

As one of the Institute's several practicing artist-researchers, I worked with SFEI scientist Robin Grossinger and Susan Schwartzenberg, a fellow artist and investigator, to collaborate on "BayBoards," a public billboard/artwork. For a site in Albany we chose a Watkins photograph near the Bay related to a land-grant case I had

discovered in Bancroft. We decided to reproduce the photograph—much enlarged—on a billboard positioned to fit the location that corresponded almost exactly with the view that Watkins had shot in 1861.

When California became a state, the families who held property had to go to court to defend their titles. These cases were often lengthy, both in years (sometimes into the twentieth century) and transcriptions (thousands of pages) and costly, often driving their claimants into bankruptcy. Each claimant had to produce the original title and the accompanying *diseño*, or sketch of the land at the time of the request. Often, additional surveys were required. The land-grant cases with their hand-drawn sketches of the land, worn leather bindings, and wax stamps are mesmerizing. The sepia pages of swirling penmanship that hold these early testimonies provide rich scientific detail because the grant boundaries were based on prominent landscape features: hills, creeks, and the Bay.

One of the most famous land-grant claims was that of the Peralta family for Rancho San Antonio—the greater portion of what we now know as the East Bay. Watkins was commis-

sioned to document the northern boundaries of the contested property. We read Watkins' court testimony and further appreciated the photographer's sensitivity and eloquence for the landscape. When pressed to determine the age of Cerrito Creek, a question he admitted to having no expertise on, he finally responded, "It is as old as the first rains upon the land."

Jack von Euw, curator of Bancroft's Pictorial Resources, showed Susan and me Watkins' original photographs, stored in big boxes bound in blue linen. We pondered Watkins' camera—a 24-inch glass plate framed in wood—and the effort he'd made in carrying it across the plains to photograph El Cerrito, a prominent hill by the Bay. We discovered that he had taken two shots from the same location. We were able to merge the two photographs into a larger view of the landscape and one totally appropriate to the wide billboard format. With some careful work to improve contrast for the brief "impression time" of the freeway viewer, Watkins' images reentered the landscape, 14 feet high by 48 feet wide, viewed by 48,000 people each day.

The billboard image reveals open grasslands with wildflowers and subtle details of the tidal marsh shoreline. On the north slope of the hill, now called Albany Hill, stands a grove of live oaks now partially hidden by a plantation of eucalyptus. Amid the now tree-enriched plain and the cacophony of freeways and bulging warehouses of the East Bay shoreline, the oak grove, the shape of the hill, and parts of the marsh still persist.

Brought into public view, Watkins' photography reveals an ever-changing dynamic between active remnants of the old landscape and alterations made over time. His work helps us envision what that landscape was and what this generation may help revive as testimony to this time and place.

As working artists, the public opportunity to make use of Bancroft's land-grant maps and pictorial resources was integral to creating and producing the billboard project. In addition to our partnership with Bancroft, the project was supported by a grant from the Creative Work Fund and partnerships with a suite of organizations, including The San Francisco Public Library, Viacom Outdoor Media, City|Space, the Lawrence Hall of Science, and SFEI.

*Elise Brewster is a Berkeley artist.*

# Collection Highlights

Ansel Adams. *Parmelian prints of the High Sierra*. San Francisco: Jean Chambers Moore, 1927

Mary Austin. *Taos Pueblo*. Photographs by Ansel Adams. San Francisco, 1930

The Bancroft Library Portrait Collection

Cased Photographs and Related Images from The Bancroft Library Pictorial Collections, bulk ca. 1845–ca. 1870

Jesse Brown Cook Scrapbooks Documenting San Francisco History and Law Enforcement, ca. 1895–1936

Mammoth Plate Landscape Photographs from the George Davidson collection, 1861

Photographs of the San Francisco Earthquake and Fire from the Charles Derleth Papers

*San Francisco Earthquake and Fire Album compiled by William Dickelman*. Contact prints from the original negatives by R.J. Waters

Arnold Genthe. *The San Francisco Earthquake and Fire of 1906*

The Rube Goldberg Pictorial Material

Construction Photographs of the Golden Gate Bridge

*Roy D. Graves Pictorial Collection*

Andrew Jackson Grayson. Watercolors of *Birds of the Pacific Slope*, 1853–1869

Johan Hagemeyer Photograph Collection

Chauncey Hare Photograph Archive, 1960–1984

Herman Herzog. *Yosemite Valley*, 1873

Robert B. Honeyman, Jr. Collection of Early Californian and Western American Pictorial Material

[*People Sitting at the Carousel, Playland at the Beach, San Francisco.*]
Photograph by Chauncey Hare, between 1968 and 1975.

This photograph was made by Chauncey Hare to protest and warn against the growing domination of working people by multi-national corporations and their elite owners and managers.

Henry J. Kaiser Pictorial Collection, 1941–1946

C. Hart Merriam Collection of Native American Photographs, ca. 1890–1938

*Charles C. Moore Albums of Panama Pacific International Exposition Views*, 1910–1915. Photographs by Cardinell-Vincent Co

Eadweard Muybridge. *Lone Mountain College Collection of Stereographs*

Eadweard Muybridge. *Panorama of San Francisco from California St. Hill*, 1878

Eadweard Muybridge. *Valley of the Yosemite, Sierra Nevada Mountains, and Mariposa Grove of Mammoth Trees*, 1872

Ira Nowinski. *No Vacancy Archive*, 1974–1981

*Oliver Family Photograph Collections*. Compiled by William Letts Oliver, 1844–1918, and son, Roland Letts Oliver

*Stereoviews of Indians and the Colorado River from the J.W. Powell Survey*, ca. 1869–1874

Granville Redmond. *Landscape with Poppies*, 1925

San Francisco News-Call Bulletin
Newspaper Photograph Archive,
1914–1964

Construction Photographs of the San
Francisco-Oakland Bay Bridge,
1931–1936

Adolph Schwartz. *The Town of Bear
Valley, Mariposa Co. [Calif.]*, 1859

Sierra Club Photograph Albums (Note:
Many albums in the collection are by
Ansel Adams.)

*Souvenirs de la campagne du Mexique de
1861 à 1867*

I. W. (Isaiah West) Taber, *Souvenir of
the California Midwinter International
Exposition : / presented to F.A. Haber,
chief of the Viticulture Department,
San Francisco*, 1894

Taller de Gráfica Popular collection.
Mexico City, 1937–

*Michelle Vignes Photograph Archive*,
1964–1994

Edward Vischer. *The Mission Era:
California Under Spain and Mexico and
Reminiscences*, completed 1878

War Relocation Authority Photographs
of Japanese-American Evacuation and
Resettlement

Carleton E. Watkins. *Hearst Mining
Collection of Views*, 1871–1876

Carleton E. Watkins. *Mendocino Coast*,
1863

Carlton E. Watkins. *Photographic views
of the Golden Gate Mining Claim [and
the Golden Feather Mining Claim]
situated on Feather River, Butte County,
California*, 1891

Carleton E. Watkins. *Mammoth Plate
Photographs of Yosemite Valley*, ca.
1878–ca. 1881

*[Carousel with "Tickets Only" sign,
Playland at the Beach, San Francisco.]*
Photograph by Chauncey Hare,
between 1968 and 1975.

This photograph was made by Chauncey
Hare to protest and warn against the
growing domination of working people by
multi-national corporations and their elite
owners and managers.

# Rare Books and Literary Manuscripts

Anthony S. Bliss, CURATOR

## Collection Profile

*Chronology*    Second millennium BC to the present

*Subject Areas*
- Western European literary and historical works with emphasis on the Middle Ages, the Renaissance, and the Enlightenment
- American literature from the eighteenth century to the present with special emphasis on California authors, African American writers, and the San Francisco Beats
- The history of books and printing, including private presses, fine printing, and fine bindings
- Theater collections (European and American, principally play texts)
- American wit and humor (nineteenth century)
- French revolutionary pamphlets. Smaller focussed collections deal with tobacco, coffee and tea, Hermann Hesse, the Yoruba tribe of Nigeria, and the Latin poet Horace.

*Formats*    Printed books and pamphlets, manuscripts and archives, typographical artifacts (including printing presses, type, papermaking equipment, and binders' tools), pictorial material, printed ephemera, posters

FROM PHARAOHS TO BEATNIKS, the Rare Book Collection presents research opportunities spanning 3000 years of written records. Medievalists, Renaissance specialists, Enlightenment scholars, and literary critics and historians come to Bancroft from around the world to use its unique assemblage of sources. A clay tablet, a fragment of papyrus, manuscripts on vellum or paper, printed books and pamphlets, typescripts, or mimeographed documents—any of these formats may find their way to the Bancroft Reading Room.

UC Berkeley was one of the last major American university libraries to establish a Rare Book Department. It was not as if the University didn't have any rare books. The Doe Library had had a Case R (rare) and a case B (medium rare) for many years. In 1948, University Librarian Donald Coney appointed a Special Committee on Rare Book Policy,

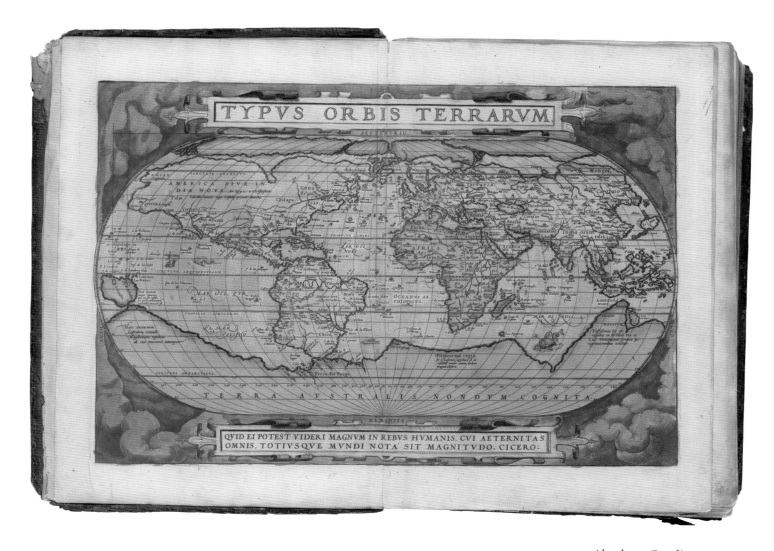

Abraham Ortelius.
*Theatrum orbis terrarum.*
Antwerp: A. Coppenius,
1574.

which, reporting back in April of the following year, stated that "the Library has accumulated, without sound policy and often without design, a collection of rare books housed in Cases B and R and presumably has many unrecognized in the general stacks" and continued, "the Committee is of the opinion that this Library should give attention to the collecting of rare books and manuscripts for scholarly purposes." This recommendation eventually led to the establishing of a Rare Book Department in the Main Library in 1954.

The Department limped along through the 50s and 60s with insufficient staff, space, and funding. The core of the collection had been formed prior to its establishment by gifts of Phoebe A. Hearst, Albert M. Bender, and James K. Moffitt, the John Henry Nash Library, Professor Henry Morse Stephens' Kipling and Omar Khayyam Collections, the Tebtunis Papyri, and a miscellany of other donations and bequests.

By 1968, it was apparent that the Rare Book Department was not meeting expectations. University Librarian James Skipper asked Herman Liebert of Yale's Beinecke Library to survey the situation and make recommendations. The Liebert report (February 1969)

"The Apocalypse." Hartmann Schedel. *Nuremberg Chronicle.* Nuremberg: Anton Koberger, 1493.

This is the most lavishly illustrated book of the fifteenth century. The text begins with Genesis and runs to the end of the fifteenth century, omitting any mention of Columbus but including the Apocalypse. The 1800 illustrations were printed from only 600 woodblocks, so many are repeated: the same block was used for different cities, and Old Testament kings reappear as medieval emperors. On the engaging theory that history was not over, six pre-numbered blank pages were included for the owner to continue the chronicle. —*A. S. B*

recommended the merging of the Department with The Bancroft Library: "Because of the strong intellectual and bibliographic relationships between the Bancroft Library and the Department of Rare Books and Special Collections, the two would be mutually strengthened by an appropriate physical and administrative relationship." James D. Hart, professor of English, former Vice Chancellor, and the Chair of the 1948 Special Committee, also reacted positively to the Liebert report. On January 1, 1970, Hart was named the new director of Bancroft/Rare Books.

The hopes of Skipper and Hart were realized in the following years. Endowments for collections were established, collecting policies were refined, the Rare Book Collection was finally catalogued, usage increased markedly, and by the mid-1980s we were fully engaged in converting the catalogues into machine-readable form.

We never stop collecting. Additions to the collections come in as gifts, by bequest, or by purchase. Many acquisitions are targeted at particular campus research interests, and purchase decisions are often made in consultation with faculty members. This is what I call "laying track in front of the scholarly locomotive." Established areas of specialization are regularly augmented, but Rare Books is open to new subjects as well. It would be a disservice to future scholars for the institution to limit its acquisitions to traditional fields. The generosity of donors may also propel us into new collecting areas, just as Norman Strouse's gifts launched Bancroft into the collecting of fine bookbindings. Twenty to fifty years from now, the collections outlined below will still be important, but they will be joined by others as yet unimagined that will further enhance Bancroft's scope and bolster its importance for teaching and research.

Generally, the Rare Book Collection avoids the fields of law, medicine, music, architecture, and non-European languages, which are well covered by other special collections on the Berkeley campus. Because of our conviction that scholars and students need to consult the actual artifact, not just reprints, fac-

*"How King Leire was driven out of his land through his folly and how Cordelle his youngest daughter helped him in his need."*

*Brut Chronicle* (England, circa 1450).

The *Brut Chronicle*, first written in Latin in the early twelfth century by Geoffrey of Monmouth, tells the legendary history of the kingdom of Britain. It introduced the Arthurian legends into both English and French literature. In the course of the thirteenth century, the London Chronicle was appended to the English translation of the text, and the *Brut Chronicle* in its expanded form remained popular into the sixteenth century. Shakespeare drew on the text for the basic plot of *King Lear*. —A.S.B

*La Grande Danse Macabre*.

Troyes: Pierre Garnier,

[not after 1728].

*The Dance of Death*, a well known medieval text, is one of a series of chapbooks called the "Bibliothèque Bleue"; this copy was published in the first quarter of the eighteenth century but with fifteenth-century iconography. Printed on cheap paper from the mills of Troyes in France and originally issued in blue wrappers, these editions were sold all over France and to readers from all levels of society. This copy of the *Danse Macabre* belonged to the mistress of Louis XV, Madame de Pompadour, with her arms stamped in gold on the covers. —A.S.B

Virgil. *Opera*. Venice: Aldus Manutius, 1501.

A noted scholar with connections in humanist circles all over Europe, Aldus Manutius (1449–1515) set up a press in Venice in 1494 to print Greek and Latin classical texts. Aside from his carefully edited texts, he is famous for two innovations: the pocket book and italic type. His 1501 edition of Virgil's works is the first book printed entirely in italic. The small format of his pocket books and the use of space-saving italics made the publications less expensive without sparing on legibility or scholarship. —*A. S. B*

Eusebius of Caesarea, Bishop of Caesarea, ca. 260–ca. 340.
*De euangelica præparatione.* [Venice]: Nicolas Jenson, 1470.

In 1470, Nicolas Jenson introduced his new roman type based on contemporary Humanist scripts. His is the Godfather of all roman types, the inspiration of every roman typeface to date. Jenson roman has never been equaled for beauty, legibility, and versatility. —*A. S. B*

similes, microfilms, or digital images, we maintain a commitment to collecting original materials in whatever format they were created. In broad outline, the Rare Book Collection continues to build on significant collections of such originals in the following areas:

Nearly 300 medieval codices and more than 400 fifteenth-century printed books (incunabula, books from the "cradle years" of printing) offer a significant resource for both teaching and original research in medieval and early modern Europe. Early acquisitions through gifts of Regents Phoebe Apperson Hearst and James K. Moffitt were the springboard to this collecting area. Theology and classical texts in Latin and Greek are well represented, but French, Spanish, Italian, and English vernacular texts draw much more attention from researchers worldwide. Supplementing the holdings of original materials for this period is a collection of nearly 350 published facsimiles of medieval manuscripts.

The collection of Renaissance and early modern history and literature was established with acquisitions that predated the founding of the Rare Book Department (for example, the Karl Weinhold German collection in 1904, the Burdach/Bremer library purchased in 1938, the Fontana and Trevisani collections of Italian culture from 1924–1930, the Juan C. Cebrián collection of Spanish books, 1912–1935). Building on this propitious

[Jonathan Swift].

*Travels into several remote nations*
*of the world. In four parts. ...*
By Lemuel Gulliver.... London: Printed for
Benj. Motte, 1726.

What we now call *Gulliver's Travels* was really a
hoax. The book looks just like dozens of other
eighteenth-century travel narratives with its
portrait of the author (Gulliver) and four maps. One
map shows Brobdingnag jutting out from the coast
of California like a polyp. The map is mostly blank
but includes such place names as New Albion, Sir
Francis Drake Bay, Monterey, and Mendocino. Swift
looked at a map of the world for the blank spaces,
*terra incognita,* and that's where he put his fictional
lands. *Gulliver's Travels* is satirical not only in its
intent but in its presentation. —*A.S.B*

Joan Blaeu. *Tooneel der steden van de Vereenighde Nederlanden....*
Amsterdam: J. Blaeu, [1649].

This Dutch atlas of the entire Low Countries includes views of every town, burg, and city
beautifully printed from etched copper plates. It was published in two volumes—one for
what is now Holland, the other for what is now Belgium—by one of the greatest Dutch
cartographers, Joan Blaeu, in the same year that the Low Countries won their independence
from Spain in the treaty of Westphalia. It has always seemed to me that these maps would be
a national security risk. In the plan of Antwerp, you can pick out just about every house, but
also all the fortifications, moats, even the gun emplacements and details of the port. —*A.S.B*

It's always fascinating to put things
of the same era next to each other
and see what they tell us. The book
is a microcosm of what is going on.
Yes, it's true, a lot of stuff deserves
to disappear, but you will hear much
argument about what when you get
down to specifics. In the sixteenth
century collection, we collect any-
thing we can get our hands on. In the
eighteenth and nineteenth centuries,
we find a huge boom in printed
material and a consequent need to
focus acquisitions. There is no way to
collect it all. I once submitted a pro-
posal—one that did not fly—where
Bancroft would collect everything
printed in one decade: books, laundry
lists, railroad timetables, pornogra-
phy, political and religious tracts, all
manner of ephemera. The idea was
to provide a paper snapshot of a par-
ticular period. I proposed the 1850s
in England. Once organized and pro-
cessed—and that presented some
problems—the collection would
serve any number of kinds of schol-
ars and faculty departments: history,
religion, criminology, and so on. The
idea finally died because none of us
could decide which decade to docu-
ment! This proposal does represent
an idea where acquisitions were to
have been driven by Bancroft and
not—as with specific portions of the
collection—by a particular branch of
the faculty. —*Anthony S. Bliss.*

Bernard Despreaux.
*Manuscript diary.*
Paris, 1792–1798.

This handwritten diary gives
an eyewitness account of the
worst years of the French
Revolution. Its author was
both a devout Catholic and a
royalist, dangerous attributes
in Revolutionary France.
Portions of the text are
written in code—actually a
replacement cipher—which
I was able to break. The first
passage decoded was a lament
over his lost love, Emilie;
others are urgent letters to the
king. —*A. S. B*

beginning, additions continue to be made in Italian, French, Spanish, and German texts as well as in the work of the great scholar-printers like Aldus Manutius (Venice), the Estienne family (Paris and Geneva), Froben (Basel), Plantin (Antwerp), and the Elzevirs (Amsterdam and Leiden). An especially rich resource is the Fernán-Núñez Collection: 225 manuscript volumes, most dating from 1500 to 1700, that once belonged to the Dukes of Fernán-Núñez in southern Spain. The collection, purchased with the help of the Chancellor's Office and Summer Sessions income in 1984, is rich in unpublished Spanish and Portuguese literary, political, diplomatic, and historical texts. Publications and manuscripts of the members of the seventeenth-century German learned society, the Fruchtbringende Gesellschaft, are another special strength. This collection was assembled by Swiss scholar Martin Bircher, director of the Bibliotheca Bodmeriana in Geneva, and purchased for Bancroft *en bloc*.

Many hundreds of European maps and atlases complement the print and manuscript collections. The core of these holdings is formed by the Alfred H. DeVries collection acquired in 1972.

Focussing on Diderot's *Encyclopédie*, its publication, and the controversies surrounding the *philosophes*, the European Enlightenment collection is particularly strong,

especially for the second half of the eighteenth century. A major collection documenting the German Swiss contributions to the Enlightenment, also assembled by Martin Bircher, was acquired in 2005 to add another perspective to what has been mostly a French collection. Politics, philosophy, education, science, polemics about women, and social mores are all included in this collecting area.

The French Revolution, arguably a consequence of the intellectual upheavals of the first eight decades of the century, has been a major concentration of the Rare Book Collection since the first acquisition, the Ledru-Rollin collection, in 1923, the gift of Mark Requa. With other acquisitions since then, the collection totals nearly 10,000 Revolutionary-era pamphlets supplemented by periodicals, contemporary monographs, posters, and manuscript material, making it one of the richest such collections outside of Paris's Bibliothèque nationale.

Horace is by far the best-represented classical author (with more than 250 editions, manuscript and printed, ranging in date from 1300 to 1800). The works of Horace were a particular passion of UC Regent James K. Moffitt, whose gift in 1956 launched this collecting area. Ovid and Virgil are also well covered. The classics collection is particularly good for demonstrating the transition from medieval to Renaissance scholarship, interpretation, and presentation of ancient texts.

Bancroft holds a broad chronological range of the works of English authors, from fifteenth-century manuscripts of the *Brut Chronicle* and John Lydgate's *Fall of Princes* to the latest manuscripts of John Mortimer (*Rumpole of the Bailey*) in the twenty-first. Elizabethan and Jacobean printings are well represented, including all four Shakespeare folios and both folios of Ben Jonson. The Shakespeare first folio (1623) was Berkeley's

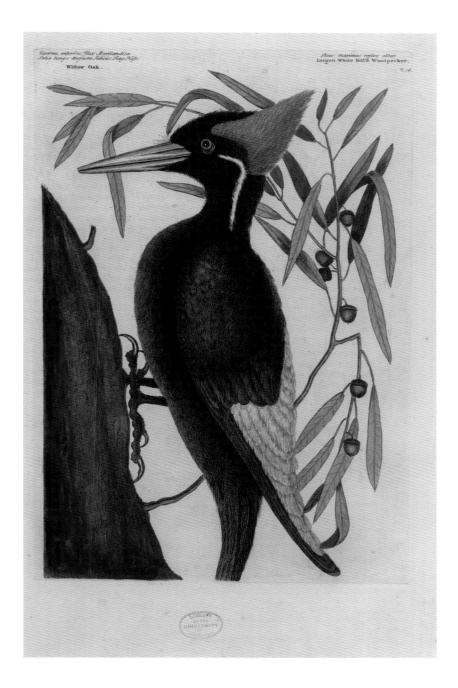

Mark Catesby. "White Billed Woodpecker." Hand-colored etching, from *The natural history of Carolina, Florida and the Bahama islands….* London: Printed at the expense of the author, 1731–43. 2 volumes.

# On Paper versus Electronic Media

As a curator, I am not worried about the fifteenth century. I am much more worried about forms of preservation in the twentieth and twenty-first centuries. Digitization is a fragile medium. It is ephemeral and hard to preserve. The technology keeps evolving. You can skip one generation in either hardware or software programs, but no more than that. DVDs, CDs will not be worth a damn in 25 to 30 years. I have a box of fifty 5¼-inch discs on my desk and not one computer in the place that can use them. We have a similar problem with wire and tape recorders. Even if we preserve the technology, soon there will be no technician knowledgeable or affordable enough to fix it.

We also have the phenomenon of books and articles being "born digital." There is no paper manifestation. The work is viewed only on the monitor screen. With the screen we have abandoned the codex and the book and are back to the scroll. One of the immediate problems for the scholar or the reader is thus one of authenticity. With hackers able to invade practically any system—unlike paper—there is no way to verify an original document. A web-based critical citation, for example, may totally disappear within a year of its reference. To top it off, as a collection, when the operating system changes, we will continue to have a preservation problem

On the manuscript side of acquisition, we lose evidence. Emails and digital revisions are lost or erased. In Maxine Hong Kingston's archive, for example, we have nine versions of her novel, *China Men*—an invaluable resource for present and future scholars. With writers composing on the computer, however, revision as an aid to critical study may be a lost art. Though a writer can still preserve the content of emails and final drafts, it is not the same kind of documentation. For those kinds of preservation purposes—including their emails—we tell people to print or photocopy materials on good bond paper so that acids will not cause them to fall apart. —*A. S. B.*

two-millionth volume in 1955, the gift of San Francisco's Crocker family. The Milton collection is remarkably strong, and there are very good eighteenth-century holdings. For the nineteenth and twentieth centuries, the collections focus more on particular authors than on breadth of holdings. Especially significant collections for this later period include Percy Bysshe Shelley (the Roger Ingpen collection, acquired in 1951), Thomas Hardy, Rudyard Kipling, Joseph Conrad, D. H. Lawrence, and Stephen Spender. The Spender and Mortimer collections were acquired thanks to the authors' personal friendship with former director James D. Hart.

Largely at the insistence of Hart, the Rare Book Collection from its inception in 1954 emphasized the manuscripts and published work of many authors associated with California. Hubert H. Bancroft had ignored California literature in his collecting, so the merger of Rare Books with Bancroft filled a significant gap in the collections. With one stroke of the administrative pen, the merged collections now prided themselves on extensive holdings of Bancroft's contemporaries Ambrose Bierce, Bret Harte, Frank Norris, Gertrude Atherton, Ina Coolbrith, and later authors such as Gertrude Stein and her circle, Robinson Jeffers, and William Everson. Continuing this collecting thrust, more recently we have added the books and papers of Yoshiko Uchida, Joan Didion, Maxine Hong Kingston, and a great number of San Francisco Bay Area poets.

Charles Dickens.
*The personal history of David Copperfield.*
With illustrations by H. K. Browne.
London: Bradbury & Evans, 1849–1850.

Before Dickens' novels were published as complete volumes, they were issued in monthly parts, a marketing ploy common in Victorian England: it was easier for the public to purchase one part a month for a shilling than to shell out a pound all at once. Literature on the installment plan! Each part came with two illustrations, 32 pages of text, and several pages of advertisements. Seeing "Dickens in parts" gives the reader a real sense of what it was like to read a Dickens novel when it was new. —A.S.B

The San Francisco Beat scene of the 1950s and 1960s has become more of a collecting priority as its creators grow older. The anchor of the collection is the archive of the City Lights Publishing Company. To it we have added the papers of Lawrence Ferlinghetti, Michael McClure, David Meltzer, Philip Whalen, Philip Lamantia, Ted Joans, ruth weiss, Richard Brautigan, and smaller manuscript collections of many other authors. To complement our unparalleled holdings of literary archives, the library has recently managed to acquire the papers of several artists (Joan Brown, Jay DeFeo, Bruce Conner) to give a fuller picture of the Beat world. In addition to thousands of printed books and pamphlets, scarce periodicals (for example, *Semina* complete), ephemera, and artwork add further depth to an extraordinary resource.

Bancroft is also very strong in post World War II Bay Area poetry (Robert Duncan, Jack Spicer, Josephine Miles). Professor of English Robert Duncan began serving as the collection advisor for the "Bancroft Poetry Archive" in 1965. Other American literature collections include African-American writers (Gwendolyn Brooks, Langston Hughes, Eldridge Cleaver), and American wit and humor (predominantly nineteenth-century material from Davy Crockett Almanacs to Mr. Dooley), the collection formed by Theodore Koundakjian and acquired by purchase and gift over several years beginning in 1970.

Bancroft has major holdings in theater and dance, especially of play texts. Of special

85

of the DAO in Saigon before the last helicopter
left was three-and-a-half million dollars American
and eighty-five million piastres.  The code name
for this operation was MONEY BURN.  The number
of Vietnamese soldiers who managed to get aboard
the last American 727 to leave Da Nang was three-
hundred and thirty.  The number of Vietnamese soldiers
to drop from the wheel wells of the 727 was one.
The 727 was operated by World Airways.  The name
of the pilot was Ken Healy.

I read such reports over and over again, fixed
in the repetitions and dislocations of the breaking
story as if in the beam of a ~~derailed~~ *runaway* train, but
I read only those stories that seemed to touch,
however peripherally, on Southeast Asia.  All other
news receded, went unmarked and unread, and, ~~had~~ *if*
the first afternoon story about Paul Christian
killing Wendell Omura not been headlined CONGRESSIONAL *had*
FOE OF VIET CONFLICT SHOT IN HONOLULU, I might
never have read it at all.  Janet Ziegler was not
mentioned that first afternoon but she was all
over the morning editions and so, photographs in
the Chronicle and a separate sidebar in the New
York Times, VICTOR FAMILY TOUCHED BY ISLAND TRAGEDY,

Corrected manuscript page from Joan Didion's *Democracy*, 1984.
A 1956 graduate of Berkeley, Ms. Didion has presented the Library with the original
manuscripts and related materials for her works since 1981.

note are Italian plays of the sixteenth and seventeenth centuries, French and English eighteenth-century texts, and Spanish eighteenth- to early twentieth-century drama, through the outbreak of the Civil War in 1936. Bancroft is actively pursuing the acquisition of the archives of Bay Area theaters; those of Theater Rhinoceros and The Magic Theater have been recently acquired.

Bancroft is especially interested in documenting the history of books and printing. The collection includes important examples of printing techniques and landmarks in the history of publishing (from eighteenth-century chapbooks and nineteenth-century dime novels to sumptuous deluxe editions). The Strouse Collection on the Art and History of the Book—still growing thanks to the endowment created by Norman H. Strouse, former president of the J. Walter Thompson advertising agency—features more than 900 fine bindings, private press books, and typographical landmarks.

In addition, Bancroft maintains the "BART" (Book Artifacts) Collection documenting the history and technology of writing and printing from hieroglyphics and cuneiform writing to type, punches, matrices, presses, woodblocks, copperplates, and desktop publishing. BART even includes the last full box of carbon paper found in the library so that future generations of emailers can understand what it really means to "carbon" someone, as well as an Apple II computer, one of the landmark machines in personal computing.

Bancroft's Press Room houses all the equipment necessary for letterpress printing. On Friday afternoons, half a dozen students gather there for our course, "The Hand Printed Book in Its Historical Context." They receive an introduction to the history of books, printing, and typographic design by viewing and discussing items from Bancroft's collection. They also learn to set type by hand, producing each semester a substantial pamphlet, usually

Maxine Hong Kingston. *China Men*. New York: Knopf, 1980.

based on a manuscript from the Bancroft collection, under the guidance of master printers Les Ferriss and Peter Koch. The printing is done on Bancroft's 1856 vintage Albion hand press. There is no final examination, but 35 copies of the pamphlet must be sewn up and on my desk by the last day of class. Student evaluations of this course range from enthusiasm to ecstasy.

This class continues a long and proud tradition of fine printing in California going back to Edward Bosqui (1832–1917) and Charles Murdock (1841–1928). The Bay Area especially has been home to many of the most distinguished printers of the twenti-

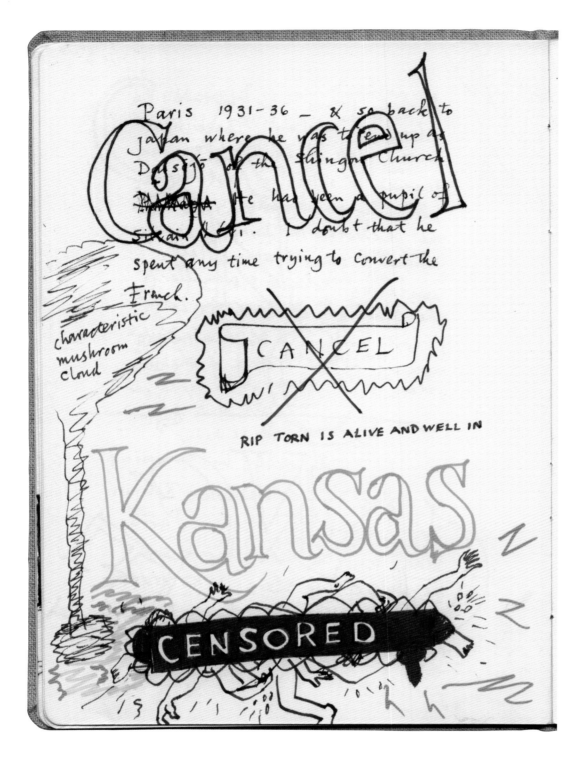

Philip Whalen.
Kyoto Notebook, 1969.
Philip Whalen Papers.

eth century. The Bancroft collection contains nearly complete holdings of such notable private presses as Grabhorn, Lewis and Dorothy Allen, John Henry Nash, Adrian Wilson, Greenwood, Auerhahn, Arion, and many more. British and European private presses from the eighteenth century to the present are also well represented. The holdings of the Kelmscott, Doves, Ashendene, and Gregy-nog presses are virtually complete. Documentary archives of several of these presses—most significantly T. J. Cobden-Sanderson's Doves Press—also form part of the collection.

As part of a University-wide program, the publications and archives of California feminist presses have recently become a collecting focus. Sexual orientation and social conflict is another new collecting area established to document the history and current status of gay, lesbian, and transgender Americans. These new programs are a tangible response by The Bancroft Library to evolving conditions in American society and to the interests of students and scholars.

This overview of major areas of the Rare Book Collection omits many smaller, spe-

cialized collections. I grudgingly resist the temptation to describe our holdings dealing with tobacco, coffee, tea, and chocolate (the gift of Joseph M. Bransten, 1972), gastronomy, Hermann Hesse, Omar Khayyam, the Yoruba tribe of Nigeria, twentieth-century war posters, Hebraica, the Pahlavi Archive (sixth- to ninth-century Persian documents and seals), travel guidebooks, and many others.

It is a source of pride for Bancroft staff to see the Reading Room full of researchers—a visible sign of success. Bancroft welcomes scholars from around the world to use its extraordinary collections, but the opportunities for Berkeley students are especially great. Right here in their own back yard, they have access to books and documents that would not be available to them in many other rare book libraries. Many college and university rare book collections receive little use, but Bancroft actively promotes its holdings with liberal access policies, on-line catalogues, publications, exhibitions, class sessions in library seminar rooms, and personal communication with potential users, class-by-class and reader-by-reader. In fact, we urge our students to come to Bancroft for their projects or at least to get a sense of what it means to do research with primary source material. We make a special effort to introduce students and faculty to the strength and depth of the collections and to the various opportunities they provide for research at all levels, from freshman term papers to doctoral dissertations. Part of this process involves demystifying rare books and manuscript collections so that they are perceived as essential research material and not as intimidating museum pieces. The obvious enthusiasm of a student when first working with a fourteenth-century French manuscript of *Lancelot*, or Dickens' *The Pickwick Papers* in the original parts, or the manuscript of D. H. Lawrence's *Sons and Lovers* amply repays the librarian's effort. The excitement of the real is the fullest justification of our dedication to rare books and manuscripts. For those students who may go on to professional careers involving original research, this exposure to real documents, ancient or modern, is crucial to their development. Even for the students who may have only their Bancroft experience as a bridge with the past, the thrill and excitement of working with the actual books and manuscripts enriches them for a lifetime.

## In Class

In Bancroft seminars, one of our intentions is to study the impact of technology and the economics of book production on the text, and what the artifact tells us about its text, its times, its author, its readers, its use, and its audience. Every aspect of the artifact contributes. A first printing shows you how a manuscript was presented. The physical layout, size, dimensions, heft of the volume tell you something about who it was intended for and how it was used. Large script could be read by flickering torch light in a dank castle. That tells you it was not for private reading but for public reading as an instrument for performance—no pictures, gold initials but not an illuminated text. In any copy you want to determine who owned it and when. —A.S.B.

Portrait of the young Gwendolyn Brooks. Gwendolyn Brooks Papers.

Jack Spicer. *Beowulf*.

Notebook with translation,

circa 1946–1947.

Jack Spicer Papers.

# At Work | *Jack Spicer*

KEVIN KILLIAN

Jack Spicer was a San Francisco poet who died young, at age 40, in 1965. When he died intestate, he left behind a trunk crammed with papers. His family, led by his younger brother Holt, agreed to entrust the papers to Spicer's literary executor, the poet Robin Blaser, who from Vancouver edited the important volume *The Collected Books of Jack Spicer* (1975) and has been assisting Spicer scholars ever since its publication.

Holt Spicer and Robin Blaser have made a gift of the Spicer papers to The Bancroft Library. Spicer, who graduated from the University of California, Berkeley, in 1947, continued to work there in the 1950s and 1960s. These new holdings solidify Bancroft's already significant Spicer collection, established in the years since the poet's death.

The new archive consists of several thousand pages of manuscript in notebooks, ring-leaved binders, tattered folders, and single sheets. Spicer saved the letters of many of his correspondents, and after his death the estate solicited the return of Spicer's letters. Dozens of them are included in the collection, and in many cases both sides of the correspondence are available. His term papers and student projects survive, as does a translation of *Beowulf*, and the manuscript for

Jack Spicer. *Clouds*.

Typescript,

circa 1959–1961.

Jack Spicer Papers.

an unfinished detective novel from 1958 (posthumously published in 1994 as *The Tower of Babel*). A dramatic version of Nathaniel Hawthorne's famous story "Young Goodman Brown" has survived, as well as several other plays of varying length. Most importantly, we now have the manuscripts of many of Spicer's finest poems, and a significant number of previously unknown poems that vary in quality, but the best of them are as good as anything he ever published. Spicer's most characteristic form was the "serial poem," an assemblage of linked poems on a common theme. We are pleased to have found a number of such poems, including a long sequence on Helen of Troy that parallels in some ways his poem "Billy the Kid," substituting a classical myth for a Western one.

The poet Peter Gizzi (University of Massachusetts, Amherst), who has edited a volume of Spicer's lectures and critical prose, is now the general editor of a projected four-volume edition of Jack Spicer's writing. Peter and I are editing a book of the poems, and Kelly Holt (University of California, Santa Cruz) and I are editing Spicer's letters. Aaron Kunin of Duke University is editing the plays. With the encouragement of Blaser and of Anthony Bliss, Curator of Rare Books and Literary Manuscripts, we have been working at The Bancroft Library continually since June 2004 on this extraordinary archive.

Spicer has been known as the "poet of dictation," yet we find that the published poems sometimes took tortuous courses of revision and juxtaposition before reaching final form. In the future, we will see, perhaps, not the Jack Spicer of legend—the damned poet struck by poetic lightning —but Spicer the craftsman, never satisfied with what he had written, always seeking the next turn round the bend.

*Kevin Killian is a well-known poet, novelist, playwright, and actor. With Lewis Ellingham, he is the co-author of* Poet Be Like God: Jack Spicer and the San Francisco Renaissance *(Wesleyan University Press, 1998).*

Jack Spicer. *Billy the Kid Poster*. 1958.
Jack Spicer Papers.

# Collection Highlights

## Pre-medieval

The Pahlavi Archive. Manuscript documents and clay seals from pre-Islamic Persia, 6th–9th centuries

## Medieval Manuscripts

The Heller Hours. Illuminated book of hours. England, ca. 1450, in a fine early binding

*Amadís de Gaula*. Spain, ca. 1420. Fragments of the only known MS of this prototypical romance of chivalry

Christine de Pisan and Gonthier Col. *Le Débat du Roman de la Rose*. 15th century. From the library of the Duke of Berry

*La Vie des Pères*. France, late 13th century. With other vernacular texts

*Brut Chronicle*. England, mid 15th century. Arthurian legends and London chronicle

Rashi. [Perush Rashi al ha-Torah]. Italy, 14th century. On vellum

Wycliffite Bible. New Testament (Middle English). England, 14th century ex. On vellum, in a splendid Tudor binding

## Incunabula

Colonna. *Hypnerotomachia Poliphili*. Venice: Aldus, 1499. 3 copies

Schedel. *Nuremberg Chronicle*. Nuremberg: Koberger, 1493. 4 copies, 3 in Latin, 1 in German

Eusebius of Caesarea. *De euangelica præparatione*. Venice: Jenson, 1470. Introduces Jenson's great Roman type

Pliny, the Elder. *Naturalis historia*. Venice: Jenson, 1472

Ludolf von Sachsen. *De vita Christi*. Lisbon: Valentim Fernandes and Nicolaus de Saxonia, 1495. First book printed in Portugal

Aristophanes. *Aristophanis comœdiae novem*. Venice: Aldus, 1498. Louis XVI's copy

Book of hours. Paris: Philippe Pigouchet [for Simon Vostre], 1497. Printed on vellum

Cardinal Bessarion. *In calumniatorem Platonis*. Rome: Sweynheym and Pannartz [before 13 Sept. 1469]. By the first printers in Italy

## Renaissance

Virgil. *Opera*. Venice: Aldus, 1501. First book printed in italic type

*Teuerdank*. 3rd ed. Augsburg: Schonsperger, 1519

Coverdale Bible (English). [Marburg?: Cervicornus and Soter?], 1535

Bible. N.T. (English). William Tyndale translation. [Antwerp?: S. Cock?], 1536

Bible. N.T. (Greek). Paris: Estienne, 1550. First Bible with chapter and verse numbering

Bible. Polyglot. 6 vols. Alcalá de Henares: Brocar, 1514–1517. Hebrew, Greek, Latin, Chaldaic texts

MSS of the Dukes of Fernán-Núñez. 225 volumes, mostly Spanish and Portuguese, fifteenth-seventeenth centuries

## Seventeenth and Eighteenth Centuries

The four Shakespeare Folios (London, 1623, 1632, 1663, 1685)

Miguel de Cervantes. *Don Quixote*. 2nd ed. Valencia, 1605, 1616

Fruchtbringende Gesellschaft. MSS and publications (1400 items)

Joan Blaeu. *Le Grand atlas*. 12 vols. Amsterdam, 1663

Bibliothèque Bleue (Troyes). French chapbooks. 93 vols. 1664–1809

John Milton. *Paradise Lost*. 1st ed. (1667, 5 states) and 2d–4th eds. (1674, 1678, 1688)

Anne Bradstreet. *Several poems....* 2nd ed. Boston: J. Foster, 1678

Philip Dormer Stanhope, 4th Earl of Chesterfield. Diplomatic papers, 1720–1748. 44 vols

Giovanni Battista Piranesi. *Opere*. [Rome, etc., 1756?–1807]. 27 vols

Denis Diderot et al. *Encyclopédie*. 1st ed. Paris: Briasson, etc., 1751–65. 39 vols

French Revolutionary pamphlet collection

## English Literature

Mary Shelley. *Frankenstein*. 1st ed. 3 vols. London, 1818

John Keats. *Lamia, Isabella, The eve of St. Agnes, and other poems*. 1st ed. London: Taylor and Hessey, 1820

Charles Dickens novels in monthly parts (8 titles)

Rudyard Kipling collection

William Butler Yeats. Books and correspondence

D. H. Lawrence collection, ca. 1906–1929. MSS and drawings

Stephen Spender Papers, 1931–1967

## American Literature

Frank, Kathleen, and Charles Norris Papers

Ambrose Bierce Papers

Gertrude Atherton Papers

William Everson Papers

Joan Didion Papers

Maxine Hong Kingston Papers

City Lights Publishing Company Archives

Lawrence Ferlinghetti Papers

Michael McClure Papers

Philip Whalen Papers

Philip Lamantia Papers

## African American Writers

Phillis Wheatley. *Poems on various subjects, religious and moral.* London: Printed for A. Bell … and sold by Messrs. Cox and Berry, King-street, Boston, 1773

Eldridge Cleaver Papers

Ted Joans Papers

Gwendolyn Brooks Papers

## Fine Printing

Doves Press / T. J. Cobden-Sanderson: books, bindings, ephemera, and MSS

Kelmscott Press / William Morris: books (especially Kelmscott Chaucer [1896]. 4 copies), ephemera, scrapbooks

John Henry Nash: books, ephemera, archives

Grabhorn Press: books, ephemera, archives

Adrian Wilson: books, ephemera, archives

Auerhahn Press: publications, archives

Lewis and Dorothy Allen: books, archives

Arion Press: publications, ephemera

Fine bindings (Norman Strouse collection)

Hartmann Schedel.

*Nuremberg Chronicle.* Nuremberg: Anton Koberger, 1493.

# History of Science and Technology Program

David Farrell, CURATOR

## Collection Profile

*Chronology*    Fifteenth century to the present

*Scope*    History of mathematics, science, and technology in Western civilization from the fifteenth to twenty-first centuries with a special emphasis on subjects, individuals, and corporate entities active in the American West, Northern California, the University of California, and on the Berkeley campus.

*Subject Areas*    Categories of special strength include:

- physical, life, earth, and environmental science
- bioengineering and biotechnology
- science, technology, and the public interest
- social and political aspects of science, scientists, and scientific institutions

THE QUALITY AND VALUE of the History of Science and Technology Program lie in the particular character and culture of the American West. The collection's riches reflect the region's history of adventure and experimentation coupled with inventive, pragmatic applications. The West's unique terrain and its extraordinary wealth of natural resources, combined with its initial isolation from the East, stimulated fresh, often unique approaches to the new state's scientific and technological challenges. The establishment of the University of California in 1868 provided an essential element for the region's development: an environment that stimulated the theoretical inquiry, scientific experimentation, and technical solutions required for the exploitation of the American frontier. By 1900 an extraordinary "culture of creativity" was firmly established in the region, and the San Francisco Bay Area was its center.

    As a Land Grant institution established under the provisions of the Morrill Act of 1862, the University curriculum gave special emphasis to agriculture and the mechanical

OPPOSITE PAGE

Hearst Memorial
Mining Building, 1907.
Gift of Phoebe Hearst
in memory of her
husband George Hearst.
Designed by John Galen
Howard. Restored in 2002.

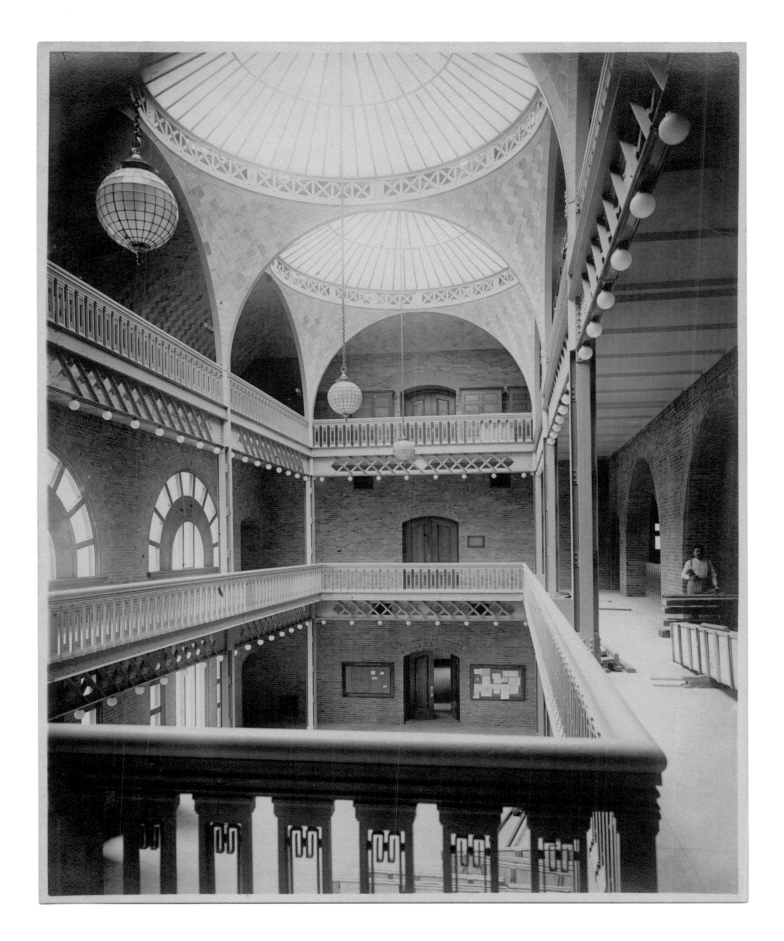

Le Conte Family Papers
Bancroft Library

_Steam Boiler Design._

We are to investigate ... what proportions, what size and weight and in general what construction will in the locality in which a boiler is to be operated, and under those conditions which the designing engineer has ascertained to be those under which it will be operated, will supply the demanded quantity of steam continuously for the largest practable period at minimum risk and cost throughout its probable length of life. The

Advanced Laboratory

Notebook (page 2),

Joseph N. LeConte, circa 1890.

arts. The first appointed faculty member was professor of physics (and third president of the University) John LeConte (1818–1891). Very early on, the University's scientists began conducting basic research, initially focusing on the land-grant fields. Soon the focus broadened considerably, as the University's faculty began absorbing and reflecting the work of public and private scientists.

In 1875, a surprise gift from James Lick (1796–1876), an eccentric real estate speculator in San Francisco, vaulted the fledging frontier university to the first rank of research universities. Lick gave $700,000 (the equivalent of more than $10 million today) to construct an observatory on Mt. Hamilton in Santa Clara county, to be equipped with "a powerful telescope, superior to and more powerful than any yet made ...." When Lick Observatory opened in 1888, it was the world's largest, and the first high-elevation observatory to be occupied year-round. Groundbreaking applications in photo-astronomy were the first of many great discoveries made by scientists at Lick. The University's reputation as a world leader in scientific discovery was established

Bancroft's resources provide an unsurpassed opportunity to explore the issues, personalities, political forces, social movements, successes and failures that have occurred in Northern California and at the Berkeley campus. These sources include the unique records of

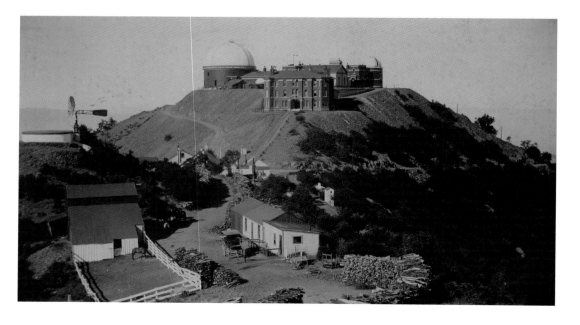

View of Buildings at

Lick Observatory,

Mt. Hamilton, California,

1891.

Photograph by

Edwin R. Jackson.

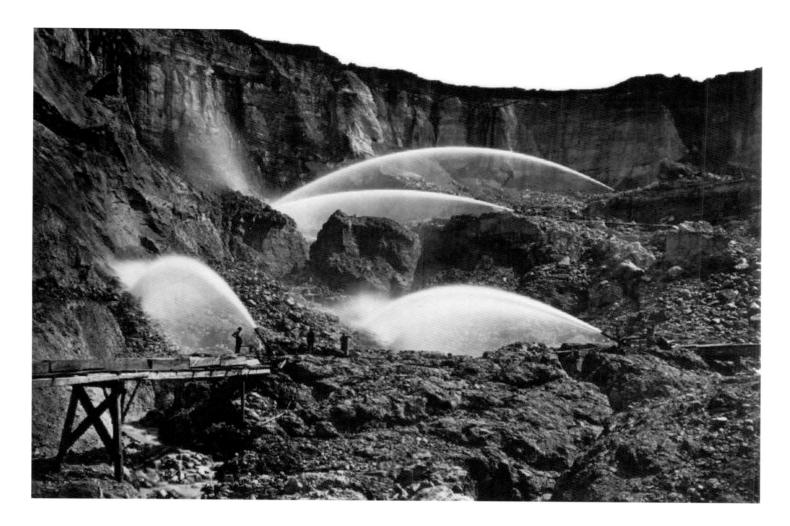

scientific research and discovery—scientists' laboratory notebooks, explorers' field notes, journals, diaries, correspondence—as well as printed books, maps, and photographic and multi-media images. The technological history of the West is lavishly supported by records of companies large and small directly involved in the exploration, development, and management of natural resources, including corporate bodies that have been directly influenced by the work of scientists at UC and other universities in the region.

Smaller but still important collections document scientific and technological discoveries and developments from the fifteenth to the nineteenth centuries in Western Europe and the United States.

The most significant collections date from the late nineteenth century and include such items as manuscript and printed materials related to the landmark explorations and discoveries of Josiah Whitney (1819–1896), George Davidson (1825–1911), and C. Hart Merriam (1855–1942). Whitney conducted a geological survey of California on behalf of the Legislature (1861–1866); Davidson surveyed the Pacific Coast for the U.S. Coast and Geodetic Survey (1850–1860); Merriam conducted the U.S. Biological Survey across the western states, including California (1886–1910). Rich documentation also exists in the

Hydraulic mining at the Malakoff Diggings. Carleton E. Watkins, circa 1869–1872.

Hearst Mining Collection of Views.

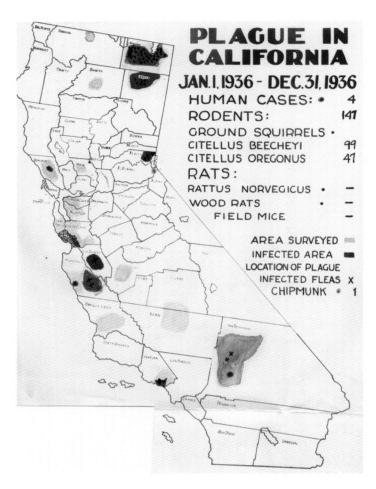

California State Plague Map, 1936.

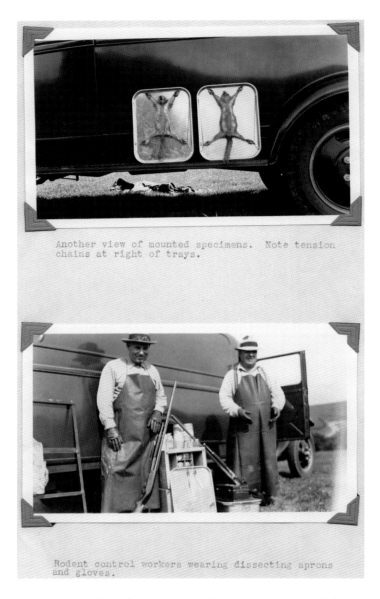

Another view of mounted specimens. Note tension chains at right of trays.

Rodent control workers wearing dissecting aprons and gloves.

Rodent control workers wearing dissecting aprons and gloves, circa 1935.

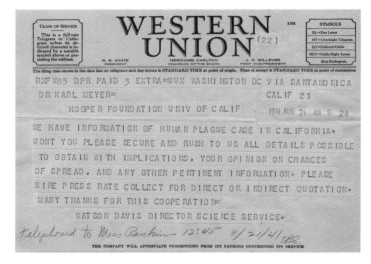

Telegram, August 21, 1941, from Watson Davis, informing Meyer of human plague cases.

## VIROLOGY AND PUBLIC HEALTH

In the 1920s and 30s, Dr. Karl F. Meyer worked with both industry and federal and state Departments of Public Health to conduct exhaustive fieldwork in infected areas, hunting and dissecting thousands of wild rodents. An obsessive detective, he tracked down plague in thirteen Western states, laying the groundwork for a new theory of plague epidemiology. The telegram, map, and photographs reflect the history, challenge, and struggle of his research and fieldwork. —D. F.

## NUCLEAR PHYSICS

"Big science"—large-scale research characterized by outsized budgets, staff, and equipment engaged in leading-edge discoveries—received a big boost from Berkeley with the development of the first cyclotron by E. O. Lawrence in 1931. Subsequently, seven Berkeley faculty members received the Nobel Prize for their work on "big science" projects in physics. Later, Berkeley scientists were prominent in local and national efforts to limit the proliferation of nuclear weapons and the construction of nuclear power plants. The work of many of these eminent scientists is documented in manuscripts, archives, pictorial images, and oral histories in Bancroft's History of Science and Technology collections. —D. F.

Glow from 11" Cyclotron Beam, 1931. Radiation Laboratory.

Ernest Orlando Lawrence above the 184-foot Cyclotron Building, University of California, Berkeley, 1941.

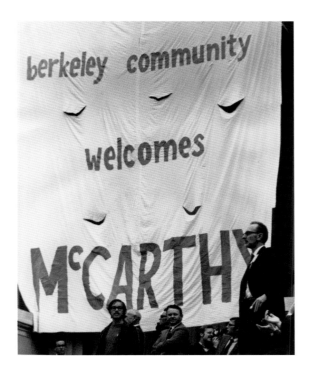

"Berkeley Community Welcomes McCarthy." Owen Chamberlain at Rally for Anti-war Presidential Candidate Eugene McCarthy, 1968.

## THE DOBLE
## STEAM CAR

In 1920 Abner Doble and his brothers (chiefly Warren Doble, with early involvement of John and William) organized the Doble Steam Motors Corporation in San Francisco with the intention of developing the finest steam car ever built. Doble modeled his factory, which later moved across the bay to Emeryville, on the Rolls-Royce plant in Springfield, Massachusetts. The cars manufactured by Doble were luxury vehicles guaranteed to run for 100,000 miles. Their reputation for fine performance spread, and orders came in quickly. The production process was costly and enormously time consuming, given the amount of attention paid to nearly every detail. As a result of Doble's high standards, the company manufactured only forty-two cars between 1923 and 1931. Finally, unable to secure adequate financing, Doble Steam Motors went bankrupt in 1931. Despite the company's failure, steam enthusiasts still consider the Doble steam car of this era to be among the best ever produced.
—D. F.

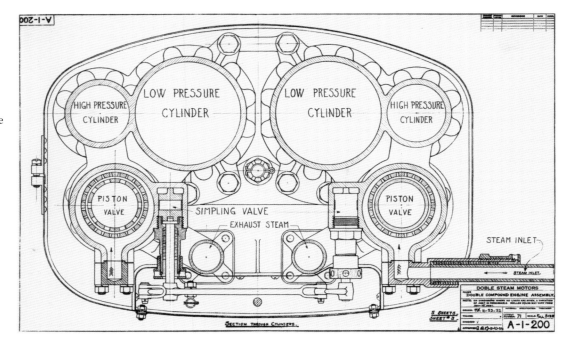

Doble double compound engine assembly drawing, 1922.

scientific papers of faculty and staff in the Department and Museum of Anthropology, founded in 1901, especially on the state's indigenous peoples.

Important collections from the first decades of the twentieth century include the papers of such scientists as Karl F. Meyer (1884–1974), who headed what became the School of Public Health as well as the George Williams Hooper Foundation for Medical Research, the University's earliest biological research institute. Meyer's success in conquering botulism, which threatened the viability of the state's billion-dollar agricultural and canning industries in the 1920s, and selvatic plague resulted from a strong partnership linking academe, industry, and government, foreshadowing the future achievements of Berkeley's physicists and molecular biologists. Another collection from the period are the papers of Andrew C. Lawson (1861–1952), who researched and wrote the standard report on the 1906 San Francisco earthquake and fire and led the development of the science of seismology.

Exceptionally strong collections documenting science later in the century include the papers of ten of Berkeley's thirteen Nobel laureates in the sciences, among them physicist Ernest O. Lawrence (1901–1958, the first Nobelist in a public university [1939]), virologist Wendell Stanley (1904–1971), and chemists Melvin Calvin (1911–1997) and William Giauque (1895–1982). The papers of Nobelists Luis Alvarez (1911–1988), Owen Chamberlain (1920–2006), Donald Glaser (1926–), Edwin McMillan

Abner Doble driving his steam car (body by Kimball of Chicago), 1917.

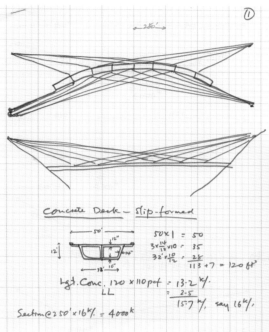

*"Ruck-A-Chucky Bridge,"*
planning sketches, 1976.
T. Y. Lin Papers, 1932–1998.

## THE T. Y. LIN PAPERS

Bancroft houses the T. Y. Lin Papers, 1932–1998. A structural engineer—whose projects, particularly bridges, can be found around the world—Lin was internationally known for innovative, imaginative use of pre-stressed concrete. The "Ruck-A-Chucky Bridge" was designed to cross the Middle Fork of the American River ten miles above the proposed Auburn Dam site. Lin, in collaboration with engineer/architect Myron Goldsmith, envisioned a bridge whose alignment included a horizontal arc with a radius of 1500 feet that was developed to avoid heavy cutting or tunneling into the hillsides. The project was dropped when the dam was not built. Lin's San Francisco Bay Area projects included the San Mateo-Hayward Bridge and the Moscone Center Exhibit Halls. —*D. F.*

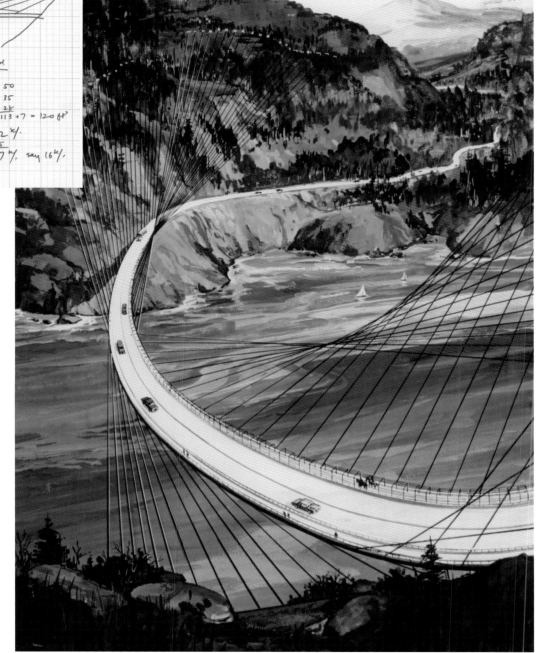

*"Ruck-A-Chucky Bridge,"* watercolor, 1976.
T. Y. Lin Papers, 1932–1998.

## BIOTECHNOLOGY

Scientists in many disciplines—including agriculture, molecular biology, chemistry, public health, and virology—have made important contributions in biotechnology, helping to make the San Francisco Bay Area the global center of a vigorous new industry. The history from its inception is richly documented in Bancroft's collections of archives, manuscripts, oral histories, and pictorial images. —*D. F.*

Graph of DNA testing from Jim Kadonaga's Lab Notebook Number 2 (April 1985 to January 1986). Kadonaga was a scientist and assistant in Robert Tjian's laboratory, where he recorded research relating to gene expression. In 1991, Tjian became a co-founder of Tularik, Inc., in South San Francisco.

## The Scientific Concept behind Tularik:

SALLY HUGHES: Describe the technology, and why you think it's competitive.

DAVID V. GOEDDEL: There's probably nothing in the technology that's so special except there's a lot of pieces that have to be put together right. The concept is that every human disease has associated with it genes that are not regulated correctly, that are either too active or too inactive, and that if you could correct those you could treat the disease. I think the simplest way to describe our approach is we want to understand the mechanisms of the inappropriate gene expression in disease, and then use an understanding of that biology to find small-molecule drugs that will get in the cell, bind certain regulatory components, and restore normal gene expression.

Rheumatoid arthritis, that's one of our examples. What genes are expressed wrong? A lot of that's known in the literature already. But what regulatory components in the cell have turned those genes on that shouldn't be on? Then our biology can really go to work and make the discoveries of the components. Now we take those components, make recombinant proteins, for example, and develop assays, where we can test hundreds of thousands of chemicals to see does any chemical affect the activity of that regulator. If it does, then we can test in cells and so on….

—*From* David V. Goeddel, Ph.D., Scientist at Genentech, CEO at Tularik.
*Interview conducted in 2001 and 2002 by Sally Smith Hughes, Ph.D., Director, Program for Bioscience and Biotechnology Studies, ROHO.*

(1907–1991), and Emilio Segrè (1905–1989), in addition to Lawrence, form an especially rich collection because the scientists worked at the same time, often on the same problems. Together, they created "Big Science"—defined by the big machines, big budgets, and big staffs which Lawrence first created and which dominated international physics research for the remainder of the century. The papers of many other Berkeley and Bay Area scientists, engineers, and mathematicians are also prominent among the collections.

These collections, and the campus's continuing eminence in Big Science, led to the establishment of Bancroft's Program in the History of Science and Technology in 1972, at the same time as the campus's Office for the History of Science and Technology; the Office and the Program collaborate closely and for a time shared staff.

Special note should be made of engineering and mathematics in the University. The collections include records of the Department of Nuclear Engineering and the logs of Berkeley's nuclear reactor; the papers of members of the Kaiser family and Kaiser Industries; of Charles Derleth (1874–1956), builder of the San Francisco Bay bridges; and T. Y. Lin (1912–2003), who designed more than 1000 bridges in America and abroad. These records enable the comprehensive study of both small and major events in the construction of the West and economic innovation: Hoover Dam, Kaiser Shipyards, and Kaiser Permanente, the country's first health maintenance organization. Mathematics and statistics are well represented by the collections of the papers of Stephen Smale (1930–) and Vaughan F. R. Jones (1956–), two of Berkeley's five winners of the Fields Medal (the world's most prestigious award for mathematics), and other members of this prominent department.

Rounding out these exceptional collections is a rich aggregate of related materials from the University Archives, Western Americana, Pictorial Collections, and the Regional Oral History Office: regental, presidential, and chancellorial documents, correspondence, images, and memoirs, as well as similar materials from academic divisions and departments—the Departments of Anthropology and Physics, the Colleges of Chemistry and Engineering, and the Academic Senate, Berkeley Division. These diverse holdings support a wealth of research and instructional activities in the fields of regional and western European history, sociology, public policy, higher education, business and finance, law, biomedicine and biotechnology, and the physical and biological sciences. Pictorial images, a special strength, include portraits of academic and industrial leaders and images of buildings, bridges, and construction sites.

In 1996 the History of Science and Technology Program took a new direction with the establishment of the Program in the History of the Biological Sciences and Biotech-

nology. The focus of the new program is on personal and corporate records, papers, and oral histories documenting the Bay Area's global leadership in this growing field. Still in its infancy, this collection's strength lies in the several dozen oral histories of scientists, physicians, patients, and corporate leaders, including those of Herbert Boyer (1936–), co-discoverer of recombinant DNA technology and co-founder of Genentech, Inc., the pioneer biotechnology company, and his co-founder Robert Swanson (1947–1999). Other oral histories include those of Nobel laureates Paul Berg (1926–) and Arthur Kornberg (1918–), as well as David Goeddel (1951–), William J. Rutter (1928–), Edward Penhoet (1940–), and venture capitalist Thomas J. Perkins (1932–). Archival collections have begun which document Genentech, Inc., Tularik, Inc., and Chiron Corporation, as well as many of Berkeley's molecular biologists: Daniel E. Koshland, Jr. (1920–), Horace Barker (1907–2000), Melvin Calvin (1911–1997), Robert Tjian (1949–), Peter Duesberg (1936–), and Gunther Stent (1924–). The synergy of the oral histories and the scientific papers and records enables the study of science and scientific history to explore the differing accounts and views of scientists—their sense of competition and collaboration with each other—as well as an understanding of the marketing and venture capital forces that shaped the choices and directions of the various companies in the process of making new scientific discoveries and creating new technologies.

The Program continues to expand with new initiatives to build collections and reach new audiences. In recent years, for example, Bancroft has sponsored or co-sponsored public programs, most importantly national symposia celebrating the twenty-fifth anniversary of the invention of rDNA technology and the centennial of the birth of J. Robert Oppenheimer. The Program has also begun to digitize research collections and make them available via the Internet, for example, selections from the Abner Doble Papers (1885–1963) and the Doble Steam Motors Corporation photograph collection (1912–1930). The program's first digital collection, it comprises an online research archive of manuscripts, notebooks, blueprints, and photographs documenting the Emeryville, California, corporation that built the finest steam-powered vehicles of its day.

With a strong, unique base of research collections, the prominence of the University's work in science, engineering, and mathematics, and the global impact of technologies developed in the Bay Area (information technology and biotechnology, in particular), the continuing development and excellence of Bancroft's History of Science and Technology Program appears to be assured.

# Special Scientific and Technological Collections

*Euclidis geometre cum commento Campani.*
Italy, circa 1460.

The collections include a rich selection of rare books and periodicals. Its most noteworthy aspects are the 45 incunables, some 50 early editions of Euclid (including a fine Italian manuscript ca. 1460 and two copies of the 1482 edition from the press of the Venetian printer Erhard Ratdolt), and a collection of manuscripts relating to the Accademia del Cimento (1657–1667) of Florence, Italy, and Lorenzo Magalotti (1637–1712), the academy's scientist-secretary. Related collections include unique curiosities such as the Hearst Medical Papyrus (ca. 1800 BC), which, if genuine, qualifies as the oldest work of science in the Library, and the notorious "Drake's Plate" (ca. 1936), once thought to have been left by the English explorer on the shores of Marin county in 1579 to claim "New Albion" for Queen Elizabeth I but subsequently proved to be the subject of the cleverest fraud in the history of California scholarship.

Among the later collections are the richest holdings in the Western Hemisphere of the papers and publications of the eighteenth-century Jesuit polymath Ruggero Boscovich (1711–1787) and a major gathering of the papers of the family of the mathematician, astronomer, and physicist Pierre-Simon Laplace (1749–1827), the "Newton of France." Also of special importance are three collections given by members of the faculty: The Cajori Collection of 1750 volumes, chiefly mathematics, the gift in 1931 of the widow of Professor Florian A. Cajori (1859–1930); the Essig Collection of rare entomological texts, given in 1962 by Professor Edward O. Essig (1884–1964); and the Kofoid Collection of zoology, botany, medicine, and travel, eventually comprising 31,000 volumes and 46,000 pamphlets, given in 1947 by Professor Charles A. Kofoid (1865–1947).

The Program is also strongly supported by historical collections that focus on eighteenth- and nineteenth-century European and American materials, including English and Continental (particularly French and German) science and technology, and on scientific and technological developments that contributed to the exploration, settlement, and development of the American West. —*D. F.*

"Molino fatto col moto degli animali" (Animal-Operated Grinding Wheel), from *Novo teatro di machine et edificii* (New Theater of Machines and Buildings) by Vittorio Zonca, Padua, 1607.

# At Work | *The Rube Goldberg Collection*

CATHRYN CARSON

In my field, the history of science and technology, The Bancroft Library is a repository of record. My colleagues often come to do research at Berkeley, usually in search of something very specific: the papers of a famous scientist they are studying or particular manuscripts we have preserved.

But my own experience in Bancroft has shown me another side of its richness. It is the richness of serendipity, of collections encountered nearly by chance. Some sidelights catch the eye unexpectedly while paging through lists looking for something else. Matthew Axtell, an undergraduate student of mine, zeroed in on Bancroft's splendid Rube Goldberg materials. Matthew intended a thesis on Goldberg's wacky "invention" cartoons. But glances into other collections opened new vistas—and ultimately turned his project around.

Reuben Lucius Goldberg was a student at the University of California. He entered the College of Mining Engineering with the new century and left with his degree in 1904. Goldberg as the engineers' cartoonist has become a cliché. But why did a freshly minted graduate abandon the mine and the drafting board to, instead, sketch fantastic mechanical contraptions? How might the young Goldberg—this was Matthew's question—have encountered machines in his education? What attitudes toward them would he have taken away? These thoughts might have led nowhere, as they had for previous scholars, except that another Bancroft collection caught Matthew's eye.

Although now forgotten, Samuel B. Christy was Berkeley's Dean of Mining Engineering during Goldberg's student years. And from Christy's letters and publications and odds and ends, a mining engineering student's world began to come clear. Goldberg's short stretch at the University was a phase of intense transformation. Christy and his allies looked to reform engineering training in light of the machines so fervently advertised as the field's future. Goldberg went through this program. A comparison of images shows him visually quoting in his cartoons, reproducing a style of specifications as well. Pictures and words made the case.

Sketch of an Elevator.
Samuel B. Christy Papers.
(No date).

The link to Goldberg's education was tangible. Yet for all their triumphalism, academic enthusiasts like Berkeley's Christy did not rule the roost. They met fierce resistance from engineering practitioners. For mining engineering, it also became evident that Goldberg's moment was marked by deep ambivalence about exactly the mechanical technologies colonizing the field—their inefficiencies and imperfections, their excesses and dangers, their capacity to wrench control from the human masters themselves.

When the engineers' conflict was made visible again through Matthew's research, Goldberg's early cartoons appeared in a more somber light. Nothing in Goldberg's personal papers gave a clue to his serious intent; he later retold his own story in a more optimistic vein. So if Rube Goldberg was the engineers' cartoonist, he initially drew from a profession split down the middle. Matthew's side glance into Bancroft's less celebrated collections made Goldberg's early twentieth-century setting recoverable at all.

*Cathryn Carson is Associate Professor, Department of History, and Director, Office for History of Science and Technology at the University of California, Berkeley.*

## Rube Goldberg *lends a hand to medical science*

Tradition will be served. In the common sense spirit of mankind's historic mistrust of rational approaches, Mr. Goldberg once again cries "Logic, schmogic!" and offers up another of his classic constipation correctives prepared for Warner-Chilcott.

*No. 3 in a Series—* **The Stoker—***for those who can't or won't eat enough bulky foods*

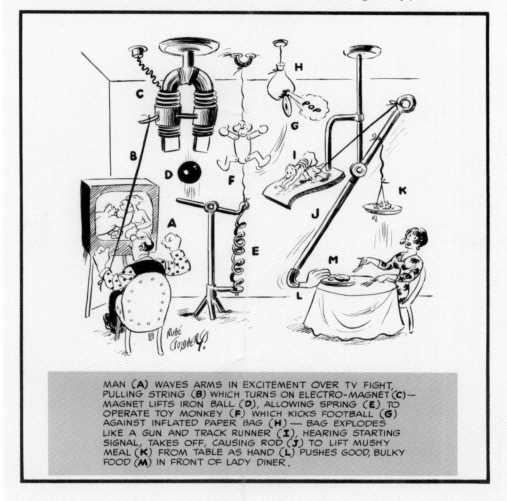

"Rube Goldberg lends a hand to medical science."

*The Stoker* – No. 3 in a series. (No date).

# Collection Highlights

## Engineering

### PAPERS

Abner Doble Papers, 1885–1963

George Leitmann Papers, 1955–

T. Y. Lin Papers, 1932–1998

Thomas Pigford Papers, 1970s–1989

John R. Whinnery Papers, 1947–1994

### RECORDS

College of Engineering, 1906–

Department of Electrical Engineering and Computer Sciences, 1970–

Department of Nuclear Engineering, 1964–1989

## Mathematical Sciences

### RARE BOOKS

Archimedes. *Archimedis opera non nulla.* Venice, 1558

George Berkeley. *The Analyst; or, a Discourse Addressed to an infidel Mathematician.* London, 1734

Jean-le-Rond D'Alembert. *Opuscules mathematiques.* Paris, 1761

Euclid. *Euclidis Geometre.* Manuscript. Italy, ca. 1460

Euclid. *Elementa geometriæ.* Venice, 1482. 1st Latin ed.

Euclid. *Eukleidou Stoicheion bibl.* Basel, 1533. 1st Greek ed.

Nathan Daboll. *Daboll's Schoolmaster's Assistant.* Norwich, 1818

René Descartes. *Discours de la methode.* Leiden, 1637

John Napier. *Raddologia, ouero arimmetica virgolare.* Verona, 1623

Isaac Newton. *Philosophi naturalis principia mathematica.* London, 1687

Luca Pacioli. *Summa de arithmetica.* Venice, 1494

### PAPERS

Griffith C. Evans Papers, ca. 1875–1970

Pierre Simon Laplace Papers, 1697–1873

Derrick H. Lehmer Papers, ca. 1926–1990

Jerzy Neyman Papers

Julia B. Robinson Papers, 1946–1992

Stephen Smale Papers, ca. 1950–1998

Alfred Tarski Papers, ca. 1940–1983

## Life Sciences

### RARE BOOKS

Charles Darwin. *On the Origin of Species.* London, 1859. 1st ed.

Dmitry Mendeleyev. *Osnovy khimii.* St. Petersburg, 1869–1871. 1st ed. of the periodic table of the elements

### PAPERS

Herbert M. Evans Papers, 1904–1969

Emil Fischer Papers, 1876–1960

Karl F. Meyer Papers, ca. 1900–1975

Agnes Fay Morgan Papers, 1904–1983

Wendell M. Stanley Papers, 1926–1972

### RECORDS

Botanical Garden, 1916–1983

College of Agriculture, 1881–

Department of Botany, 1929–1936

Genentech, Inc., 1980–

## Physical Sciences

### RARE BOOKS

Tycho Brahe. *Astronomiæ instauratæ mechanica.* Wandsbek, 1598

Nicholaus Copernicus. *De revolutionibus orbium cælestium.* Basil, 1566

Galileo Galilei. *Dialogo di Galileo Galilei.* Florence, 1632

William Gilbert. *De magnete.* London, 1600

Johannes Kepler. *Astronomia nova aitiologetos.* Prague, 1609

### PAPERS

Luis Alvarez Papers, 1943–1987

Ruggero Boscovich Papers, 1711–1787

Leo Brewer Papers, 1940–2004

Melvin Calvin Papers, ca. 1938–1986

Owen Chamberlain Papers, 1943–1996

William F. Giauque Papers, ca. 1930–1981

Joel H. Hildebrand Papers, 1913–1979

Ernest O. Lawrence Papers, 1948–1958

Yuan T. Lee Papers, ca. 1964–1993

Kenneth Pitzer Papers, 1943–1998

Henry Rapoport Papers, 1936–2003

Emilio Segrè Papers, ca. 1942–1989

Otto Stern Papers, ca. 1910–1968

### RECORDS

Department of Chemistry, 1874–1955

Lawrence Radiation Laboratory, 1943–1945

Department of Physics, ca, 1919–

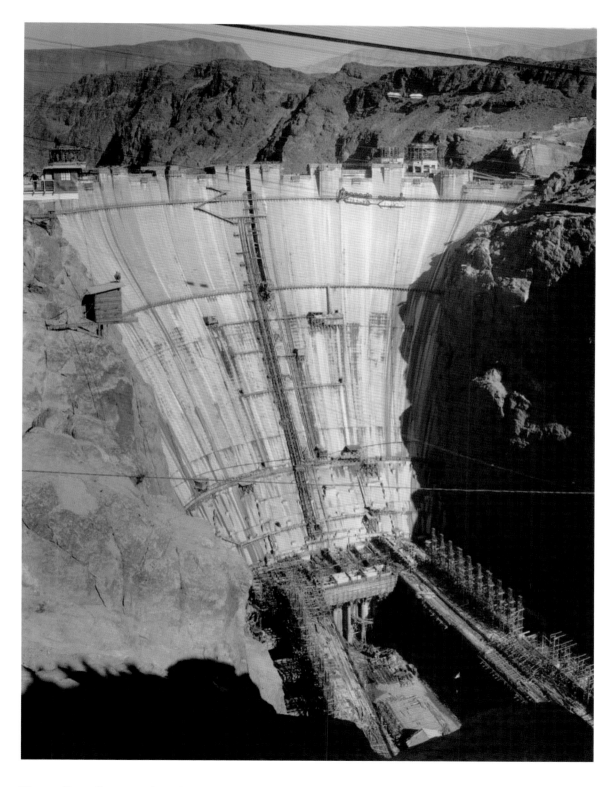

Hoover Dam Construction, circa 1935.

# University Archives

David Farrell, UNIVERSITY ARCHIVIST

## Collection Profile

*Scope*    Historical records and documents of the University of California and its predecessor, the College of California (1855–1868), from the mid-nineteenth century to the present. The collection dates largely from the founding of the University in 1868. Routine gathering of printed material began in the 1870s, but the University Archives at Bancroft was not officially designated as the repository of administrative records until 1964, by President Clark Kerr. Following the decentralization of campus administration in 1952, the University Archives narrowed its focus to the Berkeley campus while remaining the official repository of the Office of the President, including some Regents' records.

- The Archives' most extensive early collections include administrative and meeting records of the Regents, the Academic Senate, departments and research units of the University, and faculty papers (selectively)

- "Town and Gown" relations with the City of Berkeley

- student activities, including sports, residential life, publications, and protests

- research contracts and reports

- joint entrepreneurial developments and contractual relations

John F. Kennedy. Charter Day Speech,
Memorial Stadium, March 23, 1962.

THE UNIVERSITY ARCHIVES (24,000 VOLUMES, 3,500 linear feet of records, and 25,000 photographs) provide a rich opportunity to explore the history of the dynamic interplay between University, public, and private interests in the evolution of the world's premier public institution of higher learning. Historically, this dynamic has put the University of California at Berkeley at the fulcrum of many important events—scientific, economic, technological, cultural, and political—during the nineteenth and twentieth centuries. Since its founding the University of California has been distinguished by its remarkable contributions to the shape of higher learning and by its globally signifi-

...I am delighted to be here on this occasion for though it is the 94th anniversary of the Charter, in a sense this is the hundredth anniversary. For this university and so many other universities across our country owe their birth to the most extraordinary piece of legislation this country has ever adopted, and that is the Morrill Act, signed by President Abraham Lincoln in the darkest and most uncertain days of the Civil War, which set before the country the opportunity to build the great land grant colleges of which this is so distinguished a part. Six years later this university obtained its Charter....

*Roma*, 1897, an architectural drawing for the Berkeley campus by Emile Bénard.

In the late nineteenth century, the nation's architectural taste was moving toward the formal planning and classicism taught at France's architectural school, the École des Beaux-Arts. Bernard Maybeck, a future architect and a Beaux-Arts trained drawing instructor at the University, convinced University benefactor Phoebe Apperson Hearst of the necessity of a comprehensive campus plan. In 1897 she financed an international competition to select an architect. Not surprisingly, given the École's preeminence, a Parisian, École-trained architect Emile Bénard, won first prize. His plan for the University was a formal Beaux-Arts composition arranged around a central east-west axis with a minor cross-axis. The buildings were to be monumental structures in classical styles built of uniform materials.

Emile Bénard declined to be appointed supervising architect. In 1901 the position was offered to John Galen Howard. Although he was directed to execute Bénard's plan without any substantial departure, while remaining loyal to Beaux-Arts design principles, Howard made small alterations until the plan was more his than Bénard's.

cant research. In particular, the University has supported Nobel Prize-winning accomplishments in the sciences and economics; multiple and innovative working partnerships with local, state, federal, and international governments and agencies; productive relationships with private business and industry; and, not least, the influential (some will say revolutionary) student responses to political, social, cultural, and environmental issues.

This "dynamic interplay" began with the University's founding, when the California Legislature, with the signature of Governor H. H. Haight, established the University on March 23, 1868 (now known as Charter Day), incorporating into it the College of California, a private liberal arts institution founded in Oakland in 1853. Its president, Henry Durant, became president of the new

university. The Federal Morrill Act of 1862 endowed the University with a substantial land grant for the new campus with the decree that the new University should provide a curriculum in the "mechanical and agricultural arts." The legacy of the College of California ensured a commitment to programs in the arts, letters, and sciences. To protect the independence of the University from political intrusion into its affairs, the legislature established the Board of Regents, a body with virtual autonomy from state control and complete authority for the University's governance.

This initial foundation provided ideal mechanisms to create the educational and research initiatives the new state required for its burgeoning agriculture, mining, industrial, and commercial development. In addition, it defined the new University's emerging vision of its role. The foundation also set in play the University Regents' and Administration's dynamic and at times fractious history of balancing the interests of international, federal, state, and various municipal bodies and private sectors with the needs and objectives of an institution of higher academic and professional learning for both faculty and students.

The Archives contain a large variety of materials that reveal the history of the University:

*Campus Development.* These materials show how the campus defined its goals and ambience through its architectural and landscape design and construction. Key records relate to the College of California, the first buildings constructed on the Berkeley campus, and the ambitious Phoebe Hearst International Architectural Competition (1897–1901) that produced a comprehensive, long-range physical plan for the campus. The Competition is extensively documented in reports, correspondence, maps, photographs, and architectural drawings. These records are complemented by the personal and professional papers of John Galen Howard (1864–1931), the campus architect who implemented the winning plan and who became the University's first professor of architecture. Of equal interest are subsequent collections recording the history of the design and development of much of the rest of the campus and its individual buildings. Campus maps dramatically chart the growth from the first building to the present.

*Administration, Regents, and Faculty.* The records of the Board of Regents, the Office of the President, and the Chancellor of the Berkeley campus provide an unparalleled opportunity to interpret the processes that led to decisions about the course, structural shape, and development of the University. The most extensive single record group is that of the Office of the President (1885–1975), including papers of the family of the first president, Henry Durant (1802–1875), through the administration of Charles J. Hitch (1968–1975).

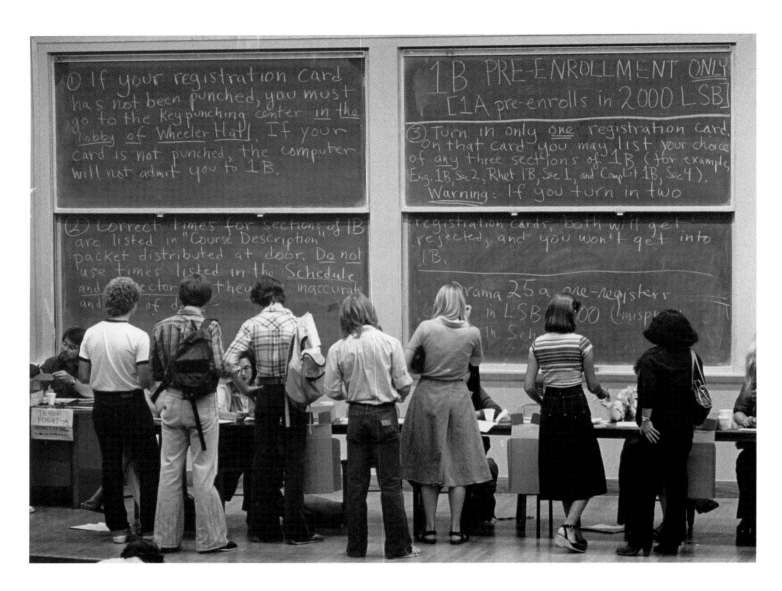

On the blackboard:

① If your registration card has not been punched, you must go to the Keypunching center in the lobby of Wheeler Hall. If your card is not punched, the computer will not admit you to 1B.

② Correct times for sections of 1B are listed in "Course Description" packet distributed at door. Do not use times listed in the Schedule and director... their... inaccurate and... of d...

1B PRE-ENROLLMENT ONLY
[1A pre-enrolls in 2000 LSB]

③ Turn in only one registration card. On that card you may list your choice of any three sections of 1B (for example, Eng. 1B, Sec 2, Rhet 1B, Sec 1, and CompLit 1B, Sec 4). Warning: If you turn in two registration cards, both will get rejected, and you won't get into 1B.

...rama 25a one-registers in LSB...00 (misp... in Sch...

Students Registering for English 1-B, September 17, 1980.

The records of the Board of Regents contain similar documentation for the early decades of the University through the 1910s; later records are collected in the Office of the Secretary of the Regents in Oakland. Since decentralization of the University administration in 1952, when chancellors' positions were established on the Berkeley and Los Angeles campuses, each campus has assumed responsibility for its own chancellor's records. These materials are often revisited—for example, in consideration of new campus policy proposals and decisions.

The Archives also maintain extensive records of the Berkeley Division of the Academic Senate, which in 1920 won a role in the shared governance and development of policies of the university, some of which have had national impact on issues facing institutions of higher learning. These include such questions as research collaborations with either private businesses or government entities; the faculty's struggles for authority in hiring and establishing new academic departments and curricula; and faculty responses

to and participation in such cataclysmic events as the Loyalty Oath Controversy, the Free Speech Movement, and the People's Park controversy.

*Relations with Public and Private Entities.* The vested interests of University divisions, individual professors, governmental units, and private industry are extensively reflected in administrative records and faculty papers; for example, contentious University positions on the ownership and royalties for faculty patents and the limits on research for contracts with the Department of Defense.

*Records of Town and Gown Relations* with the City of Berkeley and the University define a relationship that has been by turns both cooperative and acrimonious. For example, documents reflect the work of the University's Criminology Department with the Berkeley Police Department in the development of scientific criminology. Results included innovative fingerprinting technology and the invention of the polygraph. Alternatively, controversies over the construction of Memorial Stadium and International House or, more recently, People's Park, are amply documented. For example, one may find extensive files including planning documents, memoranda, confidential minutes of administrative bodies, handbills and flyers, and extensive photographic documentation.

*Departmental, School, and College Histories* extensively document unique histories of the conceptualization, argumentation for and against, and development of the University's individual departments, schools, and colleges. One of the earliest examples is found in the records of the Department of Physics, founded by John LeConte (1823–1901, the University's first professor and third president), a department that in the course of the twentieth century invented "Big Science" and served as home to seven Nobel laureates. The issues and vigorous arguments surrounding the development and successes of the Colleges of Chemistry, Engineering, and Natural Resources are broadly reflected in the records of those divisions. These records document the history of confrontation and response to leading public issues such as the Physics Department's commitment to the

Czeslaw Milosz receiving news of Nobel Prize for Literature in Bear's Lair, Berkeley Campus, October 9, 1980.
*Saxon Donnelly, Photo.*

# The Free Speech Movement (FSM)

In the Fall of 1964—spurred by the example of the Civil Rights Movement—Mario Savio, a Berkeley undergraduate, led a demonstration in support of the rights of students to express and promote their political views on campus. The Free Speech Movement (FSM)—as it was baptized on September 30—proposed that the First Amendment be considered the only guide to student political activity. After more than two months of negotiations, picketing, and demonstrations failed to resolve the issue, Savio would give a speech, now famous, that initiated a sit-in of about 1,000 persons, including folksinger Joan Baez, in Sproul Hall:

> "There is a time when the operation of the machine becomes so odious, makes you so sick at heart, that you can't take part; you can't even passively take part, and you've got to put your bodies upon the gears and upon the wheels, upon the levers, upon all the apparatus, and you've got to make it stop. And you've got to indicate to the people who run it, to the people who own it, that unless you're free, the machine will be prevented from working at all!"

> *Mario Savio, Berkeley Campus, December 2, 1964.*

The arrest of 800 of the participants led to a student strike that precipitated the resolution of the conflict with passage of an Academic Senate resolution

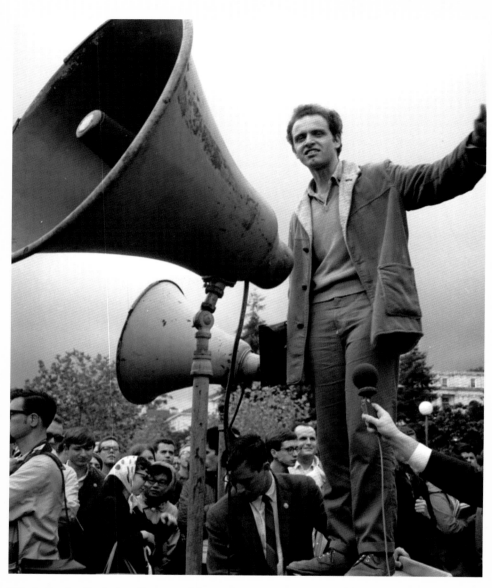

Mario Savio, Berkeley Campus, November 9, 1964. *San Francisco News-Call Bulletin Newspaper Photograph Archive.*

December 8: "That the content of speech or advocacy should not be restricted by the University." The students had won.

The Free Speech Movement Participants Papers, 1959–1997 (bulk 1964–1972), consists of small collections and single items assembled by the Free Speech Movement Digital Archive and Oral History Project between 1998 and 2001. The collection consists of writings, correspondence, and miscellaneous printed matter including pamphlets, leaflets, programs, songbooks, and other ephemera.

development of nuclear energy, with its potential impact on government policy, military action, health, and the local public. Records of the life sciences departments document groundbreaking discoveries in virology and molecular biology, while providing insight into the University's role in the development of the biotechnology industry, in which the San Francisco Bay Area leads the world.

The collection includes a significant number of faculty papers, including those of Berkeley economists, three of whom have been awarded the Nobel Prize, and extensive records of academic life, including academic personnel files, statistics, registers and bulletins, and a complete set of course catalogs.

*Social Activism.* The sometimes volatile political relations between the regents, administration, faculty, and students are well documented in the separate records of the Berkeley Division of the Academic Senate, the Office of the President, and the papers of individual presidents, administrators, and faculty who were participants in struggles engaging the campus, local, and world communities. Two comprehensive and highly popular collections, one focused on the Loyalty Oath Controversy (1949–1951) and the other on social protest on campus, including the Free Speech Movement (1964), contain personal reflections, posters, photographs, and other memorabilia. The Loyalty Oath Controversy is particularly well documented from multiple perspectives: the official memoranda, records of the administration (and personal papers of administrators and faculty, including both those who signed the oath and those who did not), the papers of university presidents, and records of the symposium documenting the controversy's fiftieth anniversary.

*Student Life and Activities.* Whether for alumni or the cultural and educational

Third World Liberation Front demonstration to establish Ethnic Studies program, 1969.

anthropologist, the intimate and public history of campus life—in all of its similarities and changes over the generations—is documented in papers, photographs, scrapbooks, newspapers, periodicals, and monographic publications. Residential life, the Associated Students of the University of California (ASUC), sports, fraternities and sororities, campus rituals and cultural events, the founding history and activities of campus institutions—such as International House, Stern Hall, and the Greek Theater—are well represented.

*Pictorial Collections.* A popular feature of the University Archives are the more than 25,000 pictorial images relating to campus history. Among the many subjects represented are cultural activities; athletic events; theatrical performances; ceremonial occasions, including the visits and presentations of major dignitaries, artists, politicians, and scholars; images of prominent Berkeleyans; student social and political life, including fashion and hair styles, dances, and parties; dorm living; and, of course, protests and demonstrations. Campus buildings, landscaping, classrooms, and laboratories are also documented extensively with architectural drawings. These resources are cross-referenced with other forms of archival documentation, providing the opportunity for detailed visual interpretations of the evidence and the tenor and tone of specific events and periods in the University's history.

*Affiliated Collections.* The Archives' collections are supported by several collateral collections within Bancroft, particularly those of the Regional Oral History Office (ROHO) and the History of Science and Technology Program (HSTP). ROHO's University History and Faculty Series and HSTP's collection of departmental records and faculty papers augment the Archives' administrative, departmental, and faculty records and papers.

*The Archives As a Campus Learning Center.* The Library staff—individually and through

Loyalty Oath form.

The Loyalty Oath Controversy erupted in 1949, in the era of McCarthyism and anti-communist "spy trials," when the Board of Regents, at the request of President Robert Gordon Sproul, adopted an anti-communist oath for all University of California employees to sign.

will well and faithfully discharge the duties upon which I am about to enter.

And I do further swear (or affirm) that I do not advocate, nor am I a member of any party or organization, political or otherwise, that now advocates the overthrow of the Government of the United States or of the State of California by force or violence or other unlawful means; that within the five years immediately preceding the taking of this oath (or affirmation) I have not been a member of any party or organization, political or otherwise, that advocated the overthrow of the Government of the United States or of the State of California by force or violence or other unlawful means except as follows:...........................................................................................................................................................................

*If no affiliations, write in the words 'No Exceptions'*

.................................................................................................................................................................................................................

...................................................................................... and that during such time as I am a member or employee of the University of California I will not advocate nor become a member of any party or organization, political or otherwise, that advocates the overthrow of the Government of the United States or of the State of California by force or violence or other unlawful means.

Signature of
Officer or Employee..................................................................

Title.........................................................................................

Department..............................................................................

Campus...................................................................................

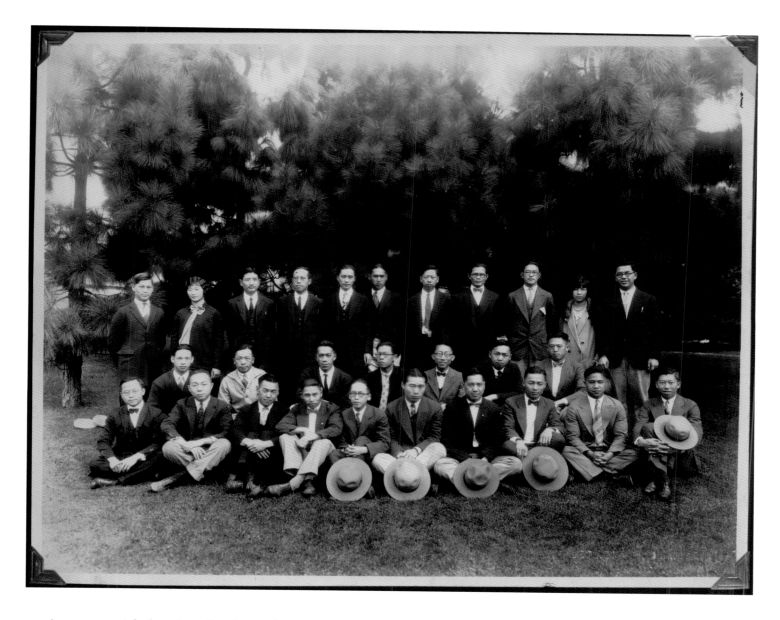

seminars—nourish the educational use of the Archives, assisting professors and their students to make use of primary materials from a variety of perspectives. Those with a focus on the history of education may study the evolution of particular academic disciplines and/or the Administration's structural response to the changing curricular demands in light of new discoveries and student interests. Students of political and social history may explore the ramifications of the issues engendered by student and faculty protests. Cultural anthropology students may investigate the ever-changing transformations of social and other conditions in the campus community. To maximize the research value for both students and scholars—whether on campus or on the web—the Archives are currently embarked on a program to digitize essential historical materials.

*New Initiatives.* As the University enters the twenty-first century, the Archives have entered a period of renewal and expansion of the commitment to document the University's distin-

Loyal Sons & Daughters
of California –
Chinese Students Club.
October 1925

Freshman
Sophomore Brawl
(Tug-of-War),
Class of 1941.

*Amber*, from the
"People Passing
Series: Student
photographs
of the Berkeley
Campus, 2003."
Sasha Gulish,
photographer.

guished history. Two initiatives define the Archives at this important juncture:

First, to put the Archives on a sound organizational footing and to address the major gaps in the historical collections. Some say historical amnesia is a fact of life in California, where the emphasis has always been on today and tomorrow, not the past. It is harshly ironic, given the significance of the University in the history of higher education in the world, that not until the administration of President Kerr in 1964 were the Archives officially so designated—almost one hundred years after the founding of the institution. Up until that time, the Archives was a haphazard, opportunistic collection. Absent an adequate professional status and a

focused interest, important records and documents were collected sporadically or not at all. At the beginning of the new millennium, an advisory task force for the Archives developed a systematic plan for future development, and a few critical steps have been taken to implement it. Staffing has increased, with more promised, and, with luck, persistence, and substantial administrative support, the Archives of the future will be truly worthy and representative of the great institution they serve.

Second, the development of new research and instructional programs and the renewal of continuing academic initiatives. These efforts will stimulate fresh approaches to understanding the history of the University and its role in higher education, as well as a reinterpretation of the collection's direction, organization, and use in light of new scholarship, for example. Certain administrative records once dismissed as insignificant are now considered essential to the cultural and political measure of historical events. The University's constant partnership with academic, private, and public interests requires the vigorous pursuit of relevant documents as they emerge from the University administration, faculty, and students. The University's major role in historic events of the nineteenth and twentieth centuries renews the challenge to identify the players and the records of future value, and to collect and preserve them.

*Pelican* magazine, September, 1924.

Berkeley students have been prolific writers and editors from the earliest days, publishing their work in a wide array of publications. The catalog lists more than 200 entries, reflecting interest in the arts, literature, sports, politics, and humor. The earliest publication was *The College Echo* published by the Durant Rhetorical Society of the College of California. It continued at Berkeley as *The University Echo* (1871–1874). Two of the oldest continuously published records are the *Blue and Gold* yearbook (first appearing in 1873) and the *Daily Californian* (founded 1897). Humor was a particular specialty for Berkeleyans, beginning with *Smiles* (1891) and *The California Pelican* (1903), with its stylish covers. More specialized interests and politics are reflected in publications that flourished (sometimes for no more than a few issues or years) including *Communist Campanile* (1941–1943) of the Young Communist League; *Out in Academia* (unknown date), from the Multicultural Gay and Lesbian Studies Program; *California Engineer* (1922); *California Patriot* (2000), reflecting conservative thought; *Asian Students Unite!*; and the humorous *Heuristic Squelch* (1991).

# At Work | *Community Conflict*

ROBERT M. BERDAHL

For any historian or student of history, the true joy of discovery is in the process of searching through archives containing original materials. Reading letters and documents preserved in the archives becomes a means of literally touching the past and learning from it. For me, there is a sense of awe in handling the actual documents—handwritten or mimeographed memos, now-fragile carbon copies, yellowed telegrams—written by or to the people who form the object of my study.

One of the more interesting uses to which I have put the University Archives was for a presentation I gave entitled "Berkeley vs. Berkeley: A Brief History of Town-and-Gown Relations."

Tensions between colleges and the surrounding communities go back to medieval Oxford, if not earlier. In contemporary America, the sources of conflict have been fairly consistent. They include land-use disagreements; aggravations over parking, traffic, noise, and other real or perceived impacts; student misbehavior; and, especially where public universities are concerned, community angst about institutional exemptions from local regulation and taxes.

Sometimes the disputes are cultural. In the 1920s, for example, the town of Berkeley was up in arms over the plans of the University to build an International House. Not only would non-white students be housed in what was then a racially exclusive neighborhood but male and female students would actually live together in the same structure, albeit on separate floors. Community standards of decency would be violated, neighbors complained. In later years, the wheel turned, and one finds

town-and-gown disputes where the community is pointing an admonishing finger at the campus for not being sufficiently progressive or socially aware on various issues.

Town-and-gown disputes can also arise from the fundamentally different missions of municipality and university. Cities have, as a core responsibility, helping to establish and safeguard the quality of life of their residents. Educational institutions must respond to broader external mandates and impulses. For instance, when a university receives a grant or appropriation to build a high-tech laboratory in some cutting edge scientific field, the university is apt to emphasize the state, national, or international benefits of the research that will be conducted there, while the town will focus more on the issues that are, literally, closer to home, such as construction impacts, additional traffic, or possible toxic wastes.

My research included far more material than I could use in the talk (this is nearly always the case, and is particularly amplified at Bancroft, which has such a wealth of primary research resources). I reviewed the records dating from the conflict over the construction of Memorial Stadium, the development in the 1940s and 1950s of plans for the physical expansion of the campus, the long-standing conflict between the city and the campus over traffic and parking, and a large file of complaints about student misbehavior in the later 1940s in the neighborhoods adjacent to the campus.

I read, for example, dozens of letters from beleaguered boarding house and homeowners near campus who reported their fences demolished and even some of their furniture

Greek Theater: Axe Rally,
November 18, 1948

taken to fuel the many bonfires that were lit in the public streets by students—not in political protest but to celebrate victory in the annual Big Game with Stanford.

I was both heartened and discouraged to learn that previous presidents and chancellors dealt with most, if not all, the same tensions we face today. I was also reassured to learn that students in earlier decades were every bit as raucous in their behavior as they are today. And I was thankful to my predecessors, their staffs, and Bancroft for ensuring that illuminat-

ing records were preserved on such subjects. For those who tend to think of the past as the good old days, a trip to the archives is often an important reality check.

*Robert M. Berdahl is Chancellor Emeritus of the University of California, Berkeley.*

# Collection Highlights

## Administration

### RECORDS

Regents of the University, 1868–1933

Office of the President, 1885–

Office of the Chancellor, 1952–

Chancellor's Advisory Administrative Council, 1952–1965

Chancellor's Advisory Committee on Discrimination, 1958–1960

Dean of the Undergraduate Division, 1920–1930s

Dean of Students, 1922–1970

Office of the Registrar, 1869–1948

Housing Office, 1910–1981

Office of Research Administration, 1940–

University Extension, 1949–1965

Cooperative Extension, 1918–

Academic Personnel Office, 1920–1981

College of Agriculture, 1889–1908

Department of Anthropology, 1901–

Department of Astronomy, 1882–1960

College of Chemistry, 1874–1955

School of Criminology, 1916–1975

Department of Dramatic Art, 1911–1977

College of Engineering, 1906–1954

College of Environmental Design, 1959–

Boalt Hall School of Law, 1909–

School of Librarianship, 1899–1950

Department of Military Science and Tactics, 1872–1944

Department of Physics, 1919–2002

Museum of Vertebrate Zoology, 1908–1949

### PAPERS

Clark Kerr Papers, 1952–2003

George and Phoebe Hearst Papers, 1849–1926

Charles Hitch Papers, 1968–1975

John Neylan Papers, 1911–1960

Robert Gordon Sproul Papers, 1929–1975

Correspondence and Papers of the University Controller, 1868–1942

## Faculty

### RECORDS

Academic Senate, 1869–

Loyalty Oath, 1949–1964

Academic Personnel, 1910–1985

Committee on Research, 1921–

Section Club, 1907–

### PAPERS

Luis W. Alvarez Papers, 1943–1987

Bruce Ames Papers, 1951–1999

Horace A. Barker Papers, 1933–1999

Melvin Calvin Papers, 1938–1986

Owen Chamberlain Papers, 1943–1996

Peter H. Duesberg Papers, 1965–1998

Donald A. Glaser Papers, 1947–1997

Daniel E. Koshland, Jr., Papers, 1965–2000

Alfred L. Kroeber Papers, 1869–1972

Emilio Segrè Papers, 1942–1989

Wendell M. Stanley Papers, 1926–1972

Gunther S. Stent Papers, 1915–1998

Jerzy Neyman Papers

Warren Winkelstein Papers, 1960–

## Student Life and Activities

Student Housing, 1950–1976

Office of Student Activities, 1917–1990

Skull and Keys Society, 1892–1952

International House, 1928–

Cal Band, 1934–1952, 1958–1974

Order of the Golden Bear, 1900–1966

Circle C Society, 1947–

Student Dormitory Associations

Associated Women Students, 1912–1968

Free Speech Movement, 1959–2001

### PUBLICATIONS

*Pelican*, 1903–

*Blue and Gold* Yearbook, 1874–

Newspapers

Media Coverage

### SPORTS

California Memorial Stadium, 1920–

Women's Athletic Association, 1921–1972

## Campus Planning and Architecture

### LANDSCAPE

Master Building Files, 1950–1969

Architectural Drawings, 1889–

Phoebe Hearst Architectural Plan, 1898–1900

John Galen Howard Papers, 1874–1954

All-American tailback Vic Bottari gains against UCLA at Memorial Stadium in Berkeley, October 15, 1938 in Cal's 20-7 victory. The previous year Bottari led the undefeated Golden Bears to the Rose Bowl, January 1, 1938, where he was named Player of the Game after scoring two touchdowns to defeat the University of Alabama, 13–0.

## Town and Gown Relations

August Vollmer Papers, 1918–1955

People's Park Clipping Files, 1969

## Pictorial Collections

Greek Theater, 1903–

Campus Views, 1873–

Campus Events, 1880–

Lawrence Berkeley Laboratory, 1940–

Portraits of UC Individuals and Groups, 1850–

Photographs of the University of California, Berkeley, 1961–1996

Photographs of the University of California, Berkeley, 1968–1970

Views of the College of California, 1855

Photographs taken by Ansel Adams for the Centennial of the University (1968)

# Center for the Tebtunis Papyri

Todd Hickey, CURATOR, ASSOCIATE DIRECTOR, AND
ASSISTANT PROFESSOR OF CLASSICS

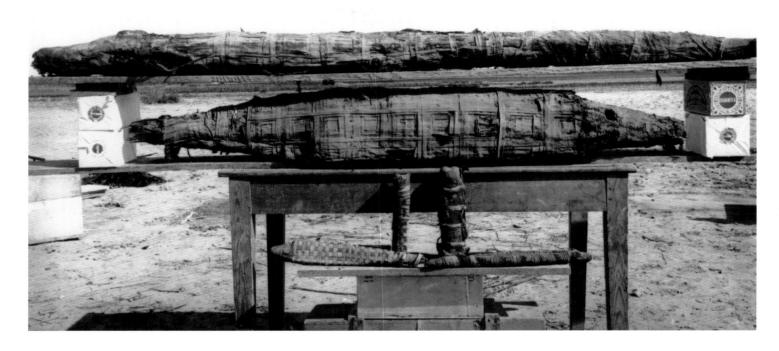

## Collection Profile

| | |
|---|---|
| *Geographic site* | Umm el-Breigât (ancient Tebtunis), 29 07' N 30 45' E (roughly 70 miles southwest of Cairo) |
| *Chronology* | 3rd century BC—4th century AD (with a few exceptions) |
| *Number of papyri* | approximately 31,000, of which fewer than 1200 have been published |
| *Collection subject areas* | agriculture, demography, economics, government, law, literature, religion |

I KNOW MORE ABOUT A FAMILY of Egyptians, priests of the crocodile god Soknebtunis, than I do about my own family. I can trace my own roots only back to the nineteenth century, and about those ancestors who lived before my grandparents, my information is rather incomplete. In contrast, I have data about eight generations of the priests—all of whom lived more than 1700 years ago—and enough of it to fill an entire book.

The principal reason for this anomaly is simple: My own family has not consciously recorded its history, and it has tended not to maintain the records that it has been given. The priests, on the other hand, were part of a culture in which both physical preservation (think mummies) and record-keeping verged on obsession. Much of this recording-keeping was done on papyrus, and thanks to a dry climate in which most organic material buried above the water table survives, we now possess a wealth of documentation concerning the lives not only of priests, but of a remarkably broad section of Græco-Egyptian society. No part of the ancient Mediterranean is better documented than Græco-Roman (332 BC–AD 641) Egypt.

Most of the priests' papers that I am studying currently reside in The Bancroft Library, where they form part of the Tebtunis Papyri Collection, the largest assemblage of its kind in the New World and one of the largest anywhere. The collection came to Berkeley through the generosity of Phoebe Apperson Hearst, who, at the instigation of Egyptologist George A. Reisner, financed the 1899–1900 excavation season of Oxford papyrologists Bernard Pyne Grenfell and Arthur Surridge Hunt. Mrs. Hearst's £500 investment (equivalent to about $60,000 today) was an excellent one: The site at which Grenfell and Hunt chose to work, Umm el-Breigât, the ancient Tebtunis, was rich, yielding over 31,000 fragments of Greek, Egyptian, Latin, and Arabic papyri. Grenfell informed Reisner that he did not think that he would ever have such a season again. He would not.

The "Tebtunis" papyri were actually unearthed at four distinct sites: the town itself, in which the textual material was largely of Roman (1st–4th c. AD) date; a human necropolis south of the town, from which papyri dating to the third and second centuries BC came; an adjacent crocodile cemetery, which yielded texts from the second and first centuries BC; and another human necropolis some six miles to the west at Kom el-Khamsin, a site for which most of the textual material is now missing. The papyri from the three

OPPOSITE PAGE

"Crocodile mummies found at Tebtunis."
*Courtesy of The Egypt Exploration Society.*

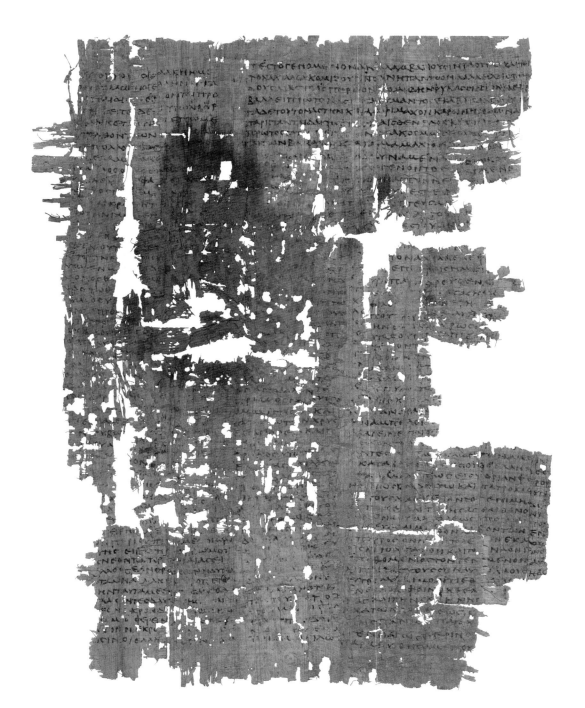

cemeteries were recycled material, reused by the morticians either to make "papyrus-mâché" masks, pectorals, and footcases for people or to stuff or wrap crocodiles. They also largely concern affairs in nearby settlements: in the case of the Tebtunis human mummies, Oxyrhyncha; of the crocodiles, Kerkeosiris.

According to the regulations of the day, Egypt retained only a portion of the finds, in the case of the Tebtunis excavation, some papyri in demotic Egyptian and some objects. The lion's share came to Berkeley: the objects, about 2,500 of them, immediately to UC's new Museum of Anthropology in San Francisco (now the Berkeley cam-

Unique fragment of the lost Greek original of Dictys Cretensis' *Ephemeris belli Troiani* (Diary of the Trojan War; 3rd c. AD).

pus's Phoebe A. Hearst Museum of Anthropology); the papyri, after a sojourn of almost forty years (in some cases, more) in England for study and publication, to the Library, and in 1970, to the Rare Book Collection of The Bancroft Library.

Highlights of the Berkeley portion of the collection include unique fragments of Sophocles' lost satyr play *Inachos*; a unique fragment of the lost original Greek version of Dictys Cretensis' *Ephemeris belli Troiani*, one of two works responsible for transmitting the Trojan War legend to the Medieval West; the oldest witness to the *Georgics* of Vergil

Unique fragments from Sophocles' lost satyr play *Inachos* (2nd c. BC):

[CHORUS]
*Very, very knowing was whoever it was among those of the past who rightly called you by your name, beneath the uncanny darkness of the cap of Hades!*

[?]
*No, from the noises you are making we can guess that it is the messenger of Zeus' amours, the great errand-runner, Hermes!*

[?]
*Hermes himself, yes, himself, who has turned back towards me.*

[?]
*You are likely to have a second effort go for nothing before you can wink!*

[CHORUS]
*Ho! Do you see? It's best to keep away! It drives you mad to hear it. In truth, Zeus, your word cannot be trusted!...accursed...with a clasp...*

[?]
*...very subtle whispers. The sons of Zeus [like those of Sisyphus] are up to every trick.*

[?]
*Is it Zeus, is it Zeus indeed whose lackey he is? He's coming at me!...There's terror in the sound of him!*

Translation by Hugh Lloyd-Jones

(a writing exercise); an early demotic Egyptian mythological text concerning the battle between the sun god Re and the serpent Apophis; and the earliest securely dated image of the protective sphinx god Tutu. Also of great importance are the ancient administrative and private (or family) archives that are preserved in the collection, the letters, contracts, accounts, and other documents that individuals deliberately assembled in antiquity. These include the archives of the village scribe Menches, of the *sitologos* (granary official) Adamas, of the landowners Sarapias and Sarapammon, and of the village administration of Oxyrhyncha. The research and instructional value of the entire collection is enhanced by the objects from the site, which provide a material context for the written evidence.

Despite its manifest importance, the collection's history at Berkeley was mixed until about a decade ago. University faculty and staff were alarmed by the condition of the papyri upon their arrival on campus in 1938. None of them had undergone any preservation treatment, and they were stored between sheets of the *Oxford University Gazette*. Some

Fragment of Book II of
Homer's *Iliad* (2nd c. AD).

of the pieces had apparently suffered water damage. The University's attempt to rectify matters, however, would prove even more harmful to the collection. Since there were no papyrologists in the vicinity, Edmund Kase, Jr., who had received his papyrological training at Princeton, was hired during the summer of 1940 to provide guidance on the cataloguing and preservation of the collection. Kase advised using Vinylite plastic, then "brand new," as a mount, citing its light weight, ease of storage, and safety advantages over glass. He did not realize that it would scratch easily, was flexible enough to allow breakage of papyrus

fibers, and was an excellent generator of static electricity. When one attempts to remove one of Kase's Vinylite mounts, the papyrus, which consists of two (perpendicular) layers of fibers, is torn apart. The plastic mounts, which were sealed completely, also prevented access to the papyrus, essential for a largely unstudied collection in which joins between fragments are likely.

For decades after his departure, Kase's choices hardly mattered: There was no one on campus to make any joins. Berkeley had a papyrologist on its faculty for only a short period during the late 1960s and early 1970s, and the research foci of the potentially interested departments largely lay elsewhere. Activity in the collection came primarily from the outside. The microfilming of most of the collection in 1979 by the International Photographic Archive of Papyri curiously did not result in a significant increase in such activity, and in the eyes of most papyrologists, myself included, the important work had long ago been completed, when, in truth, less than five percent of the papyri had been adequately studied.

The fortunes of the Tebtunis papyri began to change in the mid 1990s. On the initiation of Rare Books and Manuscripts Curator Anthony Bliss, Bancroft became a founding member of the Advanced Papyrological Information System (APIS) Project, an NEH-funded web-based catalogue of the United States' largest papyrus collections. Through APIS, the conservation errors of the past began to be corrected. The project's great success, combined with the tireless efforts of Bliss and Dr. Arthur Verhoogt, the Leiden papyrologist hired by Berkeley for the project, led to greater faculty awareness and interest and, eventually, to the creation of the Center for the Tebtunis Papyri in 2000 as one of the eight new campus research institutions funded by Vice Chancellor for Research Joseph Cerny.

I was hired as the Center's first papyrologist and curator of the collection in 2001, and have since striven to create a papyrological institute the equal of any in America or Europe. The Center is now part of an international network of institutions studying Tebtunis; it has its own publications, sponsors a full slate of events, and hosts visitors from around the world. It also provides formal training to graduate and undergraduate students in papyrology and the history and culture of Græco-Roman Egypt, and, through these courses, as well as its research, apprenticeship, and volunteer programs, affords individuals from the University and the community beyond the Academy the opportunity to apprehend the ancient world firsthand, to experience the immediacy, the shared humanity, and, perhaps, the spark that changed the course of my own life some years ago.

# At Work | *Sacred Crocodiles*

DOROTHY J. THOMPSON

To build a career on the stuffings of sacred crocodiles may be unusual, but the Tebtunis papyri now housed in The Bancroft Library have allowed me to do so. Since I first started work on them in the early 1960s, I have been fascinated by the historical importance of the papyri once used as waste paper to wrap the sacred crocodiles in mummification. When Bernard Pyne Grenfell and Arthur Surridge Hunt excavated the crocodile cemetery in January 1900, the texts that they found included a batch of official papers from a neighboring village, along with some private letters and accounts, from the last decades of the second century BC. In my book based on these texts (D. J. Thompson, *Kerkeosiris: An Egyptian Village in the Ptolemaic Period.* Cambridge, 1971), I was able to reconstruct the village as a working unit, to establish the various categories of land, the crops that were grown there, the population of the village, including its ethnic make-up, and the effect of national events on the local scene as illustrated in the land grants made to soldiers from outside.

For the ancient world outside Egypt such material is unparalleled in the wealth of unvarnished information it brings. Reading papyri, written in Egyptian demotic or in Greek, the historian comes face to face with the details of everyday life in the villages and towns of rural Egypt, unfiltered by literary sources. "You must know about our land being flooded over," writes Petesouchos to Marres. "We've not enough to feed our cattle. Please, first, give pleasure to the god and, secondly, save many lives by seeking out five arouras [the standard unit of area in Græco-Roman Egypt: I aroura = .68 acre] of land round your village to provide us with food for ourselves. If you can do this, we shall be eternally grateful. Farewell" (*P. Tebt.*

I 56). Then again in 112 BC, we find an order from Alexandria (*P. Tebt.* I 33): "Lucius Memmius, a Roman senator who holds a post of high dignity and esteem, is making the trip from Alexandria to the Arsinoite nome [one of the districts into which Egypt was divided for the purpose of regional government] to see the sights. He should be received with particular attention; make sure the guest chambers are prepared and landing stages built; the hospitality gifts listed below should be offered to him as he lands, the rooms should be properly appointed, and the regular food prepared for feeding [the crocodile god] Petesouchos and the crocodiles...." In cases like these, the level of hospitality clearly mattered.

The Menches dossier from which these examples are taken is just one part of the papyri from Tebtunis. The human mummies in nearby cemeteries yielded other texts, as did the town itself. In researching my latest book, written with Willy Clarysse (*Counting the People in Hellenistic Egypt.* Cambridge, 2005), Tebtunis papyri are featured again. On one papyrus, a local village scribe penned a salt-tax register organized by occupational category and listing all adults, household by household. On the basis of lists such as these, we have been able to analyze the population in both ethnic and occupational terms. Demographically, such salt-tax registers present the best information about family and household structure for the Western world before the fifteenth century.

What else is hidden in these texts, many of which still wait to be read?

*Dorothy J. Thompson, Fellow of Girton College, Cambridge, is a Fellow of the British Academy and President of the International Association of Papyrologists.*

OPPOSITE PAGE

Petition of the priests of Soknebtunis to the district governor; they ask that a certain Kronion be made to appear before the Prefect of Egypt's circuit court:

To Theon alias N.N., *strategos* of the divisions of Themistes and Polemon of the Arsinoite nome, from Kronion, son of Pakebkis, and Maron, son of Kronion, and Maron, son of Maron, and Panesis, son of Marsisouchos, and Panesis, son of Onnophris, and Panesis, son of N.N., all six independent and exempted priests of the famous temple at Tebtunis in the division of Polemon. Having an account against Kronion, son of Sabinos. concerning the outrages that he committed against us, which we will disclose at the specified time, we beg you to give him notice through one of your attendants to appear at the assize to be auspiciously held by his Excellency the prefect Pactumeius Magnus. I, Kronion, son of Pakebkis, have presented the petition.

(*Co-signed*)
I, Maron, son of Kronion, have presented it with him. I, Maron, son of Maron, have presented it with him. I, Panesis, son of Marsisouchos, have presented it with him. I, Panesis, son of Panesis, have presented it with him....

# Collection Highlights

# Mark Twain Papers and Project

Robert H. Hirst, CURATOR, GENERAL EDITOR, AND
ADJUNCT PROFESSOR OF ENGLISH

## Collection Profile

| | |
|---|---|
| *Chronology* | 1835–1910 |
| | *Mark Twain Papers (originals and various kinds of copies of originals)* |
| *Manuscripts* | roughly 700 stories, sketches, essays, letters to the editor, fragments, drafts, revised proofs, and working notes, left unpublished by Mark Twain, as well as manuscripts for all but two of his books and for one-third of his short works |
| *Personal and business letters* | 11,000 by Mark Twain or his immediate family; 17,000 received |
| *Notebooks* | fifty personal notebooks kept by Mark Twain between 1855 and 1910 |
| *Autobiography* | ten or eleven linear feet of both handwritten and dictated (typed) autobiography, never published in complete form |
| *Scrapbooks* | three dozen containing clippings, including unique copies of his work in Nevada newspapers, as well as documents, interviews, and news reports saved by Clemens, his secretaries, or members of his family |
| *Records* | book and other contracts, mining deeds, financial records, bills, checks, bank statements, and numerous contemporary news reports about Mark Twain |
| *Personal library* | 150 books, almost always with extensive marginalia; photocopies of an additional 140 books, with marginalia, owned by other institutions and collectors |
| *Pictorial* | 500 photographs of Mark Twain, his family, friends, and associates, as well as numerous places, houses, cities, and towns where he lived and worked |
| *Editions* | first and other lifetime editions, authorized and otherwise, for all Mark Twain's works, plus translations |
| *Collateral documents* | diaries, photographs, and other documents kept by Mark Twain's contemporaries, often referring to him |

# Mark Twain Project

THE PROJECT INTENDS TO PRODUCE scholarly editions of everything that survives of Mark Twain's writing. Scholarly editions establish the most accurate possible text; document how the editors established that text; record the history of its original composition, revision, and publication; and restore to it such things as the original illustrations. They also provide explanatory notes and supply various kinds of supplemental information. These editions are published by the University of California Press in printed volumes and soon will be available in an electronic edition.

Dr. A. Reeves Jackson, Clemens, Olivia Clemens, and Julia Newell Jackson on the porch of the Hartford house sometime in 1875. Clemens had first met his guests on the *Quaker City* excursion in 1867. Dr. Jackson became a character in *The Innocents Abroad.*

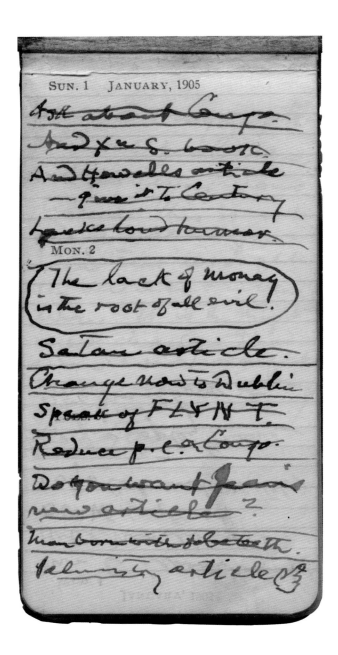

Mark Twain kept at least one notebook per year, and fifty of these survive, all but four of them in the Mark Twain Papers. He has circled one of his recently coined aphorisms. The page was written in January 1905.

# Mark Twain Papers

THE PAPERS HOLD THE WORLD'S largest archive of original manuscripts and documents by and about Mark Twain, born Samuel Langhorne Clemens in 1835. No other American writer of the nineteenth century left so large and fertile an archive of his own writings and personal documents. And no other American writer of that period had so large an impact on American literature and Americans' view of themselves. Mark Twain has become, by common consent, the representative American writer of his time, with both a large popular following and major scholarly attention.

Those charged with caring for his papers have steadily added new documents to the collection—scrapbooks, letters, literary manuscripts, and collateral documents and manuscripts written by his friends and associates, not to mention first and other rare editions of his work. There has been, in addition, a systematic effort to acquire photocopies of all manuscripts, letters, and documents owned by other institutions and private collectors. New documents, including letters and manuscripts long thought to be lost, continue to be found, purchased, and copied even in 2006, almost 100 years after Mark Twain's death in 1910. The result of these several forms of collecting is that the Papers have become both a real and a virtual archive of originals or photocopies of everything known to survive in Mark Twain's hand, as well as of thousands of collateral documents bearing on the study of his life and works. The Papers are the one place in the world that scholars can find practically all of the primary and secondary literature they need to pursue research into Mark Twain's life and works. Dozens of scholars visit the Papers each year for that purpose.

The core of the Papers consists of the literary manuscripts, typed autobiographical dictations, notebooks, letters, photographs, drawings, bills, checks, contracts, clippings, scrapbooks, and books that Mark Twain put in the hands of his official biographer and literary executor, Albert Bigelow Paine. Paine used these documents for his biography (1912) and also published small selections of the letters, notebooks, and autobiography,

quietly censoring the texts to remove whatever he thought should not be published. He also declined to allow other scholars to see the Papers. When he died in 1937, he left them largely unpublished and in a state of partial chaos—problems he handed on to his several successors.

Under Paine's immediate successors, first Bernard DeVoto and then Dixon Wecter, the Papers were slow to find a permanent home, in part because Mark Twain's only surviving daughter, Clara Clemens Samossoud, was prevented by the terms of her father's will from transferring ownership except through her own will. Mark Twain did not distrust his daughter so much as he distrusted her ability to withstand avaricious suitors. He therefore left all his property—cash, stocks, bonds, real estate, and these papers—in trust for her, expecting the income from that trust to support her. If she had wanted to sell the Papers, she would have had to persuade the trustees of her father's estate to let her do so. Instead, she bequeathed them—initially, to Yale, which was the first university to grant her father an honorary degree.

During her lifetime, therefore, the Papers had at first only temporary homes—at Harvard's Widener Library under DeVoto, then at the Huntington Library in southern California under Wecter—before coming to rest in the Berkeley library in 1949. They came with Clara's consent and at the request of Wecter, who was then the official literary executor of Mark Twain's estate. Wecter was writing a biography of Mark Twain and had just taken a job in UC Berkeley's history department. Relying on his exclusive access to the Papers for that biography, he did not relish the possibility, should Clara

One of the drawings Mark Twain made for his history game, an invention designed to help players learn the principal dates of English history.

Clemens contributed $50 to the effort to build Walt Whitman "a little cottage in the country." Whitman thanked him on June 14, 1887, evidently mistaking Clemens' middle initial as "E" rather than "L."

die unexpectedly, that they might be scooted out from under him and away to Yale. So shortly after they arrived on loan to the library at Berkeley, he suggested to Clara that she revise her will so that the Papers would ultimately be given to the University of California rather than to Yale. On June 20, 1949, she executed a codicil to her will that did exactly that, excepting only the manuscript for *Joan of Arc*, by common consent the worst book Mark Twain ever wrote, but in the eyes of his family, the best. It was given as a consolation prize to Yale. And when Clara died in 1962, the Papers, except *Joan of Arc*, found a home in the Rare Books Department of the Berkeley Library. When Rare Books was merged with Bancroft in 1970, at the insistence of Bancroft's new director, James D. Hart, the Papers came along as a distinct collection within The Bancroft Library.

Henry Nash Smith, professor of English at Berkeley, and after him Frederick Anderson, his assistant, succeeded Dixon Wecter as official literary executor of the Papers. Wecter died suddenly in 1950, shortly after coming to Berkeley. With Clara's death in 1962, Smith and Anderson were able to make the archive publicly accessible in ways it had never been under Paine, DeVoto, or Wecter. And under Anderson a selected scholarly edition of the Papers was begun, made possible under a contract between the University of California Press and the trustees of Mark Twain's estate, and later of Clara's estate. With the crucial support of the Modern Language Association's Center for Editions of American Authors, and later of the National Endowment for the Humanities, the editors published their first

...lections; + then he called suddenly
...way. After a day or two, prepare
...resume. You will now find
...hat the pages are hopelessly warped,
...e mucilage has soaked through
...made the print almost illeg-
...ble, + that colored leaves are a
...ateful thing in a scrapbook.
      Now buy a new ~~book~~,
...with pure white, stiff leaves
...— + get one ounce of good
...gum tragicanth. Leave
...a dozen flakes of the gum
...soaking in a gill of water
...over night; in the morning, if
...the gum is too thick + stiff, add
...water, but precious little of it,
...for the' paste should not be thin.

three volumes in 1967. After Anderson's death, the undersigned was appointed General Editor in 1980, and the plans for this selected edition were enlarged to undertake a comprehensive edition of everything of significance Mark Twain wrote but did not publish: letters, notebooks, his autobiography, and hundreds of literary manuscripts. The unpublished papers project was soon joined with another ongoing effort, begun at the University of Iowa in the early 1960s, to publish scholarly editions of all works Mark Twain published in his lifetime. In the same year of 1980, the Papers (Berkeley) and the Works (Iowa) were merged into a single undertaking based at Berkeley; the shotgun wedding was presided over by NEH, which made it plain that it was not about to fund two separate Mark Twain projects. The enlarged editorial program, with its team of six professional editors devoted to completing the enormous enterprise, was dubbed the Mark Twain Project. These ongoing editions of Mark Twain make up by far the largest publishing program in The Bancroft Library, as well as the largest scholarly edition anywhere devoted to a single writer.

What do editors do? Why is it necessary to edit what Mark Twain wrote? Answers to these questions differ somewhat with the kind of materials being edited.

In the case of Mark Twain's letters, of which at least 11,000 are presently known, with more found virtually every week—many on eBay—perhaps the first question ought to be "Why publish or edit letters at all?" The answer is simple: Letters are the royal road

"Recipe for Making a Scrapbook." A March 1873 contribution to the scrapbook of Mark Twain's St. Louis friend, Louisa I. Conrad. He himself patented a scrapbook of his own invention in June 1873.

DV # 316.    1892

The Snow-Shovelers.
=

[A peaceful Sabbath
morning in the elegant-residence
end of a large New England
town. Time, 8 a. m. A deep
shroud of new-fallen snow
covers everything. To the limit
of sight down the white avenues,
not a creature is stirring, no
life is visible. There is no wind,
not even a zephyr; the stillness
is profound. Presently, in the
distance a negro appears
upon Mr. Morgan's long frontage,
~~with~~ + another one appears

2

at the same time on Mr.
Newton's long frontage. They
disturb the Sabbath hush with
a couple of muffled scrapes
of their snow-shovels. They
look up & discover each
other. For the next half hour
they lean upon their shovels
& converse at long range
in powerful voices. Now
& then they spit on their hands,
but that is as far as their
activities get.]

Aleck. Hyo, Hank, is dat
you?
Hank. Hello, ~~Hank~~ Ellick
—Dat you? Is you a shovelin'
for Misto Morgan?

First two manuscript pages from "The Snow-Shovelers," an eleven-page sketch written in Hartford in 1886. In it Mark Twain gently satirizes the "socialists" and the "anarchists" through a dialect conversation between two African-Americans shoveling snow for private residences in Hartford.

to all biography and literary history because they record how the writer saw his world at the time they were written and sent, often with details no one would think important enough for official history, and with the all-important property that they were sent out into the world and (for the most part) not subjected to the author's later ideas or second thoughts. They are personal, often impulsive, free from many literary conventions, and in Mark Twain's case they therefore give us verbal snapshots of how the writer was thinking at the time, not what he thought about the experience in retrospect. For Mark Twain one must add that he seems routinely to have lavished his verbal and literary talents on letters of the most ordinary kind and purpose, so much so that we actually hear him speaking directly to his correspondents in ways that no other literary form permits. Mark Twain's letters, once reassembled and ordered chronologically, will become the great unread work of his career.

The first editorial problem posed by letters is simply finding them. Because, by and large, Mark Twain did not make copies of the letters he sent, they must be sought in the hands of the descendants of his correspondents, in those of private collectors, and in hundreds of institutions of all sizes, from university libraries down to the most humble county and village historical societies. Since Mark Twain probably wrote at least 50,000 letters in his lifetime, the discovery phase of the editorial task is not likely to end anytime soon. Editors continually find letters and add them to the chronological files.

A letter's date is crucial to its value as evidence but by no means always self-evident. For letters written without a date, or with the wrong date, editors must know how to infer the actual date from the contents, the paper and ink used, or from any other evidence in letters and documents of known date. Once letters are correctly dated, the next step is to decide what must be explained to make them useful to scholars or even to ordinary readers. Annotation also tests the date assigned by Mark Twain himself, which may seem straightforward but can be off by days, months, or even a year (think of your own habits when January comes around).

Transcribing the letter accurately and completely is itself a major editorial challenge. It entails reading exactly what Mark Twain wrote, including all crossed-out words and passages in the letter, then re-encoding his text into a typographical transcription for maximum legibility and searchability. Why transcribe cancelled words and passages? Because these were, by and large, quite legible to the original recipients. How Mark Twain or any writer changed what he wanted to say is something everyone has a natural curiosity about—as Mark Twain himself well knew. Good evidence suggests that he expected

correspondents to be able to read his cancelled passages, and indeed that he knew certain correspondents, such as his fiancée, Olivia Langdon, were regularly trying to decipher such passages.

There are always letters whose originals do not survive, so the documents in which they do survive need to be transcribed and changed to restore as much as possible of the lost original, something editors need training and experience with thousands of originals in order to do well.

The editorial challenge of published works is usually rather different from those posed by letters, although there are also similarities. For instance, finding what Mark Twain published while he worked as a newspaperman in the West can be time consuming, involving years of searching microfilms and comparing newspaper texts. Original manuscripts from this period are not likely to be found. The best one can hope for is to find the first printing of, say, what Mark Twain wrote for the Virginia City *Territorial Enterprise* or the San Francisco *Alta California* or about a dozen other newspapers on which he worked at various times.

Of the newspapers for which Mark Twain wrote, most do not survive in complete files anywhere, the last having been destroyed in the 1906 earthquake and fire in San Francisco. The problem is, therefore, to find original clippings in scrapbooks—or to locate other contemporary newspapers that reprinted part or all of what he published in the *Enterprise*—and then to compare those texts to restore as much as possible of what must have appeared originally.

With published books like *Adventures of Huckleberry Finn*, the problem is to eliminate as much corruption from the text as possible. To do that, one must find the original documents used to write and publish the text: the manuscript, any typescripts made of the manuscript, working notes, proofs, first and revised printings. From these documents, and from a detailed record reconstructed from letters both from and to Mark Twain, editors seek to establish in detail exactly who had access to the evolving text and when. That permits them to weed out errors introduced, say, by the typist copying the original manuscript or by the typesetter, who had his own notions about punctuation. The goal is to eliminate such errors in order to make the text as authorial as possible, but the result is also a very complete record of how the author revised his text, something not usually obtainable except through this kind of research.

For example, even though the typescript of *Huck Finn* that Mark Twain revised for the printer is lost, the editors can show that the author brilliantly revised his original

A first edition of
*Huckleberry Finn*, published
by Mark Twain's own firm,
Charles L. Webster & Co.,
in February 1885.

draft of Huck's famous description of the sunrise on the Mississippi (critic Harold Bloom has called the finished passage "the most beautiful prose paragraph yet written by an American"). Twain did not write this passage in a single burst of inspiration but achieved it rather by extensively revising his original draft on the typescript. For instance, to Huck's original description of the breeze as "sweet to smell, on account of the woods and the flowers," he added Huck's honest qualification: "...but sometimes not that way, because they've left dead fish laying around, gars, and such, and they do get pretty rank." Since the typescript is lost, these revisions can be read only by an editorial reconstruction of what occurred on that typescript.

With books such as *Huck Finn* it is also necessary to provide the best possible restoration of the illustrations—which always accompanied Mark Twain's texts—either by finding proofs or original drawings and photographing them for reproduction or, more commonly, by simply finding a pristine copy of the first edition and photographing it to provide the illustrations.

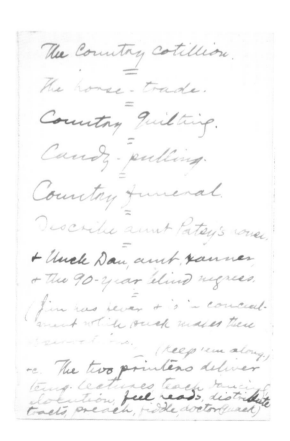

A working note for
*Huckleberry Finn*. At the
bottom of the page, Mark
Twain solves his problem
of motivating Jim and
Huck to go south. "Keep
'em along" refers to the
King and the Duke, who
come on board the raft
and enforce its southern
course.

The Project's diverse editorial activities are devoted to providing a comprehensive historical record of what Mark Twain wrote, whether or not he published it, as well as revealing a highly detailed and accurate record of what he was saying and doing at any given moment. His letters and notebooks, especially when accurately transcribed, dated, and supplied with explanatory notes, provide a fundamental record from which biographers and literary critics can do their work, in full confidence that they are reading what Mark Twain wrote and, to the extent that these materials survive, of what he was concerned with at any given point. The

critical editions of his published works continue to provide information about how his text was intended to read, as well as how he revised it to that end. Critical editing of any text constitutes the most fundamental and searching form of reading that text, and of trying to understand what its author meant by it.

The Papers and Project are by now completely intertwined enterprises. The editors are committed to maintaining the archive in the most fully integrated and informed way, with access to all known documents, accurate chronology, and complete transparency with respect to what is documented and what is not. At the same time, the editors are committed to publishing in print, and now increasingly in electronic form, all of the texts Mark Twain wrote and as many of the texts written by his family, friends, and associates as seem useful in the continuing process of trying to understand him and what he wrote.

The Mark Twain Papers and Project continues to maintain a professional staff of six, all but one of whom are paid precariously from grants and gifts. With some thirty volumes published and the equivalent of another forty to go, the Project also needs to train new editors to replace those who will retire after thirty-five or forty years on the job. The archive itself will always contain documents not scheduled for publication, including many letters to Mark Twain, his financial records, and letters between other family members. (Publication online may well make it feasible in the future to publish at least digi-

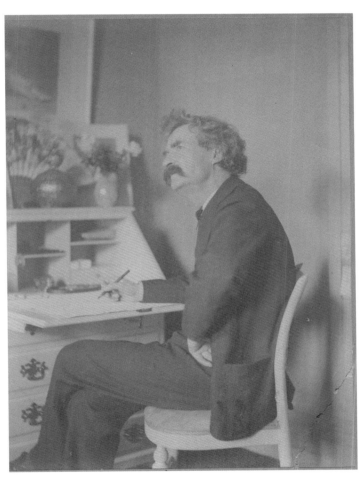

Mark Twain in 1880, probably at Hartford, about the time he was writing the middle portion of *Huckleberry Finn*.

tized images of even these relatively minor documents.) It seems apparent that when the editorial project eventually draws to a completion, the body of those documents can and should continue to serve as the nucleus of a center for studying the history of Mark Twain's times and culture. To make the transition to this broader focus will entail several changes, including a broadening of the kinds of documents the Papers collect. For instance, the editors recently decided to accept the gift of some papers of his biographer Paine, who wrote many other books besides *Mark Twain: A Biography*.

# At Work | *Mark Twain: A View of the Nineteenth Century*

Mark Twain in front of the Clemens family's house in Hannibal, Missouri, where he grew up in the 1840s. Taken in May 1902 on his last visit to Hannibal.

ROBERT MIDDLEKAUF

To do research in the Mark Twain Papers and Project is for a historian much like entering heaven. The papers of Mark Twain are found in the collection, either in original manuscripts or facsimiles, along with a small collection of reference works and editions of works by Mark Twain's literary peers. The editors preparing the scholarly edition of Twain's letters and works are friendly and helpful (although their primary work is not to serve visiting scholars). What's more, the editors know much more than you do, whoever you are, about Mark Twain—and probably know more than you do about the topic that has brought you to

this scholarly paradise.

My research in the Papers and Project is probably different from that of most scholars who pass through its doors. Most researchers have narrower interests in Mark Twain and well-defined subjects. In the past few years, for example, Karen Lystra studied the final ten years of Twain's life, spending much time on his own narrative—referred to in the editorial project as the Ascroft-Lyon manuscript after the principals who lived with him during most of those years. The conclusions Professor Lystra reached were published in 2004 by the University of California Press in *Dangerous Intimacy.*

Because of Mark Twain's broad interests and his almost universal appeal, far different research approaches to his papers are common. A Japanese scholar, Yoshio Kenaya, has worked in the Papers for several years, using manuscripts and printed materials to translate Twain's lectures from English into Japanese.

My work in the Papers is in part historical and in part biographical. I am interested in seeing Mark Twain in the broad context of nineteenth-century American culture. His life and writings can tell us much about that culture, and we can also learn much more about him when he is seen in the rich mix of nineteen-century American history. Recently, I have attempted to understand his place in genteel society. On the face of things, he seems a curious example of genteel culture—a roughneck from a backwater town on the Mississippi by way of the Nevada silver mines and post-Gold Rush San Francisco who made his way into the refined circles of Hartford and Boston. His letters, his wife's, and those of others in New

England and elsewhere in the United States and Europe reveal much about his passage into a socially acceptable literary and social life. They also bring into focus how he, while making his mark writing works of nostalgia such as *Tom Sawyer* and *Adventures of Huckleberry Finn,* also plunged into the sunshine of romance with *The Prince and the Pauper* and *Joan of Arc.*

The study of genteel culture and Mark Twain is one small example of the work I have underway in the Mark Twain Papers and Project, where all of my work is exhilarating and gives my scholarly life meaning and interest.

*Robert Middlekauf is a former Bancroft Fellow, Professor of History, three-time Chairman of the Department of History, and winner of the Distinguished Teaching award at Berkeley. He is a former Director of the Huntington Library, Art Collections, and Botanical Gardens, and the author of distinguished books about the Mathers, Benjamin Franklin, and the American Revolution, among others.*

# Project Highlights

### Novels and travel narratives

Eight volumes to date, including: *The Mysterious Stranger; A Connecticut Yankee* in *King Arthur's Court; The Adventures of Tom Sawyer; Adventures of Huckleberry Finn; The Prince and the Pauper; Roughing It; Tom Sawyer Abroad; Tom Sawyer, Detective.* Others still in process include *The Innocents Abroad; A Tramp Abroad; Following the Equator;* and *The Tragedy of Pudd'nhead Wilson*

### Early fiction and journalism

To date, three volumes, including: *Early Tales and Sketches,* volumes 1 and 2 (through 1865), and *What Is Man? And Other Philosophical Writings.* At least an additional six volumes of such work are in process

### Late fiction

To date, four volumes of short writings, many unfinished, most written in Mark Twain's later years: *Satires and Burlesques; Which Was the Dream? And Other Symbolic Writings of the Later Years; Hannibal, Huck, and Tom;* and *Fables of Man.* At least two more volumes of unpublished fiction are in process

### Notebooks

To date, three volumes (through 1891). An additional two volumes are in process

### Letters

To date, eight volumes: all inclusive (from 1853 through 1875), and selective collections (for 1867–1894 and 1893–1909); also, inclusive electronic texts available online at ebrary.com (for the years 1876-1881). The electronic edition will have all the letters arranged chronologically, including those found subsequent to the publication of the print volumes for given years.

### Popular editions

To date, eight volumes, reprinting volumes in the scholarly edition for the general public and classroom use (The Mark Twain Library).

Some examples of several drawings made for (but not necessarily given to) guests at one of two "Doe Luncheons" Samuel Clemens gave on 14 January and 11 February 1908. "Doe Luncheon" was coined by his friend Kate Douglas Riggs and was the opposite of a "Stag Luncheon." Clemens was the only male present at these luncheons.

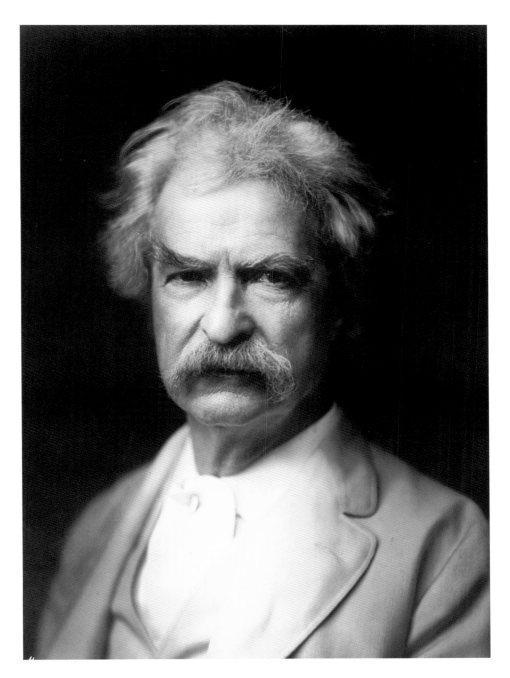

One of perhaps twenty shots taken of Mark Twain by
A. F. Bradley in New York City on 15 March 1907. Collectively
they are some of the most famous images of the author.
As a portrait photographer, Bradley had the wit to put his
subject in a chair on a revolving turntable, so he could get
various angles without having his subject move at all.

# Regional Oral History Office

Richard Cándida Smith, DIRECTOR AND PROFESSOR OF HISTORY

## Collection Profile

*Scope*    The Regional Oral History Office (ROHO) is a research program that conducts, teaches, analyzes, and archives oral and video history for the purpose of documenting individual testimony and social memory. It covers the San Francisco Bay Area, California, the West, and the United States, 1890s to the present (first interviews collected in 1954). The regional approach allows sharply focused engagement of issues of national and international interest and importance.

*Subject Areas*
- arts, architecture, and literature
- business
- food and wine
- community history
- social movements
- law and jurisprudence
- medicine and public health
- natural resources, land use, and the environment
- politics and government
- science and technology
- university history

# History and Social Memory

*An Interview with Richard Cándida Smith,*
*Director*

by Linda Norton

*Walter A. Haas, Jr. throwing out the first pitch at an Oakland A's baseball game. Photograph from The Elise Stern Haas Family Photograph Collection. Oral history: Walter A. Haas, Jr. (1916-1995), Levi Strauss & Co. Executive, Bay Area Philanthropist, and Owner of the Oakland Athletics. ROHO, 1995.*

LINDA NORTON:

Richard, can you talk about the strengths of ROHO's collection?

RICHARD CÁNDIDA SMITH:

ROHO's collection includes two thousand interviews. Many are quite long, and they deal with a broad range of subjects important to the understanding of the history of California. Several hundred interviews focus on farming and agriculture, particularly on the wine industry. We have interviews about philanthropy in Northern California. A number of interviews with major business leaders of the state allow us to see several generations of leadership from the beginning of the twentieth century—often times, within the same company, often times within the same family.

We have perhaps a dozen interviews with members of the Haas family, who built the Levi Strauss company into the world's largest apparel manufacturer. Those interviews provide a detailed record of the values and accomplishments of three generations of leadership and vision. We see how a family approached philanthropy, arts, culture, science, and environmental preservation. We see their sense of civic responsibility. Heirs of the Levi Strauss company, members of the Haas, Koshland, and Goldman families, speak to each other about how to define a community, a family, and a sense of cosmopolitan values and regional commitments. The interviews reveal areas of agreement and disagreement, concord and divergence, and this multi-interview conversation helps the student of his-

tory understand the nuances and watershed moments in the history of a city, a region, a family, and an industry. How did Levi Strauss grow from a relatively small clothing enterprise in 1945 to the world's largest garment manufacturer, and one of the ultimate American brands, by 1970 or so? That's one example of a question a historian might turn to the body of interviews to answer.

NORTON:

Historians interview individuals, yet you have spoken about communities....

CÁNDIDA SMITH:

Talking always involves two or more people exchanging responses to the world. Talk is one of the most basic things we do. We interview communities because we emerge as individuals through our relationships with other people. Interviews provide a window onto the past that we wouldn't have otherwise. Interviewees learn to share the stories they tell most easily in an ongoing, unending process of exchange with friends, families, and colleagues and how those relationships have shaped a way of explaining why things turned out as they did. Certain events get emphasized because they elicit a responsive chuckle. Other aspects of the past elicit embarrassed silence. These previous exchanges shape the oral history interview in subtle ways that may be more evident in the original audiotapes than in a transcript. ROHO's interviews provide a record of and a dialogue about collective efforts to understand the past in many fields, including, for example, the dairy industry, the history of the University of California, and the government of the state of California.

We seek a wide range of perspectives, and that helps answer such questions as "How can you trust interviewees? Aren't they subjective? Aren't people biased? Don't their memories fail them?" These questions are complex, but let's accept for a moment that memory is faulty and that people's accounts are inevitably biased. When you have a large number of interviews, you bring together a group of perspectives that begin to balance one another out. A student can move through them and make some determinations about what may or may not be accurate; what may or may not be the best explanation for what happened. To have nearly five hundred interviews on the history of the University of California at Berkeley provides a body of information that will allow a researcher to work with records in the University Archives and see more clearly the complex personal and professional relationships, the informal judgments, that went into the development of this major institution of higher learning.

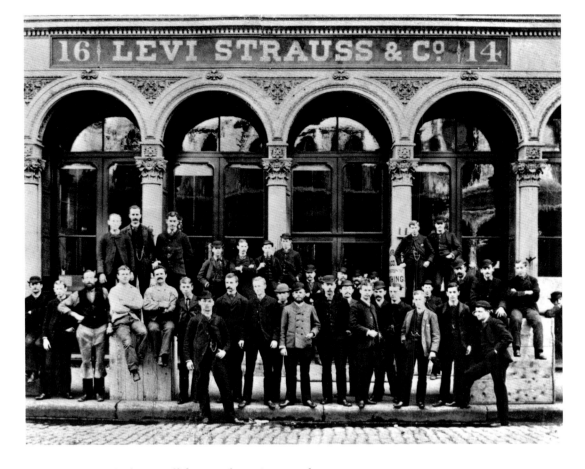

Levi Strauss & Co.'s overall factory, late nineteenth century.

NORTON:

Let me ask you about the development of the biotech sector in California and the connections between the university and the government and military. ROHO has Sally Smith Hughes' extensive interviews with leaders in the biotech industry. How does that collection aid anyone doing research in those areas?

CÁNDIDA SMITH:

The interviews in biotechnology are good examples of how oral history, begun at the right moment, while the major participants are still around, can help reconstruct the early days of a movement of great historical importance—a movement that was fluid and probably not well documented either on an institutional or a personal level. We have plenty of publications that show what the major scientific developments were and when they happened, but do we have a record that adequately explains how competition and cooperation, the relation of academia and commerce, worked to push people and technology in certain directions rather than others? The ROHO interviews address the early days of biotechnology when faculty at the University of California at San Francisco and at Berkeley began to see the commercial possibilities for the research they were doing. They then had

...Our competitors, both north and south, made waist overalls. Our chief competitors were Eloesser Heynemann, Neuseteder Brothers; in Los Angeles, Cohn Goldwater and Brownstein Lewis. Not one of them exists any more. They either went out of business or one of them was bought out and merged into another concern. There were also lots of small concerns, and there were overalls made in Chinatown which competed. And somehow we were able to promote our waist overalls. We added glamour, sex, the western theme to it, and this was what made our business. This was always a department that made money. It carried the house. It carried it through good days and bad days, so that we could say through depressions and wars, that we always did better than the average of the economy.

*From* Walter Abraham Haas, Sr. (1889-1979), Civic, Philanthropic, and Business Leadership, *an interview conducted by* Harriet S. Nathan, 1971-72. ROHO, 1975.

**Denise McQuade on disability rights as a civil rights issue:**

...We saw it as a civil rights movement. There were issues, and on those bread and butter issues, we no longer were willing to say, "Well, we're disabled; we have to take what we can get because the world isn't going to change for us." We had the concept, like, "Why shouldn't the world change?"...we realized that we're being deprived of something. And it spurred a movement ... that was not just based on one disability. It wasn't like just the physically disabled. But I have to take credit—not personally—but if you look at it, it was largely women and it was physically disabled who reached out to other [disabled] groups and said, "Hey guys, we're all in it together."

*From ROHO videotape interview with Denise McQuade, New York disability activist, conducted by Harilyn Rousso, December 8, 2003.*

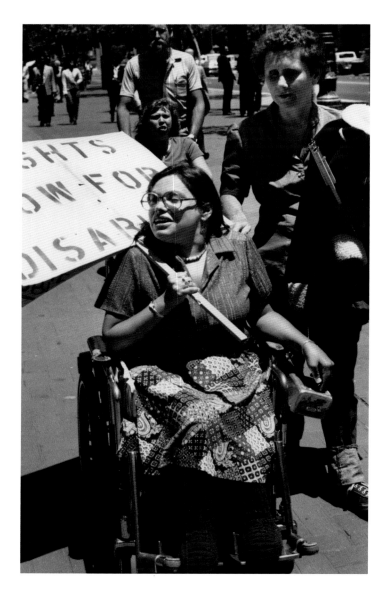

Judy Heumann during disability protest demonstration, San Francisco, circa 1979. Photo by Betty Medsger.

to confront what those commercial possibilities meant and what the best way to go about realizing those possibilities would be. Among the things that the interviews detail is the division among the faculty over whether this research should continue to stay in the university, with the university holding the patents, or whether it would be better and certainly more profitable to spin off some of this activity into privately funded, venture-capital firms focused on developing practical applications. This area is touchy, because patent issues and lawsuits are pending in this field, and some of the topics in the interviews may be proprietary. Candor in oral history does sometimes require that the interviewee have the option to seal the interview for a period of years. Even with the threat of legal action and controversy of all kinds, interviews allow a relatively safe space for reflection on what happened and why it happened.

NORTON:

How does a regional oral history office do work with national implications?

CÁNDIDA SMITH:

Speaking as an historian, not simply as the director of this office, if your mandate is to document the history of California, you are documenting the history of a place that since

at least 1848 has been at the absolute center of the development of the world economic system. Nothing has happened in California since the 1840s that has not had global impact. If we talk about biotechnology, the development of nuclear weapons, agribusiness, Silicon Valley, pop culture, the Beats, the hippies and counterculture, the multiracial and multi-cultural foundations of modern America, if we talk about the Free Speech Movement, or the University of California as the preeminent model for quality public education—any area where we've been doing active interviewing—you can study the local story for its national and international implications. California is in many ways the epitome of the modern multicultural, transnational world, with all the creativity and social turmoil that's involved.

We have, for example, the oral history of the Disability Rights and Independent Living Movement. The movement began in the 1960s, when Berkeley was one of the important centers for developing a national civil rights and political movement. After the first phase of this project documented the roots of the movement at Berkeley, it seemed clear that if you were going to write a history of the Disability Rights Movement, you then had to look at the national network that had developed since the 1960s, and that meant doing extensive interviews in other parts of the country, focusing on areas where there were important expressions of this movement. The disability rights community is also international now. We still have to get funding to expand this project to document the international movement for human rights.

Norton:

Along the same lines, California is a magnet for migration.

Cándida Smith:

ROHO, like Columbia, like UCLA, has been focused on documenting the powerful, the wealthy, leadership in various fields. We've interviewed leadership in the communities, as in the Jewish or Portuguese community series. The project we have on Mexicans in Cali-fornia is called the Mexican American Leadership Project. Most people are not leaders; they too have important stories. You can't understand why or how things have developed the way they have unless you can get down into what you could call everyday life, into the community in a more grassroots way.

We are working with the City of Richmond and the National Park Service on oral histories of the World War II period in Richmond, California, where an interpretive park about the nation's home-front experience will be built in the coming years. The oral histo-

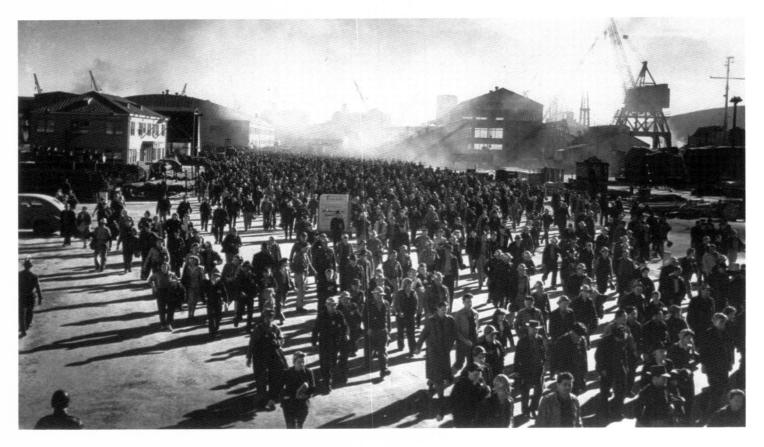

*Shipyard Workers, Yard 3, Richmond, California. Day Shift Change 3:30 p.m.*
Photograph by Dorothea Lange, October 1943.

## Lewis Van Hook on taking work in the Kaiser Shipyards, Richmond, California, 1943

…When I got to San Francisco, I caught a bus and come on to Berkeley, found a place to stay. The next day, I made my way to Sixth and Nevin in Richmond. That's where the state employment was … they were hiring everybody.

I went over there and got in line. It took me a good long while to go through that line. I never forget when the lady asked me what yard did I want to work in. I didn't know what yard I wanted. She chose for me.

She said, "Yard Three?"

I told her, "Yes." And that was the best yard.

I went in there and went to work as a driller. I would work hard. We did the drilling and the bolting of the bulkheads on the sides of the ships. My supervisor was a fine guy. I believe his name was Ted Kilgore … a young white fellow. He stayed right with me.

After I was there, a year and a half, one night he came in and told me, "Get them gloves off. You're in charge of the crew. … I was proud of that. I made it all right."

*From* Lewis Van Hook (1907-1992), Recollections of a Singing Shipbuilder, *an interview conducted by Judith K. Dunning, 1983. ROHO, 1992.*

ries explore the way the war effort challenged people, created opportunities for them, transformed lives. We want to uncover how war might have changed the ways people looked at their world. Thanks to a grant from the California Coastal Conservancy, we were able to do an initial set of interviews with forty-eight people, men and women who worked in the defense industries, as well as people who worked in education, healthcare, civil defense. These interviews ranged from two to eight hours in length. They are with Latinos, Asians, African Americans, Anglo-Americans, or European-Americans, with professionals, workers, and small business people. We wanted a range of experiences, including those of people still in school during the war. In the interviews, we tried to

reconstruct both individual trajectories and changes in community life.

For me the interviews raise important questions about people's search for social stability. In a society that is in rapid flux, there's a lot of chaos, even danger. Not surprisingly, family is an important part of this story, but so is religion. Religion and religious community come up again and again in these interviews as not simply a provider of values and community for people but also as a place in which people could learn new skills, develop themselves, and create a situation where they could take advantage of the postwar opportunities if they were so inclined. We also did some interviews with entertainers. That's another area that should be underscored.

Religion and religious culture emerged as important themes in the interviews. I want to probe further to explore how religious and ethnic affiliations related to other kinds of relationships, such as membership in trade unions. We know from other Bancroft sources (the hundred and twenty boxes of documents from Kaiser Industries) that there was a very active trade union culture in the war industries. How did these different affiliations and identities come together to create a repertoire of meaning for people? Why is it that, in these oral accounts, religion seems to stand out most sharply as providing an understanding of their place in a rapidly changing society? I think if we could answer these questions, we would have a better understanding of the political and social development of the United States after World War II. With this kind of research, oral history can provide unique insights into the past.

NORTON:

Does the process of an interview, in and of itself, lead to the possibility of a different kind of recognition and interpretation of an historical event?

CÁNDIDA SMITH:

We want to go beyond storytelling when we embark on an oral history. We start with the stories that people have to tell, but if the interview is to provide a rich historical document, the interviewer has to help the person bring out those elements of his or her experience that may conflict with the stories they've already told. If we are successful, then we go from storytelling to what Alessandro Portelli calls "history-telling," which is what happens when the interviewee, along with the interviewer, is engaged in a reconstruction and a reflection on the past and its meaning and is no longer just recounting the stories that he or she has learned to tell over the years. Now, two approaches to the past are facing each other across the tape recorder: an academic "scientific" method for reconstructing

The Grand Canyon battle got hotter and hotter. The main success was that we did elicit a lot of public support from the ads that came out of Jerry Mander and Howard Gossage for the Sierra Club. Those ads were potent. One of the things that Howard Gossage had said was that there's no point in writing an ad unless it's going to be talked about. It can't be just an advertisement; it must be an event. It must do something.

I think the stimulus there was primarily that this is the *Grand Canyon*, it is *your* Grand Canyon. Do you want them to flood this for their special purposes; do you want them to flood the heart of it? . . . The emotional argument was epitomized in the later Grand Canyon ad, which is the one most people remember—the one with the headline, "Should we also flood the Sistine Chapel so tourists can float nearer the ceiling?" . . . I think that the emotional appeal was what stimulated people to acting, to writing the letters, to coming back, to getting into the hearings, to do what they could.

As I summarize it, the first ad on the Grand Canyon lost the Sierra Club its tax status; it *did* something!

*From* David R. Brower (1912 –2000), Environmental Activist, Publicist, and Prophet, *an interview conducted by Susan Schrepfer, 1974–1976. ROHO, 1980.*

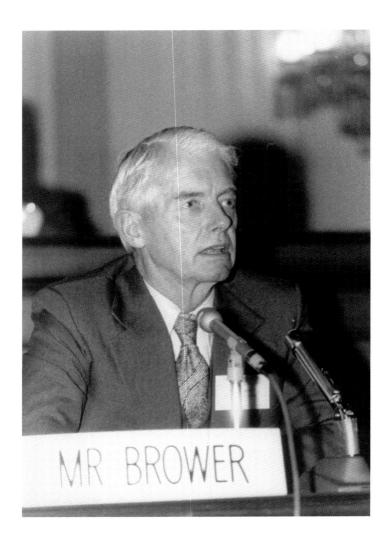

David Brower, President, Friends of the Earth, circa 1969–1975.

After Brower was ousted from his position as Executive Director of the Sierra Club, he founded and became the first president of Friends of the Earth in 1969.

the past and a vernacular experience of the past as burned into memory. We are engaging in a dialogue between a historian and a narrator, a person who has been a witness to an important part of history, a dialogue in which two distinct visions of the past come into immediate relationship. One approach does not replace the other, but in the exchange of perspectives new interpretations of what occurred, how, and sometimes why emerge.

NORTON:

Your students did some very exciting and original work through the Richmond interviews.

CÁNDIDA SMITH:

Students have been very active in our project on the World War II home-front experience. One student, David Washburn, wrote his senior thesis on the Mexican American community in Richmond, California, during the war. He interviewed nine people and with information provided by the interviews, he went back to examine the Kaiser Industries' records at Bancroft, old newspapers, and church publications to tell a story that had

## Herma Hill Kay, first woman Dean of Boalt Hall School of Law, on the creation of an "in-house" clinical program:

The programs were really begun in the late sixties and early seventies, and while this was still going on, we didn't have an in-house clinical program. We had programs where people did externships. Our students actually founded what was called the Berkeley Community Law Clinic; it's now called the East Bay Community Law Clinic. That was an off-site location in east Oakland, and they had raised the money to hire their own full-time director. We had never looked for in-house, hands-on, live client clinical education. … [I] was convinced that live client clinical education is what you really wanted, because it was the contact between the student and a client whose case the student was responsible for that, I thought, was going to create the spark of interest in professionalism and also make the theoretical learning that was going on in the classroom come home to the student, so the student would know what it meant to fulfill the role of the lawyer. While you could do some of that with simulation and skills training, my view was that it was not the same thing. It didn't have the same emotional impact….

*From* Herma Hill Kay, Professor, 1960-Present, and Dean, 1992-2000, Boalt Hall School of Law, University of Caifornia, Berkeley, *an interview conducted by Germaine Laberge*, 2003. ROHO, 2005.

been passed over. His senior honors thesis examined the craze for country swing music in Richmond during the war. He interviewed musicians, club owners, and fans, and then went into the Kaiser Industries papers to reconstruct how the company's efforts to boost war worker morale through regular concerts and dances helped support musicians during the war.

Sayuri Stabrowski, another student, interviewed her grandfather for her senior thesis, which examined the reasons why many interned Japanese Americans refused to pledge allegiance to the United States or to volunteer for the military. She showed that in many cases that refusal was based on loyalty to the United States and insistence that Constitutional rights be preserved. She then wrote a senior honors thesis examining oral history projects documenting the internment experience and the relationship of those stories to novels, films, and histories on the subject.

Student-designed research projects can take us deep into the communities of California. The beauty of it is that by working with ROHO, students learn professional-level skills and the interviews they do will be preserved at Bancroft for use by scholars and students for generations to come. When students know that their work is for posterity, that it can have an impact on the broader community, they work hard to do their assignments as well as they can, and the quality of their writing improves. Schoolwork in the ROHO context is not just an exercise; it's a real contribution to scholarship.

I believe that the skills oral history research develops are particularly relevant to the general skills that a Berkeley student should have at graduation. Oral history involves assessing the relative strengths and weakness of different kinds of evidence and then going back to reexamine the evidence. When you write about the research, the process forces

...Durer, you know, way back in fourteen hundred and something, said, "I draw from the secrets in my heart," And that's what I have, in the end. That's what it comes to and that what's the best. Provided, of course, you've got an educated heart and a sense of some kind of general responsibility. The secret places of the heart are the real mainsprings of one's action.

*From* Dorothea Lange (1895-1965), The Making of a Documentary Photographer, *an interview conducted by Suzanne B. Riess, 1960-1961. ROHO, 1968.*

you to think critically about the relationship of different kinds of evidence in making a judgment that can help explain some aspect of the past.

NORTON:

In 2002 Lisa Rubens developed the Advanced Oral History Summer Institute, which draws on all the strengths of ROHO. Can you tell us a little about the philosophy and goals of the summer institute?

CÁNDIDA SMITH:

Many academics doing oral history don't have the opportunity to discuss and think about what they are doing, in a theoretically or methodologically sophisticated way. Most oral history institutes or workshops are directed toward either the mechanics of interviewing or toward community-based projects. We found there is a niche for an institute, avowedly academic, for professors and Ph.D. students, primarily—but also for museum curators and community historians—who are going to be using interviews as a significant part of their research, and who want to learn about oral history methodology in a way that grounds the work they are doing. A good grasp of theory and practice provides them a way of thinking about their work and talking about it with others in the academy; it helps them to do better interviews. You should interview people only if you think they are going to tell you something that you don't already know. We have seen from the terrific response to the summer institute four years in a row that there is a need for this rigorous kind of grounding of oral history.

We do include some practical sessions over the course of a week of workshops and presentations, because they are important. What is unique about our program is that we center the institute around the participant's projects, and the critical issue is that we facilitate their developing—or deepening—a conceptual framework for thinking about oral history as a source, and its relationship to other sources, and what interviews can and can't reveal, and how you work with that. The summer institute is exciting because of the rapid intellectual development in the top-notch people who attend these sessions, and the networking that takes place. We start Sunday evening, and by Tuesday, people are thinking about their projects in radically new ways, such that they may have redefined the possible goals of the projects. They are going beyond asking conventional kinds of questions. I don't say that it is surprising to see this kind of growth in such good students, but it is gratifying. The summer institute involves everyone at ROHO, and we have a great range in terms of intellectual resources and practical experience. So far we have attracted

participants from all over the U.S. and around the world.

NORTON:

How would you like ROHO to be viewed and valued as a resource?

CÁNDIDA SMITH:

Professionals at ROHO are specialists in oral history and social memory. ROHO should be viewed as an important Bancroft resource that scholars, students, and researchers on campus and in institutions and communities around the globe can use to enhance their own research.

*Richard Cándida Smith is Director of ROHO.*

*Linda Norton is a Senior Editor at ROHO.*

# At Work | *Dorothea Lange and Paul Taylor*

SANDRA S. PHILLIPS

The eminent photographer Dorothea Lange had an important role in the Farm Security Administration (FSA), the government-sponsored photographic project during the Depression. She was also an active partner in fashioning one of the most important photographic exhibitions, *The Family of Man,* which opened at the Museum of Modern Art in New York in 1955 and traveled internationally, including to the San Francisco Bay Area. A whole range of photographers who matured in the 1960s—including Gary Winograd, Lee Friedlander, and even Diane Arbus—could not have made their work without reference to Lange's personal understanding of documentary photography and her commitment to it as an expressive form.

Dorothea Lange's work is so forceful and humane that it compels us to reevaluate it for every generation. In 1994, when the San Francisco Museum of Modern Art (SFMOMA) moved to its new location, it seemed appropriate to reexamine her work and dedicate an exhibition to it. SFMOMA's new home was in the South of Market area near where Lange photographed

Dustjacket from
*An American Exodus.*
*A Record of Human Erosion,*
by Dorothea Lange and
Paul Schuster Taylor.
New York: Reynal &
Hitchcock, 1939.

"White Angel Breadline" on the Embarcadero and other pictures of economic deprivation in the early 1930s. Lange realized the extreme implications of the Depression as it struck the Bay Area in photographs made in San Francisco and later in California's Central Valley.

SFMOMA's remarkable collection of photographs by early modern California artists included but few of Lange's, and those were made only in San Francisco. They did not represent the great breadth and true strength of Lange's accomplishments, which were very tied to her residence in this state and the friends and associates she had here.

The resources at The Bancroft Library were enormously useful and offered me as the show's organizer many helpful insights. Not only did Bancroft provide the ROHO interview with Lange herself but the immensely important (and massive) oral histories conducted with her second husband, economist Paul Schuster Taylor (1895–1984), a professor of economics at the University of California, Berkeley. Lange's interview necessarily focuses on her career as a photographer and enunciates her development and interests. Taylor's is certainly as important in understanding the historical and intellectual background of their work together.

Bancroft research materials include interviews with Lange's friends, among them Imogen Cunningham (1883–1976), Ansel Adams (1902–1984), Emmy Lou Packard (1914–1998), and her father Walter Packard (1884–1966), that elucidated aspects of Lange's work and the philosophy that motivated Taylor. The Bancroft sources were valuable not only in themselves but as important personalizing elements in writing the catalogue.

Lange's whole archive—not only the negative files but surviving prints, letters, and clippings—was given to Lange and Taylor's local institution, the Oakland Museum of California. After Taylor's death, his archive, consisting not only of papers but of some of Lange's important and most understudied photographs, was given to The Bancroft Library.

Taylor's papers were very important in understanding Lange's direction, especially her interest in the Central Valley migrants. Originally from the Midwest, Taylor was familiar with the culture of family-owned farms and its principles of egalitarianism, shared by the Roosevelt administration. Taylor recognized perfectly the social conflict enacted in the Central Valley. Destitute farmers who had either owned small farms in the Dust Bowl or had been tenants there migrated to California because of a combination of drought and advancing technology. They made a desperate effort to find jobs—and hoped to find land to farm.

As the Taylor papers made clear, the migrants came to a part of the country that had developed corporate farming. His papers emphasized his idealized vision of family farming—how it was nourished by a Jeffersonian tradition and challenged by large land-owning development. Taylor had been gassed in France in World War I and moved to California to recover his health, and there discovered the vast difference between what he had known and the culture of farming in the West.

As both a government worker and faculty member, Taylor was interested in another issue

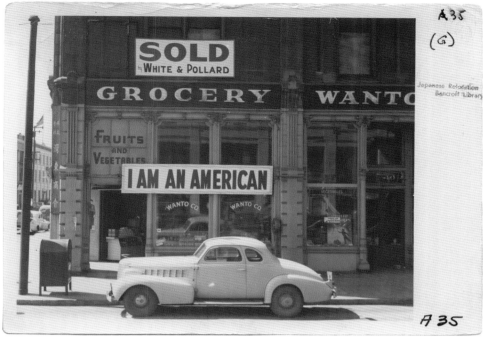

that Lange helped him document: the Japanese relocation ordered by President Roosevelt in 1942. Relocation was virtually a Western phenomenon, much like the Dust Bowl immigration, and thus a natural subject for both of them to study and document. Taylor's papers contain a significant number of beautiful photographs Lange made for the War Relocation Authority, which document the fear during wartime and the dignity and resilience of the Japanese families. Underlying the concerns of both was a respect for community, for promoting development for the greater benefit of the majority, and for a clear-eyed examination of how this was challenged and ultimately lost.

ROHO's archives illuminated the work of both Lange and Taylor and revealed the way in which they worked together, important elements in both the exhibition and the catalogue of her work.

*Sandra S. Phillips is Senior Curator of Photography at the San Francisco Museum of Modern Art.*

*I AM AN AMERICAN.* Photograph by Dorothea Lange, 1942, from the War Relocation Authority Records.

Following evacuation orders, this store, at 13th and Franklin Streets in Oakland, was closed. The owner, a University of California graduate of Japanese descent, placed the I AM AN AMERICAN sign on the store front on December 8, the day after the Japanese bombed Pearl Harbor.

# Collection Highlights

## Arts, Architecture, and Literature

Interview series on American composers, craft and fiber artists, books and fine printing, the San Francisco Opera, Oakland blues musicians, architect Julia Morgan, artists with disabilities; individual memoirs with outstanding artists such as sculptor Ruth Asawa, musician and composer Dave Brubeck, photographers Ansel Adams, Dorothea Lange, and Wayne Miller, poet Carl Rakosi, graphic designer Wolfgang Lederer, conceptual artist David Ireland, and architects William Wurster and Joseph Esherick.

## Business

Interviews on banking, journalism, transportation, clothing manufacturing, food processing, housing and commercial real estate, documenting the Bank of America, Dean Witter and Company, Crowley Maritime Corporation, Levi Strauss & Company, Aramco, Farm Machinery Corporation, and the Irvine Company. More than eighty in-depth interviews on the mining industry comprise the series on Western Mining in the Twentieth Century.

## Community History

Interview series on community groups and organizations document the Portuguese in California, the California Jewish community, the Jewish Community Federation, the San Francisco Human Rights Commission, and Bay Area philanthropic foundations. Two major projects focus on Richmond, California: On the Waterfront: Richmond Community History and Rosie the Riveter World War II American Homefront Project. The collection includes memoirs with community leaders such as Uri Herscher, Louise M. Davies, and Evelyn Haas.

## Social Movements

Projects on the history of diverse social movements including women's suffrage in the early twentieth century, the 1964 Free Speech Movement at Berkeley, and the nationwide Disability Rights and Independent Living Movement from the 1960s to the present. The collection also includes interviews with Mexican-American political leaders, California labor movement activists, Bay Area volunteer leaders, and social welfare professionals.

## Food, Wine, and Agriculture

More than one hundred oral histories on the California wine industry from the Depression era to the present, including Robert and Peter Mondavi, Ernest and Julio Gallo, Louis Martini, and the Wente family. California's innovative food industry is documented with interviews of chefs, restaurateurs, entrepreneurs, writers and critics, and agriculturists, including Chuck Williams and Howard Lester of Williams-Sonoma, dairyman Gene Benedetti, food writer Doris Muscatine, restaurateur Cecilia Chiang, and cooking teacher Mary Risling.

## Law and Jurisprudence

Projects on major Bay Area law firms, the U.S. District Court for the Northern District of California, the California Supreme Court, Law Clerks of Supreme Court Chief Justice Earl Warren; individual memoirs include interviews with Judges Thelton Henderson and Lowell Jensen, Justices Allen Broussard and Joseph Grodin, civil libertarian Francis Heisler, trial lawyer George T. Davis, and labor lawyer Norman Leonard.

## Natural Resources, Land Use, and the Environment

Series on California water resources, forestry, horticulture, the Sierra Club, land-use planning, environmental activism, and the McLaughlin gold mine include interviews with environmentalists David Brower, Margaret Wentworth Owings, and Wallace Stegner; state and federal resources managers Newton Drury, William Penn Mott, Norman B. Livermore, and Douglas Wheeler; forest economist Henry Vaux and hydrologist Luna Leopold.

## Politics and Government

Extensive series of interviews on the administrations of California governors Earl Warren, Edmund G. [Pat] Brown, Goodwin Knight, and Ronald Reagan; interviews for the California State Archives of legislators and state officers from the 1960s to the present; California women political leaders. Interviewees include civil rights activist Frances Mary Albrier, State Superintendent of Schools Wilson Riles, Secretary of State March Fong Eu, and legislators Nicholas Petris, Peter Behr, and Willie Brown.

## Science and Technology

Interviews with chemists, physicists, engineers, and bioscientists, including Nobel Laureates Charles Townes, Owen Chamberlain, and Paul Berg; founders of the biotechnology industry, including projects documenting the pioneer biotech companies Genentech and Chiron, with interviews of scientists Herbert Boyer, David Goeddel, and William Rutter as well as venture capitalists and company executives.

## Medicine and Health Care

Interviews document changes in the practice of medicine, health care, and public health administration; includes series on the early response to the AIDS epidemic in San Francisco, the history of Kaiser Permanente, medical physics, public health research and activism, ophthalmology, and individual memoirs of physicians and health care professionals.

## University History

Interviews with faculty, deans, provosts, and chancellors at UC Berkeley; key figures in the Office of the President and on the Board of Regents; series on the Berkeley Departments of History and Anthropology, the Colleges of Engineering and Environmental Design, and campus organizations such as Cal Performances, the Cal Band, and the Prytanean Society; projects documenting central topics in higher education, including diversity, access, and admission policies, African American faculty and administrators, women faculty, the loyalty oath controversy (1949–1951), and student activism; interviews with distinguished alumni in the Black Alumni series and the Class of 1931's University of California, Source of Community Leaders series.

# Behind the Scenes

Charles B. Faulhaber, DIRECTOR

## *Access*

*The problem of access, of simply finding what one is looking for, is as old as libraries themselves.*

AROUND 1870, WHEN HUBERT HOWE BANCROFT had acquired a library of about 15,000 volumes on the history of California, he realized that he couldn't find anything in it:

> On my shelves were tons of unwinnowed material for histories unwritten and sciences undeveloped. In the present shape it was of little use to me or to the world. Facts were too scattered; indeed, mingled and hidden as they were in huge masses of debris, the more one had of them the worse one was off (Literary Industries, p. 231).

Bancroft had already begun to have members of his staff catalog his collection, but he realized that to make it truly useful he would have to go much further. Thus was born the idea of using the library as the source for the thirty-nine volumes of *Bancroft's Works*, his gigantic history of California, Mexico, and the American West. In some sense the *Works* became an index raisonée of his library, and scholars still use them today to locate the primary sources on which they are based.

After the University's purchase of Bancroft's library in 1905 and its arrival on campus in May 1906, a commission was appointed to make recommendations concerning the "organization, regulation, and maintenance of the Bancroft Library." From the beginning, a small crew of graduate students was employed "in classifying and segregating the manuscripts, printed books and newspapers, and in making calendars, or analyses of the contents of important manuscript collections" (*University of California Chronicle*, 1908). Over the past one hundred years the staff, still aided by graduate and undergraduate students, have continued to analyze the collections to make it easier for scholars to find what they are looking for. For example, well into the 1980s staff maintained a card file that noted the location in printed and manuscript sources of information concerning particular individuals, localities, and subjects, and prepared

typed finding aids, that is, inventories, for individual collections.

The processing of archival and manuscript collections is an art, not a science, although the general steps are the same for all collections. The first step is to survey the collection. To the extent that it is in good order, the archivist will preserve that order; part of the historical value of an archival collection is precisely the way it was put together and used when it was a working archive.

If the collection is not in good order, which is frequently the case, the archivist must then prepare an overall arrangement plan for the collection, establishing record series and sub-series for various kinds of materials (for example, incoming and outgoing correspondence). The archivist then arranges the collection systematically in accordance with that plan, discarding duplicates as well as materials that are determined to have little or no historical value (such as canceled checks).

At the same time that the collection is arranged, it is re-housed in acid-free folders and containers. A container list is created as the collection is sorted and arranged. The list becomes the nucleus of a finding aid for the collection. The finding aid also includes a summary of information about the collection's origin as well as its scope and content (that is, the kinds of information that the collection contains).

Card files and typed finding aids continued to be the state-of–the-art for special collections libraries until the 1990s. The change from the card file to the electronic catalogue record was made possible by the introduction of the MARC (MAchine Readable Catalog) format by the Library of Congress in the 1960s. Libraries all over the country began to convert their card catalogues into electronic catalogues, a process known as retrospective conversion.

Partial results of a search for photographer Arnold Genthe on the Library's Pathfinder catalog. Bancroft was the first special collections library in the country to convert its card catalog to electronic form.

Bancroft was the first special collections library in the country to convert its card file, a process funded by a grant from the Department of Education, starting with the catalogue of printed books (1986–1991) and then tackling the much more difficult conversion of the manuscript card file (1992–1994). The results were dramatic: almost overnight usage of the collection doubled. For the first time, scholars could find out what Bancroft held without having to visit the library. Research became more productive as well because patrons had to spend less time winnowing the wheat from the chaff. The project was so successful that it became a model for other special collections libraries around the country.

The next technology that radically enhanced access to the collection was the advent of the World Wide Web in 1994, which made it possible for scholars all over the world to gain access to documents that adhered to a standard format (HTML— HyperText Markup Language). Bancroft and the University Library took the lead in developing a framework for the electronic representation of the finding aids of manuscript and archival collections on the web, the Encoded Archival Description (EAD), adopted almost immediately by the Library of Congress as a national standard. Thus by the mid 1990s it was possible to find out online what books and manuscript collections Bancroft owned, and, increasingly for the manuscript and archival collections, to determine with great detail what kinds of materials they contained.

The final step, again a pioneering effort within the national context, was to develop cost-effective techniques to digitize materials from Bancroft's collections and make them available on the web. A pilot project funded by the National Endowment for the Humanities (1994–1996) created the California Heritage collection, a selection of more then 30,000 images illustrating California's history and culture. Since then a series of similar projects has steadily added more materials, ranging from Bancroft's medieval manuscript collection to online versions of Bancroft oral histories.

Thus we currently have a hierarchy of electronic information available online. At the lowest level stands the MARC record, providing author, title, and subject access. For manuscript and archival collections the MARC record then leads to the electronic finding aid. From the finding aid the researcher can see digitized images of some or all of the materials in the collection. Thus Bancroft has continued to turn to the latest information technology to make its holdings better known and more accessible, just as, in the nineteenth century, H. H. Bancroft used the latest technology—the steam-powered printing press—for exactly the same purpose.

Recently acquired collections wait their turn to be fully identified, processed, and inventoried.

# Technical Services

THE FIRST STOP IN THE PROCESS of making new acquisitions ready for use is the Acquisitions Division, which pays the invoices for everything that Bancroft buys and prepares the Deed of Gift for everything that Bancroft is given. The Deed of Gift ensures that Bancroft has clear title and that any restrictions on access are spelled out in detail and agreed to in writing. Some donors insist that certain portions of a collection—for example, personal letters between husband and wife—be closed to access for periods up to seventy-five years or that they retain the right to decide who can consult the materials therein. Curators and acquisitions staff do their best to convince donors to make such restrictions as limited as possible.

The Acquisitions Division also serves as a traffic cop, sorting materials by format and subject matter and routing them to the appropriate processing staff. Archival and manuscript collections ranging from a single letter to several hundred cartons are sent to the archival processing unit. The small collections (up to several linear feet) go into the queue for immediate processing; larger ones are surveyed by a senior archivist to determine what needs to be done and to provide an estimate for the time and cost to complete processing and description. These larger collections then go into storage until funding is found to process them. Periodically, the list of unprocessed collections is reviewed so that curators and technical services staff together can decide on priorities

for processing. Collections of immediate scholarly interest, for example, will be treated before those of more esoteric appeal.

Like most similar institutions, Bancroft has a substantial backlog—21,000 linear feet—of unprocessed collections. Moreover, the backlog increases at a rate of roughly 800 linear feet a year. Bancroft receives about 2000 linear feet of archival materials annually, but the staff, absent special external funding from grants or donors, can process only about 1200 linear feet. Obviously, this situation cannot continue indefinitely. Eventually, we will run out of space. On the other hand, since it costs roughly $500 to process a linear foot of archival material, simply to keep current with the backlog would require an additional $400,000 per year for archival processing.

Alison Bridger, Bancroft archives and manuscripts cataloger, works on the physical arrangement of recent additions to the Miller & Lux records.

The Miller & Lux Corporation in the late nineteenth and early twentieth century owned 1.5 million acres of cattle ranches in California, Oregon, and Nevada and in 1900 was one of the one hundred largest corporations in the U.S.

From the Acquisitions Division, pictorial materials—primarily photographs now—go to Pictorial Processing and printed materials to Cataloguing. In contrast to regular libraries, Bancroft does not use pasted spine labels and we retain dust jackets as an integral part of the original artifact. The shelf mark is printed on a slip of acid-free paper and inserted loosely into the book. Once the book is catalogued and assigned a call number, it is shelved.

Both pictorial images and manuscript collections are more difficult to deal with. Given the quantities of images that come in every year and the fact that most of them are unique, it is impossible to catalogue them individually, except when they are acquired as individual items or are extremely valuable collections (for example, daguerreotypes or photographs by recognized artists). A wonderful example is a collection of twenty-five photographs of the 1906 San Francisco earthquake and fire by photographer Arnold Genthe, donated to Bancroft in 2003 by Robert and Walter Haas III and Elizabeth Haas Eisenhardt. In general, pictorial acquisitions are catalogued as collections and labeled by provenance (name of the donor) or by subject matter, period, and geographic location.

# Preservation/Conservation

ONE OF THE CONSTANT TRADEOFFS IN LIBRARIANSHIP, a cliché of the profession, is the tension between preservation and access. We must ensure that the collections in our care will last for hundreds of years; at the same time, we must provide access to those collections for scholars and students today. The tension lies in the fact that the everyday wear-and-tear of simple use is one of the greatest dangers to the collection. Such wear-and-tear is more significant in a special collections library, where the value of the physical object frequently enhances its informational value.

Gillian Boal, conservator, at work on the preservation of an Inquisition document in the Conservation Treatment Laboratory, Preservation Department of the Berkeley Library.

The first printing of a book—including the quality of the paper and binding, typography, and illustrations—reveals much about the social and political context in which it was published, as well as the aesthetic and intellectual values of both its publisher and owners. The same holds true for later editions. The evolution of the physical characteristics of a book as it is republished becomes an important feature of its reception by readers.

Part of the price of taking care of an original volume is its preservation. Exposure to light and human touch, combined with the chemical composition of original paper, ink, and binding materials, contribute to its degradation over time. When not in use in the Reading Room, the primary point of access for a user, books and archival collections are kept under tight security on unlighted shelves. Despite our best efforts, some of Bancroft's collections require restoration every year, ranging from relatively straightforward repairs of small tears in a page or broken bindings to much more aggressive treatment—for example, stabilizing crumbling wood-pulp paper through de-acidification or encapsulation.

The library's Preservation Department, which is responsible for the physical integrity of all of Berkeley's library collections, devotes much time and effort to the often-expensive work of repairing works—both recent arrivals or older volumes—that have developed problems. Thus the Berkeley Library's nine millionth book, James O. Lewis's *Aboriginal port folio* (Philadelphia, 1836), one of the most important collections

# Preservation Services

Preservation services include binding preparation, microfilming, digitizing, reformatting, repair and housing, and education to facilitate access, use, and careful handling of library materials. The Preservation staff is also responsible for responding to emergencies—typically, water, mold, and bug infestations.

Each year, we treat about 2500 items, both flat and bound. Rolled materials must be humidified and flattened and loose items must be housed before they are shelved. Deciding what can or should be done physically is the responsibility of the Special Collections Conservation Treatment Team. Items that come across the Circulation Desk with potential problems are sent to the Conservation Department for a cursory review. Most frequently it is simply a question of minor repair and housing. If the materials require extensive treatment, the decision on what to do is made by the conservator and the appropriate curator, based on the condition of the item, its value in the collection, and the use it receives. An appropriate treatment is carried out, using both physical and chemical approaches. Conservators are particularly concerned not to re-create deterioration—for example, through the use of brittle paper. Accordingly, sound, compatible materials are chosen for conservation.

New technologies are applied as they become available. For example, a Kasemake machine now allows items to be measured in-house so that custom-made boxes can be constructed at the University of California bindery. This capability enabled us to box most of Bancroft's vault materials in preparation for Bancroft's move to its temporary quarters in 2005. A Wei T'o freezer allows us to respond more effectively to small emergencies by isolating bug-infested materials and freezing wet materials. A computerized and/or photographic process will record physical treatments or changes to the physical condition of an artifact, as well as condition assessment and location inventories.   — *Gillian Boal*

of portraits of the Indian tribes of North America, required extensive paper restoration. The limp leather covers and rope fasteners of the records of the Mexican Inquisition, acquired in 1996, required equally extensive work.

The Preservation Department also plays a significant role in monitoring the state of newly acquired collections, particularly those retrieved from attics and basements, to ensure that they do not contain unwelcome guests, such as silverfish. When such an infestation is suspected, the materials in question are quarantined; if an infestation is discovered, they are blast frozen for three days at a commercial cold-storage company.

Special collections materials are used on-site only. They do not go home in a backpack or get read in the bath. Within the specific environment, the approach to conservation can be responsive to the needs of the material, which vary enormously according to type and condition. These needs are identified by a variety of factors: patron use, new acquisitions, curatorial review.

Conservation is a young science. Its challenge is to juggle all of the preservation issues to arrive at a compromise without allowing the standards of special collections to diminish. Its philosophy is to use minimal intervention to make conditions stable so that an item can be handled, keeping it as close to its original condition as possible.

# Public Outreach

## Public Programs and Publications

INTEREST IN AND KNOWLEDGE OF BANCROFT'S COLLECTIONS and research projects are enhanced by gallery exhibitions, lectures, and publications. Many of the programs—to which the public is warmly invited—receive the generous support of The Friends of The Bancroft Library.

### Exhibitions

Bancroft exhibitions highlight particular areas of the collection or illuminate a particular historical theme or event. The curatorial staff mount three shows annually, one of which, at the end of the year, always features recent gifts or materials acquired with endowment funds. The other two are emblematic of the breadth of Bancroft's collections. Bancroft has, for example, celebrated the sesquicentennial of the Gold Rush and the thirtieth anniversary of Berkeley's Chez Panisse restaurant and Alice Waters' invention of California cuisine. We have traced the travels of Mark Twain, reflected the image of the Native American from the sixteenth century to the present, and recorded the sad demise of the California grizzly bear. We have charted the history of the environmental movement, commemorated fifty years of oral history at Bancroft, and traced the triumphs and tragedies of the first seventy-five years of the Chinese experience in California. In 2006, during Bancroft's off-campus exile, a special Bancroft Centennial Exhibition was held in the Berkeley Art Museum.

### Lectures and Symposia

During the academic year, Bancroft events—an average of one a week—include scholarly symposia and lectures by Bancroft's staff, University faculty, and visiting scholars. Monthly luncheon roundtables feature presentations by scholars and graduate student fellows working with Bancroft materials on current research projects. Over the past several years, such projects have included "Unsettled Frontier: Poetic Radicalism and the Question of Nationalism in California, 1930–1940," "Building the California Women's Movement: Architecture, Space, and Gender in the Life and Work of Julia Morgan," "Indian Resistance to Colonialism: The Pimas of Sonora," and "Exorcising the Devil: Cultural Authorities Respond to Tobacco and Chocolate in Seventeenth-Century Spain." Past symposia have focused on the Beat Movement in San Francisco, the Tebtunis Papyri, and the first twenty-five years of the biotechnology industry.

## Multimedia

Bancroft has extended its reach through the use of public broadcast, web, and audio-based media. Recently, we collaborated with public radio station KQED-FM to broadcast lectures on the history of California and the American West, six of which have been made available on tape cassettes with the help of the Wells Fargo Foundation. Just as we have made digital materials available on line, we have also created virtual versions of Bancroft exhibitions such as *Looking Backward, Looking Forward: Visions of the Golden State*; *Bear in Mind*; and, in collaboration with the Library of Congress, *The Chinese in California, 1850–1925*. Such online exhibitions, coupled with Bancroft's increasingly rich digital collections, have allowed the library to collaborate with K-12 school outreach programs. The goal of the Interactive University project, for example, is to make the University's resources available to elementary and high school teachers.

## Publications

Bancroft has an extensive history of publishing, including co-publications, based on materials in the collections. Books include ROHO's more than 2000 oral histories; Keepsakes for the Friends of The Bancroft Library based on unpublished materials in the collections; illustrated trade editions, such as *Drawn West* (2004), based on the Robert B. Honeyman Collection of Western Art; and scholarly publications such as the edition and translation of *Esteban José Martínez: His Voyage in 1779 to Supply Alta California*, and the scholarly editions of Mark Twain's works.

# Awards

### The Hill-Shumate Undergraduate Book Collecting Prize

This cash prize is open to currently enrolled undergraduates of the University of California, Berkeley. Kenneth E. Hill (1915–2001) and Albert Shumate (1904–1998), two distinguished book collectors, established the prize to encourage Berkeley students to collect books, to build their own libraries, to appreciate the special qualities of the printed word, and to read for pleasure and education.

To be considered for the Hill-Shumate Prize, collections must include at least fifty items. Collections may cover specific authors or subjects, contemporary or historical, and may stress bibliographical features (edition, illustrations, binding, and so on). Judges will give special consideration to how well the collection reflects the student's stated goals and interests. Age, rarity, or monetary value is less important than the thought, creativity, and persistence demonstrated in defining a collection and bringing it into being. Winners are announced and awards made at the Annual Meeting of the Friends of The Bancroft Library held each spring.

Charles Faulhaber, Director of The Bancroft Library, presents the 2003 Hubert Howe Bancroft Award to Barney Rosenthal, dean of American booksellers and scion of two distinguished families of European booksellers, the Rosenthals of Germany and the Olschkis of Italy.

### The Hubert Howe Bancroft Award

Presented by the Friends of The Bancroft Library, the Hubert Howe Bancroft Award honors individuals for "significant achievements in support of historical research and scholarship and in the preservation of ephemera and memorabilia." The Hubert Howe Bancroft Award is announced at the Annual Meeting of the Friends of The Bancroft Library and recipients are presented with a proclamation and a miniature bust of Hubert Howe Bancroft.

Distinguished recipients to date include Michael Harrison, private collector of Western Americana, 1998; Jean Stone, philanthropist, 1999; J. S. Holliday, historian and author, 2000; Willa Baum, oral historian, 2001; John L. Heilbron, historian of science and professor emeritus of history, University of California, Berkeley, 2002; Bernard M. Rosenthal, book seller and scholar, 2003; William Barlow, bibliophile, 2004; Kevin Starr, historian and California State Librarian, 2005; and Joan Didion, writer, 2006.

# Friends of The Bancroft Library

THE FRIENDS OF THE BANCROFT LIBRARY provide crucial support for the acquisitions, programs, and operations of The Bancroft Library. Membership is open to anyone interested in furthering the growth and development of the library by making an annual donation. Members receive regular calendars of events, announcements of programs, and invitations to lectures, receptions, and exhibition openings in addition to issues of the newsletter *Bancroftiana*, which is published twice a year. Members whose annual donation reaches a specified level receive a Friends' Keepsake, a handsomely printed volume, often the first published edition of a unique manuscript or rare document owned by Bancroft. Inquiries about membership in the Friends may be directed to The Bancroft Library, University of California, Berkeley, CA 94720-6000; (510) 642-3782; bancref@library.berkeley.edu.

The earliest known photographic image of Sam Clemens, the future Mark Twain, the day before his fifteenth birthday. Daguerreotype, unknown photographer. Hannibal, Missouri, November 29, 1850.

The apprentice typesetter holds a printer's stick with SAM spelled out, probably in wooden type. The daguerreotype process reversed this image so that the type as normally set (upside down and right to left) reads normally left to right.

*Exploring The Bancroft Library*

*Editorial Design:* Gail Larrick and Stephen Vincent, Book Studio

*Design and Typography:* John Sullivan and Dennis Gallagher,
	Visual Strategies, San Francisco

*Type:* Cycles by Sumner Stone, first issued in 1992.
	Gill Sans by Eric Gill for Monotype Corp. between 1928–1930

*Paper Stock:* Printed on Tri Pine Paper of KyeSung Paper Group
	Cover: Silk 256 gsm, Text: Velvet Natural 157 gsm

*Printing:* Color Separation, printing and binding by Samhwa,
	Korea through Overseas Printing Corporation, San Francisco